Choreographics

Choreographies

Tracing the Materials of an Ephemeral Art Form

Jacky Lansley

intellect Bristol, UK / Chicago, USA

First published in the UK in 2017 by
Intellect, The Mill, Parnall Road, Fishponds, Bristol, BS16 3JG, UK

First published in the USA in 2017 by
Intellect, The University of Chicago Press, 1427 E. 60th Street,
Chicago, IL 60637, USA

A catalogue record for this book is available from the British Library.

Cover designer: Emily Dann
Collage created from photography by Hugo Glendinning
Central performer Tania Tempest-Hay, researching *Holding Space* by Jacky Lansley
Copy-editor: MPS Technologies
Production editors: Jelena Stanovnik and Matt Greenfield
Typesetting: Contentra Technologies

Print ISBN: 978-1-78320-766-4
ePDF ISBN: 978-1-78320-767-1
ePUB ISBN: 978-1-78320-768-8

Printed and bound by Gomer, UK

I dedicate this book to all the performers who have made my work possible

Contents

Acknowledgements

I would like to thank the following individuals and organisations for their help and support with various aspects of writing and assembling this book: firstly the following for their generous time discussing the material, reading drafts, doing interviews, sourcing archival text and images, writing endorsements and contributing to an ongoing artistic dialogue: Fergus Early, Sally Potter, Diana Davies, Miranda Tufnell, Matthew Hawkins, Tony Thatcher, Rosemary Lee, Professor Ramsay Burt, Rose English, Lily Susan Todd, Anne Bean, Siobhan Davies, Professor Christy Adair, Sanjoy Roy, Martha Oakes, Lynn MacRitchie, Sylvia Hallett, Jonathan Eato, Vincent Ebrahim, Esther Huss, Ursula Early and Tim Taylor; then all those who belong to the community that is the Dance Research Studio, which has provided an invaluable context for much of the work in this book. I would particularly like to thank Yoko Nishimura for her support as archivist and with all IT matters throughout the whole process; also Hugo Glendinning for his beautiful photography of certain works. During the writing of this book, the choreographer Rosemary Butcher sadly died. I will always be grateful for her kind support and the inspirational legacy of her choreography. Finally I would like to thank Jelena Stanovnik, Matt Greenfield and all at Intellect whose thoroughness and understanding have helped to make the process of publishing this book a creative and positive experience.

INWARD

Choreography is the art form which most profoundly links the mind and the body – yet very few people understand what it is. Even those of us who practise choreography differ widely on what we consider the art form to be. In this book I reflect on a selection of my own choreographic works made over forty years and the changing cultural and social forces that have influenced me over the same decades. My aim is to help demystify some of the processes that can be part of choreography, by tracing the actual materials and strategies that my collaborators and I use. The works and projects I have chosen span the period 1972–2017 and include discussion of the seminal collaborations and organisations that have inspired and supported me over the years. As part of this excavation, I have had many interesting conversations with other choreographers and performers whom I have quoted extensively; several interviews with artists are also included. This sense of conversation has become part of the book's style and has allowed me to expand on my work as a voice amongst many.

Through reflective writing, archival notes, scores, descriptive accounts, reviews, interviews and images, I have tried to reveal some of the cross art form strategies and influences within my own practice and to acknowledge the importance of this broader landscape. For me this revealing is complex, as it is concerned with 'hidden' elements which as an artist one would not ordinarily expose. For all artists there are undoubtedly periods in a creative process when an idea needs to be private in order to grow, when we don't want feedback, advice or opinion. This may seem inward-looking, but nevertheless it does seem to be part of making art and I hope my accounts of choreographic work and the contexts from which it emerged, will make a useful contribution to the understanding of practices and choices that support and become choreography.

For a long time I have found it useful to use the word 'author' when describing my role as a choreographer. By association it gives the role dignity and a connection to the idea of language creation rather than working with a received or traditional technical vocabulary. The idea that choreographers can explore and develop their own vocabularies has been established for several decades; it is a journey that has tracked modernism and postmodernism and has enabled choreographers to draw from their own experience, as a modern painter, writer or sculptor would do. My model of the choreographer as an author, however, runs contrary to some pervasive theoretical perspectives which argue against the author's voice and insist on shifting meaning away from experience and the subjective 'I'.[1] Counter arguments that question the certainty of this postmodern attack on subjectivity have come through many channels, including feminism, with its rallying cry *the personal is political*, and other communities who seek to voice their different oppressions. I hope that my own work as a writer and choreographer shows that I understand that all language is cultural, collective and borrowed; that, indeed, I have learnt from and explored postmodern systems that deconstruct traditional narratives[2] throughout my practice. I do believe, however, that the more innovative and experimental sectors of dance need the authorial voices of practitioners to reflect a layered and mature culture that is not always and only 'emerging'.

I am now part of a third generation of New Dance[3] practitioners and it is interesting to recognise the enduring processes in my own eclectic works. The critic Jenny Gilbert once wrote of my work as a 'collage of glancing fragments […] that add up to more than their sum'[4], which I think accurately reflects the mix of influences in my hybrid work. I make no claim to having any answers to the question – what is choreography? I can, however, share a significant body of experience as one of the many contemporary choreographers around the world who are not touring work extensively, but are, nevertheless, creating work consistently and have been able to make dance and choreography a life's practice. Significantly, in 2002 I was able to move into my own studio in Shoreditch, London and this

has given my collaborators and me the space and time to practise and explore choreography from artistic, philosophical and social perspectives. It is significant that the first work that organically grew from the Shoreditch studio was called *Holding Space* (2004): diverse metaphors and concepts cluster around those two words, which I endeavour to articulate in the chapter titled 'Holding Space'.

I have tried throughout the book to give a sense of how my choreography has been influenced by ideas beyond dance and, by tracking the research methods and materials of my own work, I have attempted to engage with some of the important questions about aesthetics, context, training, research and survival which surround the art of choreography. I have included a wide selection of photographs and drawings, which I hope will enrich readers' experience and understanding of the processes and research methods. Much of the work I discuss explores visual and image-based languages and I felt it was very important to share some of those images in print; particularly as I have, over the years, collaborated with some outstanding photographers who have helped to create the choreographic space within which I work. Above all I would like this book to be read *as* a form of choreography which is close to artistic and body impulses; a creative 'thing' in its own right that will find new meanings not available, perhaps, during the original choreographic making.

I have used endnotes to expand on artistic and theoretical references and to credit quotes by other artists. I have particularly credited all the performers I have worked with on the projects discussed, in recognition of the importance of their contribution and to interrupt a pattern of anonymity that dancers often experience. The archival Chapters 1–2 discuss early works throughout the 1970s and the radical cultural backdrops from which they emerged. Chapter 3 focuses on selected works through the 1980s and 1990s, and Chapters 4–8 reflect on works which have been supported by my studio base in London since 2002. In parts of Chapters 4, 6 and 8, I have used a form, which I call 'Writing Choreography'.[5] Although written from memory, these descriptive sections are in present tense, enabling the reader to 'watch' the performers and get closer to the live work and the choreographic process. Chapter 9 is called 'Other Voices' and includes extracts from interviews with the UK-based dance practitioners Rosemary Lee, Tony Thatcher, Matthew Hawkins and Miranda Tufnell.[6] In the final part 'Onward', I touch on my future work and the challenges involved in holding the choreographic space. I am sharing with readers what I do in that space, which I hope after more than 40 years of doing it, is of value and interest.

Notes

1. Roland Barthes (1915–1980): French literary critic and theorist who was an early leading advocate of this perspective. In his influential essay – 'The Death of the Author' (1967) – Barthes suggests that readers must separate a literary work from its creator, in order to liberate the text from an author's 'interpretive tyranny'. Linked to the Cartesian method of analysis which sees the world as sets of objects and signs interacting with each other; often set in opposition to the science of phenomenology, developed by the philosopher Edmund Husserl, which is concerned with the study of human consciousness and its structures.

2. Deconstruction: critical outlook concerned with the relation between text and meaning; it derives from linguistics and the study of sign systems (semiotics) and structuralism. It has been applied to a wide range of cultural theories including literary and performance criticism. Although the exact meaning of the term is uncertain, key figures who are associated with this outlook are Levi Strauss, Martin Heidegger, Ferdinand de Saussure, Michel Foucault and Jacques Derrida (see section '*Do My Shoes Reflect the Quality of My Intellect?* (1998–99)' in Chapter 3).

3. New Dance (New Dance Movement): initiated by a group of experimental British dance artists who emerged in the early 1970s and formed the seminal X6 Dance Space. A key aim was to view and explore dance within its wider social context and to enable diverse participants to engage in community, educational and professional dance activities; responsible for encouraging cross art form collaboration and creating spaces for the development of interdisciplinary performance and somatic training. *New Dance Magazine*, produced by the X6 Collective, was a voice for New Dance from 1977 to 1988.

4. Jenny Gilbert: dance and theatre critic; quote from her review of *Bird* (2001): 'There's Weird and Wondrous Life in the Old Girl Yet', *The Independent on Sunday* (London: 18th March, 2001), 6.

5. 'Writing Choreography': this concept/process has been explored by several international artists through the different media of writing, film and live work. For example, in his project *Synchronous Objects* (2009), William Forsythe creates a large set of data-visualising tools, including the 'Writing Room', for understanding the interlocking systems within his choreography. In her editorial 'Writing' for the first issue of *New Dance Magazine*, No.1 (London: X6 Dance Space, 1977, 3), Lansley first used the term 'Writing Dance' to argue the need for analysis and discussion of new dance work. Here she uses 'Writing Choreography' differently to visually materialise the live event – although both usages are part of the same paradigm.

6. See Chapter 9, 'Other Voices', for the artists' biographies.

1
MINIMAL DANCE

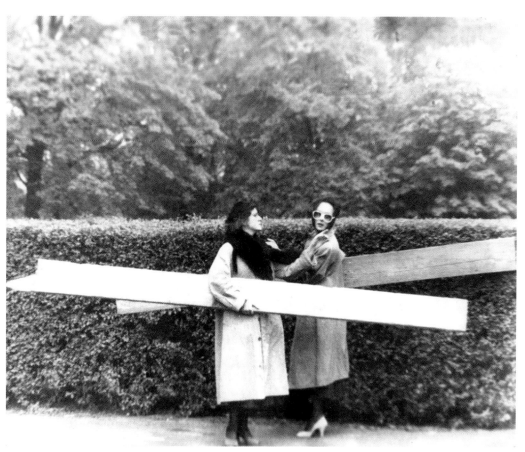

01 *Park Cafeteria* (Limited Dance Company)

By the 1970s a diverse field of performance art[1] was established across Europe and America, influenced by a minimalist art movement that had been developing since at least the 1950s. Boundaries had been broken between painting, sculpture and performance and for a brief period in the early 1970s, the London School of Contemporary Dance (LSCD)[2] allowed a space for dance to explore and interact with these interdisciplinary influences, primarily through the diverse and radical students who were part of its community at the time. In 1971 I enrolled as a student at LSCD (having performed with the Royal Ballet Company for two years) and became part of this radical community, which included artists such as Sally Potter[3] and Diana Davies.[4] We exchanged skills and learnt from each other, supported by a ground swell of political change and widespread action around societal oppressions such as sexism, racism and homophobia; all of which inspired the material and imagery of our performance work.

As activist students we created many site-specific events and performances in the LSCD building and in external contexts, with collaborators from across all disciplines. Nothing seemed to be off limits if it was useful to the realisation of what we were trying to explore. Any indoor or outdoor public space was a potential performance space; any personal or political theme was legitimate material; any found object, random image or fragment of text was a potential 'script'. We were aware of the postmodern dance-work going on in the USA, and artists such as Meredith Monk[5] (who visited LSCD in 1973 and got a group of us to camp out in a studio for several days), the Judson Group,[6] Merce Cunningham[7] and John Cage[8] inspired us. It is significant, however, that the experimental performance work that we as a group were interested in combined artistic, conceptual *and* theatrical strategies and skills. The focus on minimalist pedestrian movement in the early work of Yvonne Rainer[9] and others, wasn't our central concern at the time, although conceptually we understood the minimalist aesthetic of task-based dance performance which opposed a narcissistic, virtuosic and dramatic view of performance.

In 1972 several of us joined Strider,[10] an experimental dance company initiated by Richard Alston,[11] which drew on this radical student energy. I worked with Strider for a year, during which time I choreographed *The Truth About Me* (1973) – using music of the Everly Brothers and Elvis Presley to evoke cultural stereotypes of the 1950s – and *Halfway to Paradise* (1972), which included performers such as the sculptor Barry Flanagan[12] and the US composer Gordon Mumma[13] who performed alongside other colleagues from The Place.[14] The piece was performed at the Institute of Contemporary Arts (ICA) as part of a Strider event and this review by the dance critic John Percival reveals the kind of personal and political collage of images, themes and skills that we were exploring:

> Strider's next London appearance was 1 December when an expected new piece by Flanagan (described as using light bulbs and restaurant tables) failed to materialise, but the sculptor himself, together with composer Gordon Mumma (an associate of John Cage and Merce Cunningham), appeared as performers in an event by Jacky Lansley, *Halfway to Paradise*. Together with Banner,[15] Davies, Early[16] and Colette Lafont,[17] they played a group of rockers who burst in on the activities which had begun even before the audience was let into the room. We took our seats as Lansley, in pink tights and leotard, sitting on a small central platform and occasionally turning her head, while Alston, Levett[18] and Potter in drab overalls leant against the walls supporting piles of empty boxes. At the advertised starting time, these three began to move from one spot to another, transporting their piled burdens which were eventually aggregated to form an impossible load.[19]

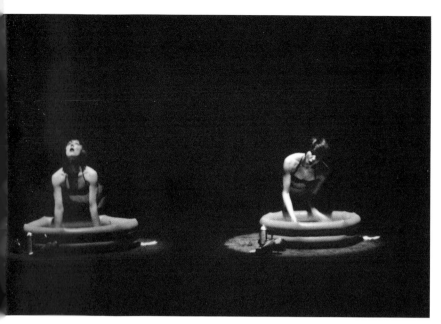

02 *Auk*

know – I didn't think it through at the time. There was so much going on. In the mid-
we, as you have already mentioned, participated in the British Council event 'The Best
Oslo we met, along with Barry Flanagan, several other visual and performance artists.
we came to work with the Yorkshire-based John Bull Puncture Repair Kit (JBPRK).[24]
mances of Mick Banks's (JBPRK) scripts – *Auk* and *Fallen Angels* (both 1973) – which you,
is Greenwood[25] and I collaborated on – arose from this. *Auk* drew on cabaret, pornography,
side holiday activities and polluted birds. In *Fallen Angels* we were three women at a tea
ng surrealistically elaborate hats, engaging in a dialogue with an angel in a sack. Quite
.

h JBPRK I met the Welfare State[26] at a festival in Rotterdam. This performance company
ransformed spaces in which they performed and I was invited to join them. As well as the
estyle of Welfare State I enjoyed an entirely other form of movement, learning how to wield
r example. Although it was often difficult as the only single woman, I enjoyed the work. The
y were mainly visual artists – it was certainly different to Martha Graham![27]

horeographed a solo piece for me called *Dry Dock* (1973) when we were at The Place. Can
er anything about the process?

s' I had about choreography; the one-movement-following-another, didn't come easily
n't make sense to me. I dream about moving; I am an excellent social dancer in a wild and
way; not in any particular form but I can make up movements at the drop of a hat in that
esn't faze me; but I couldn't connect with what was going on in this other sanitised place!
n–step method… so I guess I just went and joined Welfare State! I wanted to do quite ugly
not always want to appear linear. I found an ugly movement could be extraordinarily beautiful.

Prior to studying at LSCD, Diana (Di) Davies had been a student then teacl already considerable experience of interdisciplinary practice to the school. W several projects with other students and with Strider and in the summer of 2 home in Brittany and we revisited some of these early experiences and talke(with choreography:

Jacky: Di, I have been remembering with great affection some of our early w *Thousands* (1972), which we co-choreographed and devised with Sally Potter Flanagan. The piece was performed at the ICA and the Sonja Henie Centre Council tour. It involved two men shovelling heaps of sand backwards and f tape of the same activity while Sally, you and I wore sporty white clothes an callisthenic formation and carried each other about the space, accompanied orchestra the Portsmouth Sinfonia[20] interpreting the *Sugar Plum Fairy*!

Di: Yes, a while back I spotted a commemorative article in *Tate Magazine* a author had written that Barry 'had worked with dancers' and seemed to imf objects in this piece. I wrote in to explain that we were not anonymous dan(described, artistic collaborators… I never received a reply.

Jacky: We devised the work. Did you ever think of yourself as a choreograp fit in for you?

Di: I think I lost my way a bit with regard to choreography. I didn't easily i at ease as a choreographer working within the UK contemporary dance cul receiving an award from the Gulbenkian Foundation for my early work, wl funding from the Arts Council, firstly from the Dance and then the Theatr by both on the grounds that my work was 'not dance' and 'not theatre'. I wa because I had begun to encounter other kinds of performance that were als in the UK, but that were nevertheless welcomed at various well-known exp festivals in mainland Europe. Prior to studying at the LSCD I was a stude initial experience of contemporary art media in its many forms began in L Harpe's project, the Blackie.[21] So I had already been exposed to alternative When I went to study at the LSCD it appeared to me that some British c seemed to remain within a sort of classical framework. Important and inte to the development of the UK dance scene, there were other things 'out th other students who were also interested in pushing the boundaries. We we *Drama Review*[22] and admirers of contemporary dance coming out of the l influenced by the rare performances that were available to us, for example a 360° performance space; Trisha Brown's[23] use of non-theatre venues; M(narrative in dance performance; to name but a few. Perhaps aspects of the scene became rather sanitised for me in a way.

Jacky: So you felt that there wasn't an appropriate context for you to cont exploration with dance?

Di: I don' 1970s whe of British That's hov Our perfo Sally, Den religion, sc party wear Beckett-lil Throv essentially travelling l a pickaxe core comp

Jacky: You you remem

Di: This 'cr to me, it di(extraordina context, it (The step–u things; I di

Prior to studying at LSCD, Diana (Di) Davies had been a student then teacher of art and brought her already considerable experience of interdisciplinary practice to the school. We had collaborated on several projects with other students and with Strider and in the summer of 2013 I met up with Di at her home in Brittany and we revisited some of these early experiences and talked about her relationship with choreography:

Jacky: Di, I have been remembering with great affection some of our early works such as *Hundreds and Thousands* (1972), which we co-choreographed and devised with Sally Potter and the sculptor Barry Flanagan. The piece was performed at the ICA and the Sonja Henie Centre in Oslo as part of a British Council tour. It involved two men shovelling heaps of sand backwards and forwards across a stage to a tape of the same activity while Sally, you and I wore sporty white clothes and wielded Indian clubs in callisthenic formation and carried each other about the space, accompanied by the conceptual artists' orchestra the Portsmouth Sinfonia[20] interpreting the *Sugar Plum Fairy*!

Di: Yes, a while back I spotted a commemorative article in *Tate Magazine* about Barry Flanagan; its author had written that Barry 'had worked with dancers' and seemed to imply that we were passive objects in this piece. I wrote in to explain that we were not anonymous dancers but, as you have described, artistic collaborators… I never received a reply.

Jacky: We devised the work. Did you ever think of yourself as a choreographer? Where did this practice fit in for you?

Di: I think I lost my way a bit with regard to choreography. I didn't easily identify with it; I didn't feel at ease as a choreographer working within the UK contemporary dance culture of that epoch. Despite receiving an award from the Gulbenkian Foundation for my early work, when I tried to apply for funding from the Arts Council, firstly from the Dance and then the Theatre panels, I was turned down by both on the grounds that my work was 'not dance' and 'not theatre'. I wasn't necessarily discouraged because I had begun to encounter other kinds of performance that were also, at the time, not supported in the UK, but that were nevertheless welcomed at various well-known experimental venues and festivals in mainland Europe. Prior to studying at the LSCD I was a student, then teacher, of art and my initial experience of contemporary art media in its many forms began in Liverpool with Bill and Wendy Harpe's project, the Blackie.[21] So I had already been exposed to alternative dance and performance. When I went to study at the LSCD it appeared to me that some British contemporary dance forms seemed to remain within a sort of classical framework. Important and interesting though these were to the development of the UK dance scene, there were other things 'out there'. At the LSCD I met other students who were also interested in pushing the boundaries. We were avid readers of *The Tulane Drama Review*[22] and admirers of contemporary dance coming out of the USA at the time. We were influenced by the rare performances that were available to us, for example, Merce Cunningham's use of a 360° performance space; Trisha Brown's[23] use of non-theatre venues; Meredith Monk's re-visioning of narrative in dance performance; to name but a few. Perhaps aspects of the British contemporary dance scene became rather sanitised for me in a way.

Jacky: So you felt that there wasn't an appropriate context for you to continue your work and your exploration with dance?

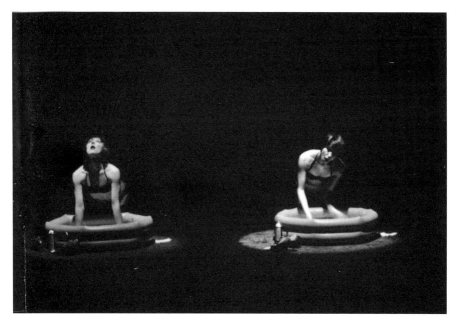

Di: I don't know – I didn't think it through at the time. There was so much going on. In the mid-1970s when we, as you have already mentioned, participated in the British Council event 'The Best of British' in Oslo we met, along with Barry Flanagan, several other visual and performance artists. That's how we came to work with the Yorkshire-based John Bull Puncture Repair Kit (JBPRK).[24] Our performances of Mick Banks's (JBPRK) scripts – *Auk* and *Fallen Angels* (both 1973) – which you, Sally, Dennis Greenwood[25] and I collaborated on – arose from this. *Auk* drew on cabaret, pornography, religion, seaside holiday activities and polluted birds. In *Fallen Angels* we were three women at a tea party wearing surrealistically elaborate hats, engaging in a dialogue with an angel in a sack. Quite Beckett-like.

Through JBPRK I met the Welfare State[26] at a festival in Rotterdam. This performance company essentially transformed spaces in which they performed and I was invited to join them. As well as the travelling lifestyle of Welfare State I enjoyed an entirely other form of movement, learning how to wield a pickaxe for example. Although it was often difficult as the only single woman, I enjoyed the work. The core company were mainly visual artists – it was certainly different to Martha Graham![27]

Jacky: You choreographed a solo piece for me called *Dry Dock* (1973) when we were at The Place. Can you remember anything about the process?

Di: This 'crisis' I had about choreography; the one-movement-following-another, didn't come easily to me, it didn't make sense to me. I dream about moving; I am an excellent social dancer in a wild and extraordinary way; not in any particular form but I can make up movements at the drop of a hat in that context, it doesn't faze me; but I couldn't connect with what was going on in this other sanitised place! The step–upon–step method… so I guess I just went and joined Welfare State! I wanted to do quite ugly things; I did not always want to appear linear. I found an ugly movement could be extraordinarily beautiful.

Jacky: I seem to remember with *Dry Dock* that you were experimenting with gesture and everydayness?

Di: If I have remembered correctly, I used part of Erik Satie's *Gymnopédies* over which John Darling (JBPRK) had taped the sounds of foghorns. You, poor thing, hardly moved from one spot! There was a huge loneliness in it, 'an atmosphere of desolating emptiness' as John Percival wrote at the time. I remember that I gave you large amounts of rocking on your ankles, almost like Irish dancing. It was extremely sparse and confined as choreography. It can't have been much fun to perform, but you did it so well! There is no record of it – it was all ephemeral – before this age of digital media so much performance work just went into the ether…

Jacky: It's an interesting question – what is choreography? It's about form, structure, meaning and as we know it's that collision of the visual and performing arts that has produced perhaps the most interesting work. And you were very much part of that.

Di: We were a group and we each brought our different qualities and interests.

Jacky: If someone gave you the resources and asked you to choreograph a work now – what would you do?

Di: I don't think I would want to choreograph now. I don't want to tell people what to do anymore – though I'm aware that this is not the only way of proceeding.

Jacky: So that would be your main concern, that you would have to direct people?

Di: No, it's not as simple as that – but even having to negotiate socially with people in order to make something, I would perhaps find difficult, I really don't know. Perhaps I have grown too selfish after all those years of teaching art in various schools. Now I am making images. It's the experience of the 'possible', of taking an image in any direction according to an inner sensibility and 'need' to express being in the 'now'; it's an experience of freedom tempered by the necessities and suggestions of the making process. This is one of the great and wonderful tensions in art, any art. Perhaps if I were to work on a cooperative effort of some kind… One of the nice things about working in the Welfare State, and subsequently IOU,[28] was that everyone had their own area, their own bit, which then got strung together as a performance. In IOU we pooled ideas much more. I do miss the generosity of chewing over each other's ideas without any sense of personal threat to the ego. Great! There is a sense of this with some dancers and some choreography. At its best it's more creative and risky.

Jacky: You have recently been involved in recreating a cabaret project that you first created with other artists, writers and musicians in Bradford in 1980, *Café Déspard*… It was obviously something that excited and moved you.

Di: The *Café Déspard* of 1980 was a brief and extremely ad hoc mini-series of cabaret evenings involving artists and musicians and anyone else who wished to commit. Its venue was in the back of a pub. Its performances were packed out and it apparently seems to have reached cult status in some of Bradford's current cultural circles. At the time we made something out of very little. Within a matter of hours, using simple tools and materials, a space and its cohort of performers were transformed into a performance possibility.

In 1975 Di asked me to participate in a Welfare State project on an open-air site in South London. It was a requirement that I worked with objects in some way. I was not confident crafting things with my hands, but I attempted to embody the idea of object with other skills. I came up with a navy-blue industrial boiler suit, which I wore, and a sturdy costume rack which I hung from and improvised around, doing eccentric movements with mysterious pauses and tableaux which I think looked rather abstract and somewhat bleak in that Welfare State context of craft and colour. I remember that I invited some bemused members of the audience into my space to have 'a go' on my costume rack – which contributed some interesting audience participation and attracted the quizzical interest of John Fox, the founder of Welfare State. Di was very supportive; it felt a bit like we were continuing our *Dry Dock* project but in a different space and context, which was a very valuable experience for me at the time.

LIMITED DANCE COMPANY
In 1974 Sally Potter and I created our project Limited Dance Company (LDC), so called because of its fusion of conceptual minimalist performance with theatrical strategies and skills, including very 'limited' dance. Following is a brief description of an early work *Episodes* (1973) which we performed over five weeks, using the central stairway and public restaurant of The Place theatre:

> A serial piece with recurring elements, and an accumulative visual and sound structure, using as image material archetypes drawn from stages in two women's lives from childhood to old age. The images were developed in relation to the physical properties of the spaces used (e.g. sequences were related mathematically to the number of steps in each flight).[29]

Limited Dance Company used formal systems which emphasised the structural make up of a piece through its use of interconnecting strategies such as repetition, fragmentation and collage. We used terms like proposals, scores and events to describe work that was part of a broad artistic flux happening across visual art and performance. Sally and I worked together as LDC for three years during which time we made work in a huge variety of public spaces, theatres and galleries as part of performance art programmes and alternative dance and theatre festivals in the UK, Europe and the USA. Our work framed and exploited the interesting mix and range of visual, theatrical, choreographic and directorial skills that Sally and I shared, even though we were at the time still in our early twenties.

LIMITED DANCE COMPANY AT EDINBURGH ARTS 74
On leaving the Place, Sally and I were invited to teach workshops and make performances as part of a six-week arts festival throughout Scotland – Edinburgh Arts 74 – coordinated by the Richard Demarco Gallery.[30] Richard Demarco is a unique impresario and was a great champion of our work; he saw the meaning and importance of what we were trying to achieve, even at that early point. We wrote this statement about our proposed work with the Edinburgh Arts 74 participants:

> We want to use a form of narrative structure in the sense that perhaps James Joyce would employ it, or as Godard[31] said, 'things with a beginning middle and end but not necessarily in that order'. We want to work in relation to the particular environments in Scotland and to the individual experiences of the participants. A kind of movement image collage structured in the form of a developing serial divided into episodes.[32]

We made several iconic outdoor performances during Edinburgh Arts 74 including an event, *Lochgilphead* (1974), which we performed in a small coastal town (Lochgilphead) in the west of Scotland. Collaborating with a group of students whom we were teaching as part of the programme, we created a sequence of actions in coordination with the incoming tide. Sally and I emerged from the sea wearing black evening dresses with flippers on our feet, while simultaneously two corresponding figures dressed in white emerged from the church and moved down the main street assembling litter. Both couples converged on a moving tableaux of groups dressed in black and white on the sea front and stepped into a paddling pool where the collected rubbish was dropped over the couple in black (Sally and I) who then floated amongst it.

Theatrical performance involves, for the performer, a kind of separation from self; one performs something unreal which requires an enormous amount of subjective investment to realise the objective precision. Task-based, real-time performance, in which the body is working in a space without illusion or disguise, requires the same investment; both approaches require a disciplined dialogue between the objective and the subjective experience. This tension between conceptual and skill-based performance languages (dance, singing, acting, circus, cabaret, etc.) was central to the work of LDC. When, in the summer of 1974, Sally and I met in the middle of the loch in our piece *Lochgilphead* in full evening dress and flippers with the sea up to our necks, the performance experience became something else. It became about risk taking and instantaneous invention of makeshift techniques to cope with the environment

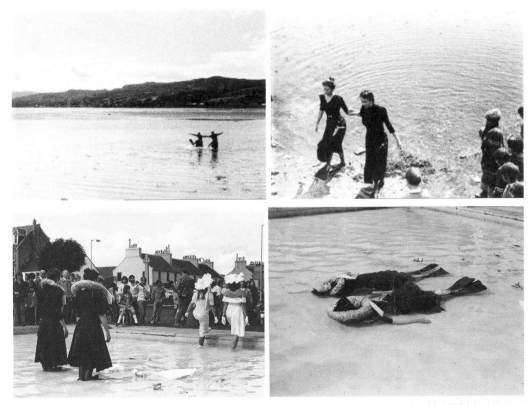

03, 04, 05, 06 *Lochgilphead*

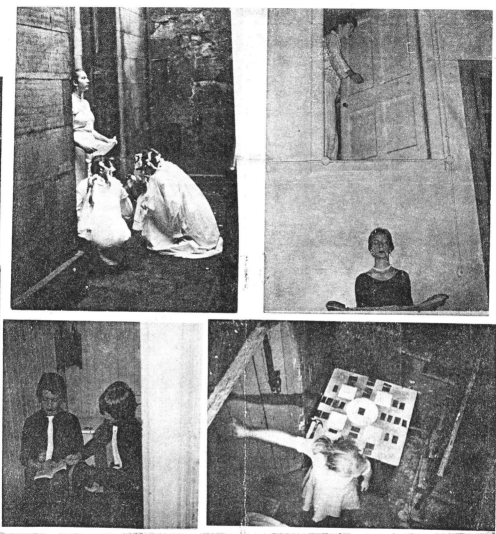

The 4 photographs above document certain sequences in the Edinburgh Arts 74 'Limited Dance' action presented at 142 High Street in the first week of the Edinburgh Festival. Directed by Jacky Lansley and Sally Potter who were responsible for the Edinburgh Arts Dance Workshop. The photographs document actions by Heidi Giuntoli, Elisa Decker, Janet Rosing, Jane Whittaker, Cheri Gaulke, Barbara Bouska, Linda Olle, Carla Stetson and Deborah Hansen.

07 *Curtains Courtesy* (1974)

A movement piece in perfect unison punctuated with verbal questions accompanied by a tartan playing card produced from our top left hand suit pockets, and discarded by being flicked into the audience when the questions were completed.

PROPS. Stage L. 2 white plastic buckets. 2 prs. tap shoes. 2 prs. pink high heels.

Stage R. On floor. Two small tape recorders.

Centre Stage. A table. Two chairs, one on either side of table. Cassette tape recorder on table.

One pack of tartan playing cards.

COSTUME. Black men's suits. Open necked white shirts. White cricket shoes. Fairly glamorous make-up.

SOUND. TAPE 1. Fog horns. Tape 2. Big band music for tap routine.

Tape 3. Personal comments of Edinburgh Arts participants.

STRUCTURE.

We walked into the space carrying our props in plastic bags, switched on tape 1. and proceeded to clear the space and set props. When completed we froze centre stage with backs to audience. After a considerable length of time we turned to face audience and executed a jazz sequence which consisted of a 14 count step. Jacky repeated this step while Sally deleted two movements on each repeat (14 counts with 14 corresponding movements) until she was finally static for the whole sequence. End of sequence.

1st. Card. 1st. Question.

" Is this relating to the Scottish enviroment?"

Flic card into audience, walk to stage left. and stand opp. plastic buckets. Take off cricket shoes and throw them into buckets, put on tap shoes. Walk to stage right, move to put on Tape 2. hesitate.

2nd. Card 2nd. Question.

" Can a tap routine be a meaningful statement in this enviroment?"

Flic card and put on Tape 2. Walk to centre and execute a tap routine. Sally repeated a single time step while Jacky went through the whole sequence of time steps giving a verbal signal to end when she had completed the series.

Walk to stage right Jacky turn off Tape 1. Sally turn off Tape 2. Walk towards shoes stop centre.

3rd. Card 3rd. Question.

" Is the meaning of a statement dependant on its political context?"

Continue to shoes, take off tap shoes and throw them into buckets. Put on right high heel.

4th Card . 4th Question.

" Do you think my shoes reflect the quality of my interlect?"

Walk to table and sit down. Put on Left high heel.

5th. Card 5th. Question.

" Is there anything you would like to say?"

08 description of Tartan Introduction (1974, Edinburgh University)

which we manipulated into a kind of grand proscenium outdoor theatre, with an audience very far away on the shore watching us approach through binoculars.

As I lined up on the opposite bank to Sally – and I remember that it seemed a very long walk to arrive at my 'entrance' point, I could barely see her on the other side of the loch – the experience became bizarrely similar to lining up in the wings at Covent Garden to meet a member of the corps de ballet entering from the opposite wing. We were, of course, deliberately quoting this context, and our imagery needed to be as precise, as we enjoyed the visceral pleasures of performing while struggling with the elements. Somehow the rich layers of training I had as a performer were distilled in this extraordinary moment. Now I think back I realise there was danger, of which we seemed oblivious, though the event and its broader artistic context was, I came to realise, supremely safe in comparison to the neurosis of a more traditional dance world. As Limited Dance Company I learnt that different kinds of performance skills could be separated from my technical, classical and showbiz dance skills – which at the time, as part of LDC, were being used only minimally. Different parts of my experience could be unpicked, identified and used as part of the material and the themes we were exploring.

An outcome of our work with Richard Demarco's Edinburgh Arts 74 was that LDC was invited to the USA, by some of the artists we met on the programme, to teach and present work at several major art institutions including Kansas City, Chicago, Minneapolis and Rhode Island. We made several strange and wondrous pieces during this tour and at that time, it did feel like we were bringing something to the USA that was fresh and which demonstrated a new hybrid performance art that combined conceptual and visual languages with theatrical skill. Following this Midwest 'tour', which presented some tough challenges for us as two young English women, we spent time in New York where contact with artists such as Joan Jonas,[33] Meredith Monk, the singer Patti Smith,[34] the activist/artist Judy Chicago[35] and others, became profoundly inspirational to both of us; when we returned to the UK we built on this experience together and separately.

LIMITED DANCE COMPANY AT THE OVAL HOUSE THEATRE

Another supportive satellite venue for LDC was the Oval House Theatre in South London. In the late 1960s under the direction of Peter Oliver, the Oval House became a laboratory in which to explore new forms of performance. Theatre companies such as Lumiere and Son, the Pip Simmons Show, the People Show, the Black Theatre Co-Operative and Gay Sweatshop used the Oval House to experiment with new forms of theatre and modes of organisation, which reflected the experience and radical politics of the companies and their audiences. The 1970s and 1980s became a period for women's theatre and performance at Oval House; under the direction of Kate Crutchley, companies such as Spare Tyre, Sadista Sisters, Cunning Stunts and the Women's Theatre Group explored topics of feminism, lesbianism and life in Thatcher's Britain. Limited Dance Company became part of this radical energy at Oval House and three pieces of work stand out – *Hurricane, Aida* and *Brief Encounter* – which were all made during the period 1974–75.

Hurricane (1974) was woven around a central image of an unmade bed and used minimal narrative with many entrances and exits; the action consisted entirely of variations on the theme of taking curtain calls after the 'phantom' performance. In *Aida* (1974) Sally and I wore outsize dressing gowns – which were removed to reveal identical dressing gowns underneath – and sung a duet from the opera *Aida*, while a nude woman on a plinth read Karl Marx's *Das Kapital* and two male ballet dancers dressed in jockstraps,

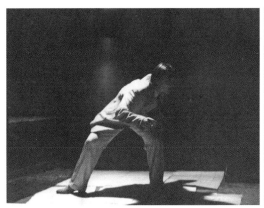

09, 10 *Brief Encounter*

practised on the rooftop above, where they could be seen through the skylight walking on pointe. In *Brief Encounter* (1975), the structural order of events remained the same on each night, although the actions of our performance changed and developed according to our response to the immediate, live situation. *Brief Encounter* playfully dissembled the fatalistic imagery from the film *Brief Encounter*, directed by David Lean, while drawing on its exquisite visual and emotional detail. This was a classic LDC work, which combined the pleasures of skilful performance with feminist politics and a rigorous conceptual and visual methodology. Following is a description of the performance from my personal archive:

> A small set was built around the central imagery of trains. One performer dressed in a drab beige coloured man's suit, sat on a bench on a raised platform behind a dimly lit miniature train track, and gradually developed an increasingly dangerous and impossible physical performance (including cartwheels, running up the wall, pirouettes off the platform etc.). She was doggedly interrupted by the other performer, dressed in a long white nightdress and coming through a floodlit door to the strains of a live soprano. This performer carried two telephones at a time, whilst phlegmatically analysing the structure of the piece and the possible meaning of the ever increasing line of telephones. The audience were led in by torchlight and shown to benches along one side of the wall, the only other light being a spot on the toy train and the light from a TV coming from a hole in the wall. Immediately in front of the platform was a line of artificial grass and in front of the grass a display of railway diagrams covering a large area of the floor.
>
> The performer on the platform was prompted into action each time the woman in the nightdress left the room; developing the narrative through a gradual accumulation of gestures towards the door which suggested murderous scheming. The woman in the nightdress became a victim, lying down on the railway track as a willing sacrifice while the other performer acted out her role as a villain and tied her to the track as a tape of a fast approaching train could be heard. At the climax of sound the lighting box window released dry ice, creating the effect of steam; a blackout enabled disappearance and a spotlight came up on women's bloody underwear lying on the toy track as a final image.[36]

PARK CAFETERIA (1975)

Sally and I were inspired by the previous history of London's Serpentine Gallery as a tearoom built in the 1930s on the site of an earlier nineteenth-century refreshment room. We invited four other women: Rose English,[37] Lynn MacRitchie,[38] Sylvia Stevens[39] and Judith Katz[40] to work with us as an ensemble of women who invoked this history, in dialogue with our experience as young women artists in the 1970s. We wore 1930s-style clothes, drank tea at intervals throughout the day, became a musical band, stalked each other with fake guns, discussed politics – with each other and members of the audience – and shifted objects and items of furniture about to create 'sets' and installations in various interior and exterior parts of the gallery.

Our 'lived in' event ran for a week – and it/we could be viewed at any time. As in all LDC's work the group played with both theatrical and real-time performance tasks. We had all come from different artistic backgrounds and this was reflected in our varied styles and approaches to performance; we all shared, however, a rigorous pleasure in image-based work, which we explored through our collective feminist consciousness. Our daily process was to discuss and agree on improvised episodes, which explored themes and images through words, spaces, dance, clothes, music, song and objects. These

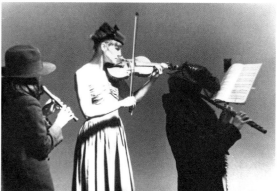

11, 12 *Park Cafeteria*

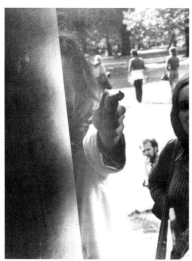
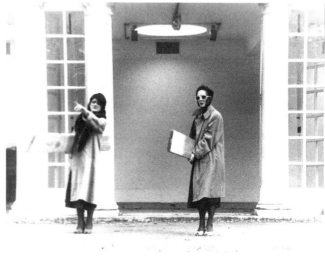

13, 14 *Park Cafeteria*

episodes made up a kind of score and would be returned to throughout the day. We rehearsed our band (and possibly one or two other performance sequences) but mostly we worked spontaneously around and within the various episodes that we agreed upon for each day. The actions took place both within and without the gallery and surrounding areas – making full use of the building's neoclassical pillars to creep up on each other with a fake gun and shoot an idea or image that any of us felt needed to be challenged. We also worked in the park itself, going on walks in deep conversation; we had mock fights and used the trees to hide behind and prey upon each other and members of the audience.

Overall my memory is of an organised chaos and an event that was exploring a female space, which borrowed the historic tea-drinking leisure activities to create a discussion about women's place within a male-dominated art world. We were both the voyeurs and the viewed – playing with the public gaze that women are subjected to throughout their lives. As in all LDC work, there was wit, humour and moments of exquisite performance.

Around the end of 1975 the artist Rose English began to work with us as a core member of LDC and together we made several significant performances, including *Death and the Maiden*, *Rabies* and *Mounting*.

DEATH AND THE MAIDEN (1975)
This was a durational site-specific performance over five evenings. Part 1 (with Dennis Greenwood) was presented at Snow Hill Station as part of the Birmingham Festival of Performance Art; Parts 2, 3, 4 and 5 at De Lantaren in Rotterdam as part of the Thema Vrouw Festival.

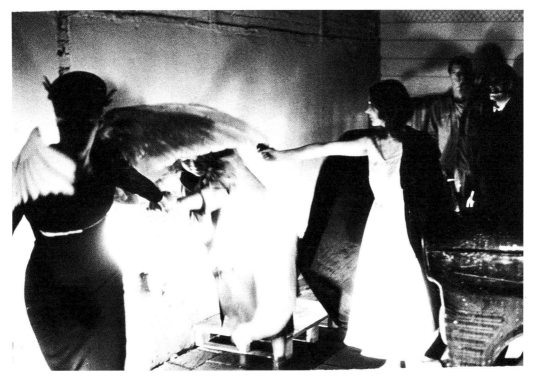

15 *Death and the Maiden*

Quite a lot of the performances, including *Death and the Maiden*, were improvised, in practice, around a concept. Even if the shape or structure was there, there was a strong element of improvisation. It was a key part of our desire to be in the present, relating to the moment; incorporating accident, chance, as part of the atmosphere. *Death and the Maiden* came from, in part, the slow movement of 'Death and the Maiden' by Schubert. I was moving about in ways that referred to silent cinema, taking up positions in the space, moments that were like stills from silent films; Rose was on roller skates pushing a spotlight around, choosing what to illuminate, and Jacky had a gun and was a kind of film noir heroine.[41]

RABIES (1976)

We performed *Rabies* as part of a week-long residency at the Roundhouse, London. Early marketing described the work as 'Piece for voice, guitar, a female nude and a card-dealer, involving song, speech, image, made in the hallucinatory long hot summer of 1976'. I remember it as the performance in which we seemed compelled to push ourselves to creative limits. We did hardly any preparation and we had no script, score or choreography. The space itself – a bare studio theatre – became the material, combined with a large mink coat, a bench and some improvised monologues on the meaning of art and politics (Rose – who was naked for much of the performance – and I had a discussion as to whether or not a safety pin could constitute a costume). Our only preparation on the day of the first performance was to approach a completely strange man in the street who had a wonderful large dog and ask him if he would turn up in the evening with his dog and be part of our performance. He agreed – but then didn't turn up! This impromptu negotiation with the street and its 'failure' became a vibrant element within our feral, strange performance *Rabies*, which made use of common elements handled differently or in diverse orders over five consecutive nights. The journal *Musics*[42] published a collection of written descriptions (rather than reviews) of the event and following is an account of what happened in the first performance by the artist and editor of *Musics*, Annabel Nicolson:[43]

> The downstairs space in darkness. Sally was sitting in a small window against the sky. She played the guitar very faintly. She came down into the dark space. A film started and she sat under the screen watching. It was a film of two deserts, the Sonora and the Sahara. The theme was men adapting to nature and men imposing on it, the obvious difference between the two deserts. Made by the American Learning Corporation.

INTERVAL

> Sally sat very close to the audience on a small wooden stool. She sang very quietly with a guitar. Jacky appeared in shorts as if about to read aloud but did not. Sally sang again, more audibly until Jacky's next appearance. Jacky looked at the invitation card advertising the show but still did not speak. She went out. Sally sang forcefully without words, Jacky reappeared in a black wig. There was a red rose in her hair.

> Rose walked on in the nude.

> Sally and Jacky sat on a long bench. They shone a spotlight on Rose who was putting on a fur coat. She uttered disturbed and creature-like sounds.

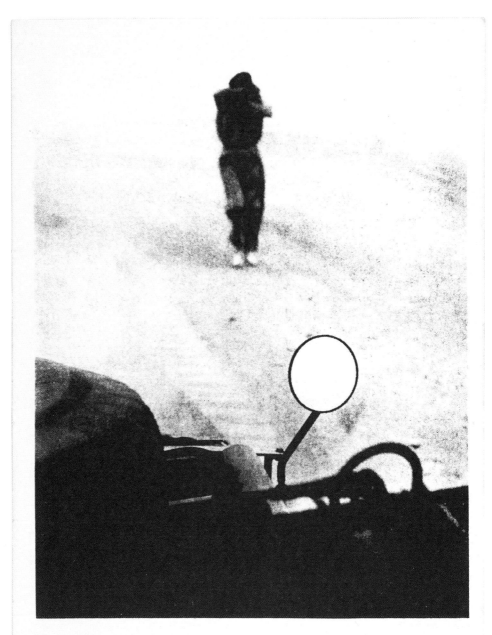

Rabies.

Rose English, Jacky Lansley, Sally Potter.
29 June — 3 July at 8pm. Roundhouse Downstairs.

16, 17 *Rabies*

Sally, Rose and Jacky walked to another bench away from the audience. They talked in deep, manly voices about each other. They were irritable in a manner designed to rouse laughter. Sally returned to the little stool and smiled at the audience. She strummed the guitar, still smiling. Jacky and Rose stood behind her minimally dancing. They still wore shorts and fur coat respectively. Finally Sally beat the guitar and firmly called an end to the theatricality, demanding a dialogue of critical terms. They quizzed each other facetiously on structural materialism while dancing, until they ran out of repartee and talked about what to do next until the end.[44]

MOUNTING (1977)

There were two performances of *Mounting* in the large gallery space at the Museum of Modern Art, Oxford in which there was a simultaneous exhibition of the painter Frank Stella's[45] work. Our performance consisted of improvised interaction with the exhibition that created stark and juxtaposing dialogues about art and show business (including themes from *West Side Story*), fear and politics, men and women. We produced a small book of the same title, *Mounting* (1977), which examines the main concerns of the performance:

BUT SURELY THE ART PRODUCT CANNOT BE DIVORCED FROM ITS MODE OF PRODUCTION OR FROM THE STRUCTURES THROUGH WHICH IT IS MEDIATED, MADE VISIBLE.[46]

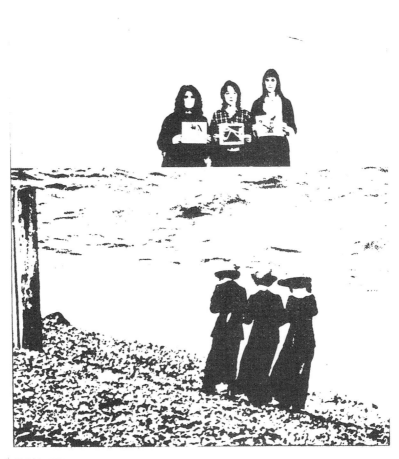

MOUNTING

Performances 20 and 21 May at 9.30 pm

Museum of Modern Art Oxford

Rose English Jacky Lansley Sally Potter

18 *Mounting*

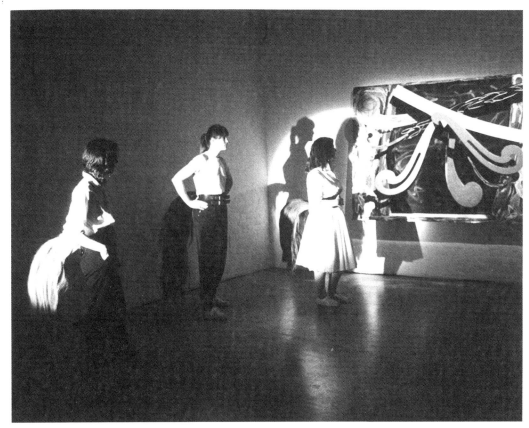

19 *Mounting*

Referring to this quote, Lynn MacRitchie writes in her review of the work for *New Dance Magazine*:[47]

> This is especially true of performance art in which the work is the performance, thus it does not retain any permanent physical record of itself; unlike a painting, a sculpture, a film, or a play which is encapsulated in its script and directions, we must attend the performance.[48]

Our book *Mounting* contains long sections of narrative metaphor and a series of powerful images which places the oppression of women central to the performance and the concerns of LDC. The illustration of three women in Edwardian dress walking on a beach, which is used in the book, and on the posters for the performance, makes a link with the historical beginnings of the women's movement:

> SPEAKING IN RIDDLES AND KEEPING THE PEACE. SIGNING THE TREATY, BEGGING CONCESSIONS, KEEPING THEIR LAND FROM THE SETTLERS' HANDS.[49]

In this work the women were seen to play with and manipulate elements according to their own scenario, no longer the passive instruments of another's vision. They constructed images of male fantasy – the Maria character in *West Side Story* – then deconstructed the same image – Maria lecturing

with a microphone. Not everything 'worked' dramatically or conceptually and the audience was invited to share in the process of making a performance, which at times felt very uncomfortable. Their attention was used to create energy and effect, they were in the 'spotlight' – we explored their presence in relation to the woman performer. In Part 1 of her review, Lynn MacRitchie describes the performance:

> The audience (at least seventy, with more arriving) sits down at one end of the long room on chairs and extra cushions hastily brought in. There is no lighting, and the room is already growing dark (9.30 p.m.). [...] Then from the silence, a growing music – horrible frightening music. The soundtrack from *Jaws*. Then another noise – water, splashing, splashing... the music fades and a spotlight goes up, on a glass bowl filled with red liquid. The door in the wall opens and (stepping past the slumped body of the cowboy) appears an extraordinary figure – a woman with around her waist a huge leather belt from which springs a horse's tail. On her feet, high stepping shoes made from horses' hooves.[50]

In Part 2 of her review, MacRitchie analyses the performance and how its imagery and content is linked up with the theory and metaphor of the book:

> The performance presents a set of 'Hollywood' images; the lone male figure of the cowboy; the young male hoodlums – the 'Sharks' of *West Side Story*; the white dressed girl, the 'Maria' figure. Such a strong element of characterisation is unusual in a piece of performance art. In this work, the character elements played a very important role in opening up certain areas of discussion without their having to be stated as such in the verbal sections of the piece. For example, the cowboy figure. The first image one sees in the piece is the lone cowboy, smoking his cheroot, ambling around the space regarding Frank Stella's work – this to the accompaniment of film theme music [...] These characters shouldn't be disporting themselves in an art gallery. They've come straight from some Hollywood sound stage with their loud music, their brashness, their energy, those qualities which distinguish so called popular art from so called high art.[51]

> HOW DO YOU DEFINE ART MAKING AS 'WORK' [...] WHEN THE PRODUCT HAS SUCH INCONSISTENT COMMODITY STATUS? IT IS LABOUR, BUT AN ARTIST CANNOT BARGAIN WITH HER LABOUR, SHE CANNOT GO ON STRIKE... THEY WALKED ON.[52]

In May 2015, Sally Potter and I were sitting in a cafe in the sunshine having tea. It reminded us of our research for *Park Cafeteria* and we decided to record our memories of this and other works:

Sally: Before you started recording, we were sharing memories of some of our early work together and you reminded me about a piece – possibly in Birmingham – that was based on the huge, towering speakers that we found on the stage – that may have been called *PART 1, PART 2, THE MANAGER* – a suitably bleak and monolithic title. Then I reminded you about one of the pieces we did in America when we were on tour; we rounded up all the dogs on the campus and at a certain cue during the show they were released into the theatre, barking like mad, then we lowered the lighting bar so that it was covering our faces.

Jacky: I have vivid memories of us doing recces at the Serpentine Gallery for our piece *Park Cafeteria*; sitting in the sunshine, chatting, hanging out and taking photographs of the Serpentine cafe. We were looking at the different functions and qualities of the space as material for the piece, do you remember?

Sally: I do. We were also finding the power spots in the space. There was always *the* place to sit or *the* vantage place from which to look at it and we tried to identify where and what that was; but mainly we were trying to open the vision – open our eyes and really see. What you realise when you do that, is that often you go into a space, or are walking along and you are not really seeing anything, you are being constantly selective. So in those performing spaces it was about going in and finding a place – or a whole series of angles – from which to look at it and then really trying to see what was there and not trying to disguise anything as anything else, but work with it – that was the honing of point of view.

Jacky: Would you say it is like a film process?

Sally: It is; but it is also conceptual. There are many film-makers who are basically trying to find an angle that makes sure you don't see XYZ, attempting to make everything look at its best; but the performance concept was more like an opening of the peripheral vision – and opening the perception of what was there, for ourselves and then for the audience.

Jacky: And we were playful and witty. For me the minimalist approach was very liberating – the idea that a whole show could be in a teacup.

Sally: It's acknowledging that anything and anywhere can be a show – or indeed is a show – so what you are doing, in a way, is drawing a frame around something and saying – OK the show starts now and finishes there and is everything that there is in that space of time and place.

Jacky: In our work *Rabies* at the Roundhouse, Rose (English) – who was naked – and I had a discussion about whether or not a safety pin could be a costume.

Sally: That was obviously a reference to the female nude in art. We were aware of the history of art and the longer context in which all these so-called minimalist performance events were happening. It was like saying one can't take anything for granted, nothing is neutral. As soon as you are there, in a space, you bring with you information, history and multiple references, whether clothed or nude. If you're clothed, you bring the references the clothes bring with them; if you're nude, you bring the whole history of western art. A great deal of the working impulse, as I remember, was the 'non-preparation' process, which one can loosely call the art of improvisation; but actually it was about wanting to arrive at the state of being in the present. It is saying this is now. Many of the traditional performance preparations, whether theatrical or other forms, obscure the fact that one is in the present. The very nature of the live event is its presentness, unlike cinema which is a recording of a presentness which then becomes a secondary presence. The uniqueness of the live event, as opposed to any made object, is now. So all that honing and minimalism was about refining how to create that awakeness of the now moment in the show. In a way concentrating on documenting an event is a form of cheating or obscuring that experience, because you're doing something for posterity rather than for now.

Jacky: I remember we'd give ourselves three weeks, then two, then one and then it came down to a day and an hour and then we would say no, we are not going to do any preparation – it was a real process.

It was scary, but it was really rigorous and I feel that it gave me a discipline which is still informing my work. I don't know if you feel the same, but I've made some pieces of work that took me two or three years to make, the opposite kind of process and yet somehow I couldn't have done that if I hadn't been there then and had those early experiences of that commitment to presentness.

Sally: Absolutely, and there is a sense in which the rigour with which we approach work creates a kind of a yardstick by which to measure lack of rigour or over-decorativeness or whatever.

Jacky: The work was also enabling for us as young women in all sorts of transitional ways.

Sally: I think it was more than that. I think as young women, what we were doing was creating a space in which it was not just OK, it was *essential* to think of oneself as an artist without limits, in any medium – and experience the act of complete dedication and passion, with nothing held back. And that was the life one was going to live. I think for a lot of young women the struggle to get to that place, to allow work to be that important in your life – that much of the driving engine, a place where you make sense of everything but also where you give out, where you give all you have – is too great, so it doesn't often happen. For a lot of women there is a constraint around them somehow – and I think what collaboration does – did for us at that age – is peer teaching: you teach each other and give each other permission to be grand, big, ambitious, though not necessarily career ambitious or money ambitious. We didn't care whether the work was photographed, documented or if anyone took any notice, it was a thing in itself, in its own right and the engagement with it was what really counted. I wish we did have a few videos though! I'd love to have a look at what we did, as a matter of curiosity. Although, having said that, often when performance gets filmed it looks kind of flat, whereas in memory, you know how intense it felt and also how intense it probably was for people watching as well. If there had been cameras then we might have started looking at it from outside. You start disembodying to some degree when you are over-thinking how it is going to look, whereas the great advantage of refusing that relationship with documentation is that we were saying, 'no we are embodied and we are now'. It was an act of total commitment.

One also has to remember that at that time performance art was almost a dirty word, or at least a very marginalised activity, unlike now where so many established artists are doing performance work. But that was part of its attraction. The Arts Laboratory in Drury Lane, run by Jim Haines in the late 1960s, had combined theatre, art and cinema spaces. Then there was the Arts Lab on Robert Street and later the Film Co-op was in another building next to the Musicians Co-op; so, yes, what we were doing emerged out of an interdisciplinary period – and none of it was career-based. The whole concept of career, making money out of it, did not come into play. With hindsight, the lack of money and the willingness to improvise in that really bottom rung of the economic situation was a fantastically powerful antidote to now when you must make money, you must take measured steps in the career path to get a one-person show, then get to a major international gallery, etc. and you do this, or you do that and then you do another pre-planned thing – which is very trapping.

The other thing I remember is that, yes, we did that particular form of self/space 'non' preparation, but then when the moment actually arrived we did a show, and then if we were doing two or three shows in a row, the next day was spent tearing it apart, revising it, refining it. So by the second night it was a refined version of the first show. So it did become something pre-shaped. What I'm saying is that the shows themselves, although spontaneous – no, spontaneous is the wrong word – evolved in the moment and then became refinable scripts.

Jacky: And that relationship with the audience. I think that feedback is so important, isn't it?

Sally: In the moment – it gels in that moment when the audience tells you what's going on, happening or not happening, by their restlessness or their focus. I'm still learning that with film by the way. Just like doing the live show.

Jacky: I am now very careful when I expose material to an audience; it has to be the right moment to get that feedback.

Sally: Exactly. By the way, I have found that the most valuable feedback is one's own sense of what's working and not working and having the guts to change it…you don't need to hear all the words from anybody else. I have also found that it is very important to have enough people watching. Because if you don't have a meaningful quorum, if a group is too small, you can get a completely skewed feeling of what's working and not working. You need a certain number to get a balance and know how to interpret the force field of the audience's attention.

As LDC Sally and I taught many students in various workshops and contexts and as I am now very immersed in developing interdisciplinary performance training, I am struck by how rigorous our work with students was. Following is a description of a project *Grass Roots* that we did with 27 students at Bingley College of Education in 1974. As I look back on these words and images I can taste again the excitement and energy of LDC's work:

> An artificial garden was ritualistically constructed in slow motion in the centre of the space while groups of performers progressed in sequence towards it from the surrounding fields and buildings, using movements based on outdoor sports, picnic and gardening activities. Eventually a series of tableaux were formed in the garden leading into a circular group dance based on steps taught in a class. During the working process emphasis was placed on performing disciplines, coordination and focus.[53]

This focus on performing disciplines seemed, at the time, like a far cry from the rejection of theatrical strategy by, for example, the American postmodern dance movement; it would take the emergence of a UK-based New Dance Movement initiated by practitioners involved with X6 Dance Space and *New Dance Magazine* (see Chapter 2) to create a context in which these different practices could come together and have a dialogue. The momentum has produced many independent and interdisciplinary artists who continue to be supported by organisations such as Chisenhale Dance Space (see Chapter 3), Independent Dance (ID)[54] and many others throughout the UK.

LDC's enduring impact on experimental dance and performance in the UK has been enormous, although its influence has been little acknowledged, in part due to its short life (three years) and to a lack of documentation, which I hope this book will help to remedy. Its unique cross art form strategies enabled the performer to see her body as more than the object of the gaze but as an instrument of her self-expression and her politics. While Sally and I have taken different paths we continue to share a sense of what is meaningful and 'true' in performance. The following quote is from Sally's book *Naked Cinema* (2014); although she is talking about film, her words express what I feel about dance: 'we work so hard on the practical, concrete, visible and audible details of this ephemeral form, precisely in order to evoke an immaterial, invisible and unhearable universe of human experience'.[55]

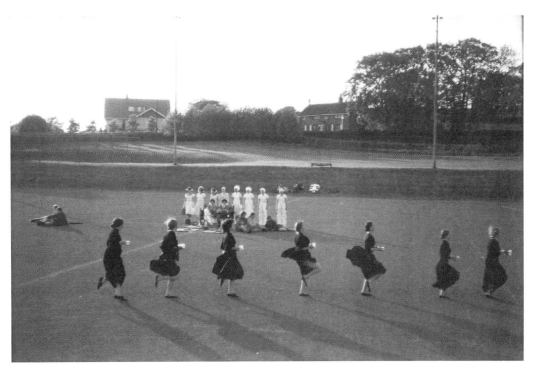

20 *Grass Roots*

Notes

1. Performance art is a performance presented to an audience most usually within a fine art context. The meaning of the term, which emerged in the 1960s, is related to postmodern interdisciplinary traditions in western culture including live art, body art, happenings, event art, conceptual and visual art. Works can draw on any medium – live performance, film, texts, installation, sculpture – and be located in any space. Often ephemeral and unrepeatable, the work is not easily commoditised or purchased. Key practitioners have included Carolee Schneemann, Claes Oldenburg, Yoko Ono, Vito Acconci, Joan Jonas, Joseph Beuys, Anne Bean, Chris Burden, Rose English, Limited Dance Company (Sally Potter, Jacky Lansley), David Medalla, Allan Kaprow, Marina Abramović, Gilbert & George, Rose Finn-Kelcey, Kevin Atherton, Paul Burwell and Geraldine Pilgrim.

2. London School of Contemporary Dance (LSCD), now called London Contemporary Dance School (LCDS): conservatoire, providing full-time training and degrees in contemporary dance and choreography; founded in 1969 by Robin Howard.

3. Sally Potter: formed Limited Dance Company (1974–77) with Lansley, later joined by Rose English. Potter is a film director whose films include *The Gold Diggers* (1983), *The London Story* (1986), *Orlando* (1992), *The Tango Lesson* (1997), *The Man Who Cried* (2000), *Yes* (2004), *Rage* (2009), *Ginger & Rosa* (2012) and *The Party* (2017). She is the author of *Naked Cinema: Working with Actors* (London: Faber & Faber, 2014).

4. Diana Davies: performance/visual artist, dancer and teacher of art who worked for some years with Welfare State International and was a founder member of IOU Theatre. Now lives and works in Brittany, France, where her more recent work and exhibitions focus on installation, etchings and photomontage.

5. Meredith Monk: American composer, singer, director/choreographer and creator of new opera, films and installations. A pioneer in what is now called 'extended vocal technique' and 'interdisciplinary performance', she creates works at the intersection of music, movement, object and image to discover new modes of perception.

6. The Judson Group (Judson Dance Theatre): a group of American experimental dance practitioners who performed at the Judson Memorial Church, New York, 1962–64. They rejected the confines of modern dance practice and theory and were considered the founders of postmodern dance. The group included artists Steve Paxton, Trisha Brown, Yvonne Rainer, David Gordon, Deborah Hay, Elaine Summers and Ruth Emerson.

7. Merce Cunningham (1919–2009): US dancer and choreographer who was at the forefront of the American avant-garde for more than 50 years. Notable for collaborations with artists of other disciplines, significantly the composer John Cage and visual artists Robert Rauschenberg and Bruce Nauman. The Merce Cunningham Dance Company was formed at Black Mountain College in 1953 and was disbanded in 2011.

8. John Cage (1912–1992): composer, artist and poet. Long-term collaborator was Merce Cunningham with whom he created some of the most influential American avant-garde dance of the twentieth century. Best-known work is '4'33' – which is performed in the absence of deliberate sound – and he was a pioneer of *the prepared piano* (a piano with its sound altered by objects placed between or on its strings or hammers).

9. Yvonne Rainer: American dancer, choreographer and film-maker who was one of the founders of Judson Dance Theatre in 1962. Since 1972 she has made seven feature-length films, one of which, *Privilege* (1990), won the Film Makers Trophy at the 1991 Sundance Film Festival. She is the author of *Feelings Are Facts* (Cambridge, Massachusetts: MIT Press Writing Art Series, 2006).

10. Strider (1972–75): often described as the UK's first postmodern dance company. Initiated by Richard Alston with Christopher Banner, Diana Davies, Dennis Greenwood, Jacky Lansley, Wendy Levett and Sally Potter.

11. Richard Alston: British choreographer; early graduate of the LSCD and a founder of Strider. After studying in the USA primarily with Merce Cunningham, he became Artistic Director of the Rambert Dance Company (1980–92). He is now Artistic Director of the Richard Alston Dance Company.

12. Barry Flanagan (1941–2009): Welsh-born sculptor and print maker who was best known for his series of monumental elongated bronze hares. He was interested in Alfred Jarry's 'science of imaginary solutions', an ethos evident in his playful approach which allowed materials to find their own sculptural form – whether stone, rope, cloth or performance.

13. Gordon Mumma: American composer and French horn player. With Robert Ashley he co-founded the Cooperative Studio for Electronic Music and the now historic ONCE Festivals of Contemporary Music. From 1966 to 1974 he was, with John Cage and David Tudor, one of the three composer-musicians with the Merce Cunningham Dance Company, for which he composed four commissioned works.

14. The Place: home of The Place theatre, LCDS and the Richard Alston Dance Company. Previously home to the London Contemporary Dance Theatre (1967-94) whose founding director was the US dancer and choreographer Robert Cohan.

15. Christopher Banner: British dancer and choreographer who trained at LSCD and became a founder member of Strider, often taking the central role in Richard Alston's early works for the group, including *Headlong* (1973), *Tiger Balm* (1972) and *Slow Field* (1974). He choreographed a solo for Lansley, *Strawberry* (1972). Now lives and works in the USA.

16. Fergus Early: British dancer, choreographer, teacher and pioneer in community dance. He was a co-founder of the dance studios X6 Dance Space and Chisenhale Dance Space and is founder and Artistic Director of Green Candle Dance Company, working for and with young and older people in community and educational contexts. The company is currently leading research into the benefits of dance for people with dementia. With Lansley he co-edited *The Wise Body: Conversations with Experienced Dancers* (Chicago and Bristol: Intellect, 2011).

17. Colette Lafont: French dancer and actress based in the UK. She was part of the radical group of students at the LSCD in the early 1970s who were making interdisciplinary performance events. She had leading roles in Sally Potter's films *Thriller* (1979) (as Mimi) and *The Gold Diggers* (as Celeste).

18. Wendy Levett: dancer, choreographer and Tai Chi practitioner who studied under Gerda Geddes; trained at the London School of Contemporary Dance in the late 1960s and was a founder member of Strider dance company.

19. Extract from review of Strider at the Institute of Contemporary Art (ICA), London, by John Percival: *The Times*, 'Proving experimental art can be fun', 4th October 1972.

20. The Portsmouth Sinfonia (1970–79): orchestra founded by a group of students at the Portsmouth School of Art in England. The Sinfonia had an unusual entrance requirement in that players had to either be non-musicians, or if a musician, play an instrument that was entirely new to them. Among the founding members was one of their teachers, English composer Gavin Bryars.

21. The Blackie (now The Black-E): co-founded in 1967 by Bill and Wendy Harpe in the former Great George Street Congregational Church in Liverpool to connect artists and communities. It is acknowledged as the UK's first community arts project and continues to focus on the arts and participation. The Harpes have overseen the redevelopment of the building which can host large-scale international events and cooperative games.

22. *Tulane Drama Review* (TDR): US academic journal focusing on performances in their social, economic, aesthetic and political contexts. The journal covers dance, theatre, music, performance art, visual art, popular entertainment, media, sports, rituals and performance in politics and everyday life. It was founded by Robert W. Corrigan (Tulane University, 1957). In 1962 Richard Schechner became editor.

23. Trisha Brown (1936–2017): studied with Louis Horst at Connecticut College, then composition with Robert Dunn in New York at Merce Cunningham's studio alongside Simone Forti and Yvonne Rainer. After working with Anna Halprin she became a founding member of the Judson Dance Theatre in 1962 and in 1970 the experimental dance collective Grand Union. She subsequently formed the Trisha Brown Dance Company for which she has been making and touring her experimental stage and site-specific works for 40 years.

24. John Bull Puncture Repair Kit (JBPRK) (1969–76): founded by Mick Banks and Al Beach (later joined by the performance artist George O'Brien) whose interest in sculpture and installations had moved into performance ideas. Concerned with image as language, they created works that combined experimental performance, street theatre and humour to create small and large-scale performances in arts labs, theatre spaces, galleries and at indoor and outdoor festivals.

25. Dennis Greenwood: Canadian-born dancer who trained at LSCD where he collaborated with Diana Davies, Sally Potter, Colette Lafont, Jacky Lansley and others and became a founder member of Strider. He went on to work extensively with the choreographers Rosemary Butcher and Miranda Tufnell and appeared as an ice skater in Potter's film *The Gold Diggers*.

26. Welfare State International (1968–2006): founded by John Fox, Sue Gill, Roger Coleman and others. Welfare State International was a loose association of freelance artists brought together by a shared philosophy around art, community and collective practice; it became well known for large-scale outdoor spectacular events throughout the UK and abroad.

27. Martha Graham (1894–1991): influential American modern dancer and choreographer who practised for more than 70 years. Her style, the Graham technique, fundamentally reshaped American dance and is still taught worldwide. The Martha Graham Center of Contemporary Dance in New York was created in 1926 and continues to be the home of the Martha Graham Dance Company and the Martha Graham School of Contemporary Dance.

28. IOU: based at the IOU Studio in Halifax, West Yorkshire. A producing company for nearly 40 years across sculpture, performance and digital arts. Works locally and internationally in diverse outdoor and indoor spaces for all community sectors.

29. Potter and Lansley (LDC): extract from the artists' personal archives of co-written quotes, notes and scripts (1974–75). Courtesy of the artists.

30. Richard Demarco: co-founder in 1963 of the Traverse Theatre in Edinburgh. He later established the Richard Demarco Gallery which doubled as a performance venue during the Edinburgh Fringe and ran from 1966 to 1992. The gallery promoted cultural links with Eastern Europe, organising exhibitions and events with artists such as Paul Neagu, Joseph Beuys and Tadeusz Kantor.

31. Jean-Luc Godard: French-Swiss film director, screenwriter and film critic. Considered the most radical French film-maker of the 1960s and 1970s; his approach in film conventions, politics and philosophies made him arguably the most influential director of the French New Wave. Important films include: *Breathless* (1960) *Pierrot le Fou* (1965) and *Contempt* (1963).

32. Potter and Lansley (LDC): extract from the artists' personal archives of co-written quotes, notes and scripts (1974–75). Courtesy of the artists.

33. Joan Jonas: American pioneer of performance and video art; Jonas works in video, installation, sculpture and drawing, often collaborating with musicians and dancers to realise improvisational works that are equally at home in galleries and theatres.

34. Patti Smith: American singer-songwriter, activist, poet and visual artist who became a highly influential component of the New York City punk rock movement with her 1975 debut album *Horses*. Called the 'punk poet laureate', she is the recipient of numerous international awards including the National Book Award for her memoir *Just Kids* (New York: HarperCollins, 2010) – dedicated to her former long-time partner Robert Mapplethorpe.

35. Judy Chicago: American feminist artist, art educator and writer known for her large collaborative art-installation pieces which examine the role of women in history and culture. By the 1970s, Chicago had coined the term 'feminist art' and had founded the first feminist art programme in the USA. Chicago's work incorporates stereotypical women's skills, such as needlework, counterbalanced with 'male skills', such as welding. Chicago's landmark piece is *The Dinner Party* (1979), which is in the Brooklyn Museum collection.

36. Potter and Lansley (LDC): extract from the artists' personal archives of co-written quotes, notes and scripts (1974–75). Courtesy of the artists.

37. Rose English: British performance and visual artist. Following her collaborative period with Lansley and Potter (LDC), she has been making and performing her own work for over 30 years in venues such as Tate Britain, Royal Court Theatre, the Adelaide Festival and Lincoln Centre, New York. Her productions feature a diversity of co-performers including musicians, dancers, circus performers, magicians and horses. Ridinghouse published a book about her work, *Abstract Vaudeville: The Work of Rose English* by Guy Brett (London: Ridinghouse, 2015).

38. Lynn MacRitchie: Scottish artist and writer based in London; founder member of the Poster Film Collective and of Artists for Democracy. As a writer she has contributed to many art magazines, including editing *Performance Magazine*. As a business journalist she worked for Financial Times Business Publishing, before becoming a regular contributor on contemporary art for the *Financial Times* newspaper. She returned to art making in the late 1990s; notable work includes her film *The Towers of Ilium* (2013).

39. Sylvia Stevens: performance artist and film-maker with over 30 years' experience as a director and producer. Co-founder of Faction Films, a documentary film production company based in London. She has run workshops in Colombia, South Africa, Egypt, Tunisia, Turkey and Cuba and is a tutor on ACCESS and teaches Producing Documentary at Royal Holloway University.

40. Judith Katz: lecturer in photography at the University of Brighton. She trained at the LSCD and later became a performance artist, working collaboratively with artists at X6 Dance Space and in particular with Sally Cranfield. Her photographic work has been exhibited internationally. Permanent collections include the Bibliothèque Nationale, Paris; Museum of Modern Art, Houston, Texas; and the New Orleans Museum of Art, New Orleans, Louisiana.

41. Sally Potter, in *Abstract Vaudeville: The Work of Rose English*, 'Interview Sally Potter' (London: Ridinghouse, 2015), 95–102 (95).

42. *Musics* (magazine): launched in 1975 by a collective of experimental musicians (Paul Burwell, Steve Beresford, Colin Wood, David Toop, et al.) and published six times a year. The content of its 23 issues made it arguably the most significant music publication of the 1970s (Issue 14 included Lindsay Cooper's legendary essay 'Women, Music, Feminism' October 1977). *Musics* proposed the destruction of artificial boundaries and linked jazz with the music of composers such as John Cage and indigenous and non-European musics.

43. Annabel Nicolson: from 1969 to 1970 she ran the gallery at the New Arts Lab, London and was Cinema Programmer at the London Film Maker's Co-op in the 1980s and 1990s. Nicolson is a founder member of Circles – Women's Film in Distribution, and was editorial contributor for *Musics* magazine, 1976–79. Her film works and performances have been widely exhibited in the UK and abroad. Her artist's book, *Escaping Notice* (1977), is in the collection of the Victoria and Albert Museum.

44. Annabel Nicolson, 'Rabies', *Musics*, no.9 (London: *Musics*, September 1976), 18.

45. Frank Stella: American painter and print maker who is known for his post painterly geometric works which focus on the formal elements of art-making. His *Black Paintings* and other series were a decisive departure from Abstract Expressionism and served as an important catalyst for the Minimalist Art of the 1960s. He lives and works in New York.

46. Jacky Lansley, Rose English and Sally Potter: *Mounting* (Oxford: Museum of Modern Art, 1977), 3. Published alongside the performance *Mounting*, created and performed by the authors.

47. *New Dance Magazine* (NDM): founded and published by X6 Dance Space in 1977; NDM aimed to develop a language relevant to the emerging new and postmodern practice in the UK. It was published quarterly for 11 years until 1988. Its scope covered performance, training, academic discourse, political-consciousness raising and community activity. It was responsible for documenting a decade of radical dance activity within the UK.

48. Lynn MacRitchie: '*Mounting*' (Review of *Mounting* the performance), *New Dance Magazine*, No.3 (London: X6 Dance Space, 1977), 20-23 (21).

49. Lansley, English and Potter, *Mounting*, 9-10.

50. MacRitchie, '*Mounting*' (Review), 21.

51. MacRitchie, '*Mounting*' (Review), 22.

52. Lansley, English and Potter, *Mounting*, 16.

53. Potter and Lansley (LDC): extract from the artists' personal archives of co-written quotes, notes and scripts (1974–75). Courtesy of the artists.

54. Independent Dance (ID): established in 1990 by co-directors Gill Clarke and Fiona Millward and now based at Siobhan Davies Studios, London. Artist-led organisation providing a responsive framework to support dance artists in their development as professionals within an independent international community. ID classes and workshops are led by renowned artists, and place a particular focus on movement exploration as a source for performance, improvisation and composition.

55. Sally Potter: 'Afterword', in *Naked Cinema: Working with Actors* (London: Faber & Faber, 2014), 420.

2

DANCE OBJECT

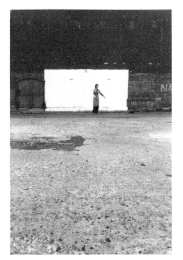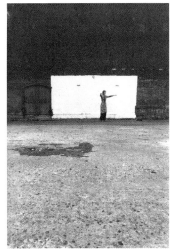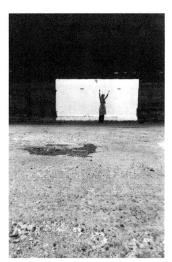

21 *Triptych* (1976)

To call something an object implies that it is without interiority; how then is a discussion about object relevant to dance? Like many of my peers I use choreographic strategies borrowed from visual art – where often the formal signifiers are shown, rather than embedded within a narrative or technical prowess. Structurally I work with fragments, interruptions and episodes which I can move around, repeat and change as part of choreographic work that behaves more like portable art objects. These choreographic strategies can be seen as something separate from the performer – who, of course, is not a portable art object. Indeed the variations and vulnerability of live performance can seem to place the artistic intention more with the dancer/performer, who is empowered to improvise, if necessary, and respond to the idiosyncrasies of the live event. For performers to have this sense of empowerment they need to feel ownership of the material as part of a genuine dialogue or collaboration with the choreographer, which I have found useful to call 'The Choreographic Exchange'.[1] Performers need to feel that they, too, can objectify the choreographic process as something both 'outside' and 'inside' their performance experience.

Within this chapter and the previous chapter, 'Minimal Dance', I discuss some of the early radical works I made in the 1970s which I feel explore this paradox of performance as object – and the collaborative relationships, organisations and environments which supported it. Through an archival collection of notes, reviews, descriptions, scores, interviews and images, I have tried to expose the underlying political concerns and cross art form influences in the work – influences which I believe have sustained my whole career and continue to inspire recent works which on the surface may appear to be quite different.

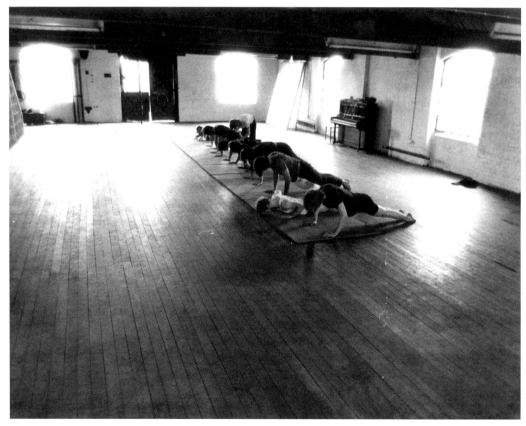

22 X6 Dance Space (a class taught by Mary Prestidge)

X6 DANCE SPACE

Space was (and is) a crucial dilemma for any dance artists not in major companies and in the mid-1970s there were a growing number of us. In 1975 a group comprising Mary Prestidge,[2] Maedée Duprès,[3] Emilyn Claid,[4] Fergus Early and myself who were working collaboratively, searched for a space and were eventually offered the top floor of an old tea warehouse – X Block in Butler's Wharf – situated in the derelict dockland area near Tower Bridge. The space was inspiring; it had a beautiful wooden floor which had been polished by the tea, large beams and huge wooden winching doors at one end. We called it X6 Dance Space and its activities became a legendary part of the UK New Dance Movement.

DANCE OBJECT (1977)

One of my first works at X6 Dance Space was titled *Dance Object*. The material came from an eclectic mix of personal memories, found objects, fragments of dance and assorted texts. I don't remember organising, choreographing or even selecting movements. The structured part of what I was doing was reflected in the 'script' for the performance which I called an event. The liberated release in my movement vocabulary – rolling, running, lying, skipping, jumping, cycling – with some moments of stillness and sculptural shape, were organised through the creation of image sequences such as:

> The woman in a man's suit
> The costume change
> A room with a bed on the floor
> A bicycle in the dance studio
> Mao and the Red Detachment of Women
> Falling and a member of the audience catching me

The whole became a score of loosely connected themes and images which had underlying political and autobiographical connections. Overall, it felt like I had created a new space within the dance studio environment by adapting and borrowing disciplines from performance art to explore my own reorientation as an artist and as a woman.

23 24 25 *Dance Object*

A central device of *Dance Object* was to use a recording of my talking voice to expose my thoughts as I performed… 'The audience was able to both hear her intellectual process and see her performance simultaneously. This device cut through the traditional image of the silent dancer and also curtailed voyeurism'.[5] The performance began with me sitting in 'a small room' – a single bed, chair, mirror, lamp – at the far end of the studio, wearing a man's evening jacket and tracksuit trousers. The tape recording began with a quote from Gertrude Stein's 'Lectures in America': 'In the first place at the

theatre there is the curtain, and a curtain already makes one feel that one is not going to have the same tempo as the thing there is behind the curtain'.[6]

The tape went on to describe and analyse the significance of my 'costume'. I became therefore like a mannequin displaying clothes while my voice – my subjectivity – scrutinised the image:

> [A]part from it being fashionable to wear a man's jacket I suppose it makes me feel bold, strong, slick, hard rather than soft – ready for action. I'll move onto the legs […] as you see I'm wearing tracksuit trousers. This is part of a very internalised dance fashion; contemporary dancers wear sports clothes rather than traditional tights and leotards. The image is one of function rather than display.[7]

Desirous of developing her dance skills, Rose English attended many of the alternative dance classes and workshops at X6 and this facilitated a series of works that she and I made and performed together during this period, including *Dancing Ledge, Women Dancing and Juliet and Juliet a Duet – Romeo and Romeo a Duel*. The work was more engaged with movement languages, yet retained many of the hallmark artistic strategies of Limited Dance Company's work.

DANCING LEDGE (1977)

In this event at X6 Dance Space, Rose and I performed a continuous slow and stately duet. We were joined by a 'chorus' of twelve performers who constantly tried to interrupt us with random activities:

> The twelve people did everything they could to create distractions and interruptions. They marched up and down in a row and sang a song. They did organised things like holding someone else's foot and then all hopping around in a circle. They slid. They shook hands with the audience. They gave the audience nails […] and all this time, which was about one hour, Jacky and the large girl with the pony tail [Rose English] persisted in their quiet choreographings and didn't get knocked over.[8]

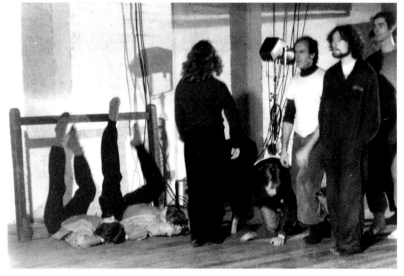

26 Dancing Ledge

27 28 29 *Women Dancing* (drawings by Rose English)

WOMEN DANCING (1978)

This work was performed as part of '5 Days at Acme',[9] a programme of one-off events focusing on dance and performance curated by Marilyn Halford and Fergus Early at the Acme Gallery. Acme is an organisation which has been supporting artists with studio space and housing for over 40 years and recently worked with the Whitechapel Gallery on an archive exhibition of material from their first decade 1972–82, which included a presentation of material from '5 Days at Acme'. This reminded me

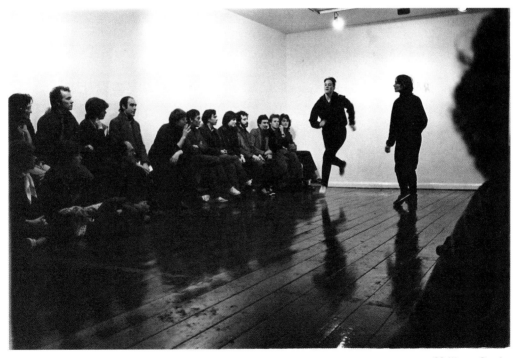

30 *Women Dancing*

that X6 Dance Space had also been invited to participate in the Whitechapel Summer Show 79, alongside 14 visual artists all working in East London. At the time this kind of invitation – to cross boundaries and work within galleries and alternative theatre spaces – was much more prevalent and stemmed from an understanding that, whether performers or painters, we were sharing many of the same conceptual and aesthetic skills and a commonality of thought about the possibility of art as an agency for change. Following is a review of *Women Dancing* by the artist Mike Leggett, who was a member of the audience:

> In what was performed, there was neither compromise with, nor false distinction between, the dance they made and that which has emerged from the hinterland of Southern Africa and the stage of Covent Garden. It combined a definite, though not conventional, narrative structure with improvisation and traces of the codes of classical ballet.

> A slide projected large onto the wall of the gallery depicted a group of children clustered around a piano, apparently the members of Isadora's Duncan's[10] dance school [...] the two performers sat in canvas chairs to either side of the projected image. They began by exchanging anecdotes concerning experiences as children in ballet class, as members of touring dance companies, as dancers on the professional stage [...] the one to the other 'do you feel like dancing?' The slide projector was removed, the lights were turned on and Bob Marley and some rocking music boomed out into the space. For another ten minutes they moved, sometimes together, more often apart, sometimes quietly then suddenly in great rushes up and down the room; sometimes with great regard being paid to the music, then apparently it being completely ignored.

> The sounds suddenly changed to a continuous twenty minute recording without any perceptible rhythmic base, other than that contained by discrete quantities of sound bursts – it seemed to have something to do with water and animals (and in fact turned out to be the sounds made by Beluga whales beneath the sea). The physical movements scarcely altered [...] the dancer's attentions, however, were becoming more related one to the other; less to do with exuberant movement, more to do with directed concentration of gesture, rhythm and 'body-shape'. The audience of fifty people strung around the skirting board were witness to this refining process and in their very proximity, became party to it. Not just from dancer to dancer and vice versa but from dancer to viewer, viewer to viewer(s):

31 *Women Dancing* (diagram by Mike Leggett)

The room was returned to darkness and another slide projected, completing the otherwise submerged narrative. This image represented the prima ballerina of the classical stage, bristling with costume, lit as if by a thunderstorm, snapped from an angle accentuating her individuality separate from the herd […]

The general implications of the entire piece could not be avoided in the basic and oppositional position taken toward the notion of dance as institution and the conditioning of children from an early age. The industrial approach to dance is remarkably similar to that of the cinema industry; another institution closely guarding the borders of a public art form; both gearing toward an audience who they feel they must please at all cost, an audience whose expectations are equally conditioned by the dictates of meaning given, rather than meaning made. With the performance made at the Acme gallery, in common with recent work in other plastic arts, the emphasis is turned toward the role of the viewer or as a group, the audience. The appeal of this work is the possibility that dance becomes something less to do with a (long) tradition, a consistently defined space, a handful of narratives with a set of codes to convey meaning; more to do with meaning being made by the audience in responses to immediate physical factors within the space they help to define.[11]

JULIET AND JULIET A DUET – ROMEO AND ROMEO A DUEL (1979)

Juliet when did you go to your first dance? When I was 11 Juliet. What were you thinking of? The feeling in my throat when a dog licks my hand.[12]

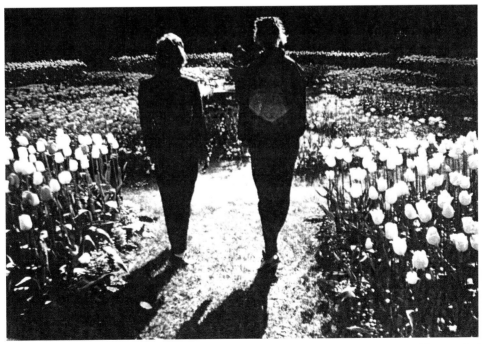

32 *Juliet and Juliet a Duet – Romeo and Romeo a Duel*

This work was performed at X6 Dance Space and at the Drill Hall, London.[13] It used theatrical elements such as a huge section of a semicircular wall, borrowed from the stores of an opera house and excerpts from Prokofiev's music for the ballet *Romeo and Juliet*. Actual scenes from the ballet (the ballroom scene and Tybalt's death) were alternatively restaged, exploiting unisex partnering which was identical for both the Juliets and the Romeos. Costume references, such as doublets for the Juliets, a dress for one Romeo, an apron for another – and both of us wearing tiaras which we eventually used as swords in a duel – played with the work's theme of gender and asked questions about the links between 'high' and 'low' art forms.

> A large, open doorway and, in front, a wall of concrete which curved from one side of the room to the other gave the setting an outdoor feeling, a feeling of some strange, rather desolate city scape. As Jacky Lansley and Rose English appeared behind the wall and rested their arms on the edge, they might have been leaning on the last remaining wall of the Royal Festival Hall complex, or on a piece of the Wall of Death. This was a performance of many beautiful poses which created a sense of quiet intimacy and of moments frozen in time not unlike 17th century Dutch paintings of bourgeois domesticity […] It would be an understatement to say that this performance gave a new slant on *Romeo and Juliet*.[14]

The following review extract delves more into the relationship between the two performers and with their audience:

> Images of T'ai Chi, of Yoga, of living sculpture emerged, formed and reformed as complementary elements of unspoken harmony and symbolic agreement of two women before an attentive gathering. The performance grew out of a casual 'warm-up' leaving the audience to be drawn into involvement at each individual's own pace rather than at a set starting point demanding the formation of an audience for a formal beginning. The progression of spectator into audience corresponded to the interaction between the performers, an unfolding as individuals and a merging into a unit, fluid but with a focus.
>
> Sudden side lighting abruptly changes the mood towards a more conscious performance by actors who speak to one another about the mechanics of movement, breaking all symmetry and causing comparison and competition between the two watched by the many. We are all defined and the theatrical process acknowledged. Rough shapes replace rhythmic patterns, asymmetric forms replace organically evolved ones. Two moods alternate, the one more contemplative but the original more spontaneous. Transitions grow more subtle between them and the celebration of co-operative shapes formed by the women begin to integrate sounds, objects, dialogue and music.
>
> Walls appear and are hidden behind and are used as territory by each actor. The backdrop makes activities more defined and less open to abstract interpretations. Work in tandem is replaced by scenes quite random and individually defined by separate spotlights. Defined space constricts the movement, actions grow dependent upon gadgets both resulting in conflict then confusion causing the performance to come to an end.[15]

HELEN JIVES

Towards the end of the 1970s, X6 Dance Space formed another important relationship across discipline boundaries with the Drill Hall in central London. The Drill Hall had developed a reputation as a radical venue that supported alternative gay and feminist theatre and through X6 it drew dance into its programming, including a very successful three-week residency, X6 and Xtras (1979), which involved up to four different performances a night. As part of this residency a group called Helen Jives, which came out of a women's creative workshop I initiated at X6 Dance Space in 1978, presented a collectively devised piece titled *Edge City* (1978): 'the idea of Edge City, paranoid metropolis […] where a story could be developed that would allow everyday and mythical elements to coincide without explanation or apology'.[16]

Helen Jives consisted of four women from interdisciplinary performance backgrounds: myself, Anna Furse[17], Suzy Gilmour[18] and Maureen O'Farrell.[19] As a group we made two further 'plays': *Bagwash* (1979), which explored the poignant camaraderie of four women sharing stories of pain and oppression as they washed clothes in a communal laundry; and *The Fast Supper* (1978), which used the theme of food and its over/under consumption and ritualisation to explore aspects of body image, religion and paternalism. Both these works were performed at X6 Dance Space and reflected the rich cross art form activities at X6, which embraced the skills and approaches of alternative, feminist and gay theatre, alongside those of performance art and postmodern dance.

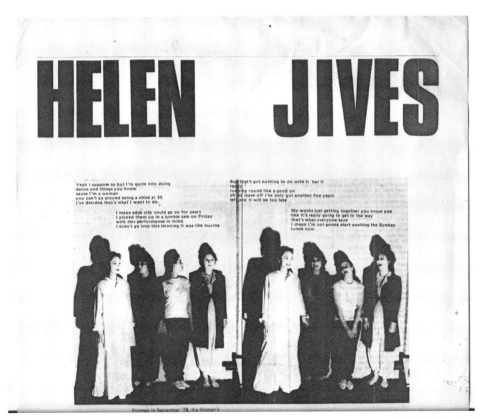

33 *Edge City* (poster)

THE FAST Supper.

MENU

apperitiff

CREATION

a taste of things that come

Hors d'œuvre
TEMPTATION
Everything we like is immoral, illegal
and fattening.

Soupe

KNOWLEDGE.
An audience plant.

Entrée

COMMUNION

Inter Course Tea

Dessert — fromage.

CONFESSION.
What you eat you are

café — Liqueure.

MIRACLE
Be realistic! Plan for a miracle

Served by Margaret Barnes, Anny Caddle, Anna Furse,
Lucy Goodison, Suzy Gilmour, Jacky Lansley,

34 *The Fast Supper* (programme)

ZENA MOUNTAIN (1979)

During this same period I also created a one woman 'show', or rather I created a character, Zena Mountain, who created improvised shows. Zena was a strange hybrid who wore a dazzling blonde wig and carried a rucksack. Her events drew on cabaret, performance art, chat shows, rock culture and stand-up, and seemed to be exploring the female performer as both entertainer and artist in edgy performances that toyed with both popular and experimental forms. Performed several times in the intimate theatre space downstairs at the Drill Hall, the performances had a clubby, chatty quality that involved lots of audience participation; following is an extract from a review in *New Dance Magazine* which gives a glimpse of Zena's oblique qualities:

> A) What did Zena Mountain look like? B) Blonde, elegant, but not afraid to touch her wellington boots. A rugged severity which can at a moment's notice transform itself into sparkling lightness […] A) What did Zena Mountain do? B) […] She was not afraid to muddle through, she was not even afraid to tell us that she, too, the performer, could feel nervous, or that things were not going right, or that she was bored, or that she didn't know what to do next […] Water was a big theme. She drank a lot of water out of a very large enamel jug; she seemed to rely quite heavily on her glass of water at times. In one of the shows there was an in-depth explanation of the water element in Zena's career to date. This culminated in a stunning slide show with dramatic commentary on the microphone of a past water ballet on the Thames […] A) What is special about Zena Mountain? B) […] she doesn't kow-tow to the audience's expectations of her as a performer […] She does as she pleases.[20]

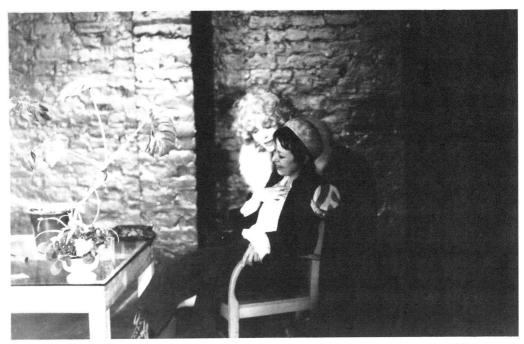

35 *Zena Mountain*

This early interdisciplinary work was ephemeral and poorly documented, neither did it have a technique as such – a code of practice learnt or written or photographed which would give it a sense of 'product' to allow it to move forward within the increasingly commercialised culture of the 1980s. In the 1970s the desire for collective cooperation and gender equality merged with extraordinary artistic experimentation and created a momentum which feeds us today. However, we were perhaps unguarded as we focused on action rather than strategy and when, for example, all the artists were made to leave Butler's Wharf to make way for the 1980s property developers – a symbol of sweeping conservative changes – we were perhaps not prepared enough. My abandoned, carnivalesque quality in *Dance Object* at X6 Dance Space now seems a long way away, although it has been inspiring, as I research and write this book, to be reminded how much the radical ideas and strategies from this early period have sustained me over 40 years and how many of the artistic disciplines are still part of my practice.

Notes

1. 'The Choreographic Exchange': a module of the professional development programme The Speaking Dancer: Interdisciplinary Performance Training (SDIPT) – created by Lansley in 2008. 'The Choreographic Exchange' focuses on the concept and exploration of exchange between choreographers and performers.

2. Mary Prestidge: independent dance practitioner and teacher; she had an early career as a gymnast then performed with Ballet Rambert before joining the X6 Dance Space collective. Also originating member of Chisenhale Dance Space where she was very active as a teacher and maker through the 1980s. She lectured in dance at Liverpool University throughout the 1990s and is a founding member of the Liverpool Improvisation Collective based at the Bluecoat in Liverpool.

3. Maedée Duprès: Swiss dancer and choreographer who trained at the London School of Contemporary Dance (LSCD) before joining the X6 Dance Space collective. Worked with artists such as Rosemary Butcher and Julyen Hamilton and with Second Stride. Performed several commissioned solo works including *Jeanne* (1979) by Lansley. Moved to the USA in the 1980s where she teaches dance and t'ai chi at the University of Colorado and runs a living arts centre.

4. Emilyn Claid: dancer, choreographer and academic; original member of the X6 Dance Space collective and one of the founders of Chisenhale Dance Space. She was artistic director of Extemporary Dance Company in the 1980s; now professor of choreography at Roehampton University, London. Author of *Yes? No! Maybe…* (London: Routledge, 2006).

5. Christy Adair: 'Beginning Again – New Dance', in *Women and Dance (Women in Society – A Feminist List)*, ed. Jo Campling (London: Palgrave Macmillan, 1992), 182–198 (190).

6. Gertrude Stein (1874–1946): quote from Gertrude Stein: 'Plays', in *Lectures in America* (New York: Random House, 1935), 93–131 (95).

7. Jacky Lansley: extract from the original script of *Dance Object* (1977). Courtesy of the artist.

8. Julia Blackburn: 'X6 Performances' (Review of *Dancing Ledge*), *New Dance Magazine,* No.1 (London: X6 Dance Space, 1977), 13.

9. Acme Gallery (1972–82): founded by Jonathan Harvey and David Panton, the gallery curated a wide range of cross-disciplinary exhibitions. Linked to Acme Studios (directors Panton and Harvey), a London-based charity which provides affordable studio space, residencies and awards for non-commercial fine artists in Greater London. The Dance Research Studio is part of an Acme Studios development.

10. Isadora Duncan (1877–1927): American pioneering dancer and choreographer. Breaking with convention, Duncan traced the art of dance back to its roots as a sacred art. She developed within this notion free and natural movements inspired by the classical Greek arts, folk dances, social dances and nature, as well as an approach to the new American athleticism which included skipping, running, jumping, leaping and tossing. She established several international schools to develop her method. When she died she was a Soviet citizen.

11. Mike Leggett: artist, film-maker, writer and academic. Member of the London Film Makers Co-op and the Bristol Film Makers Co-op in the 1970s and 1980s. Lectured at Exeter College of Art before moving to Australia where he lectures at the University of Wollongong and researches interactive technology and the arts.

12. Rose English and Jacky Lansley: extract from the original script of *Juliet and Juliet a Duet – Romeo and Romeo a Duel* (1979). Courtesy of the artists.

13. The Drill Hall: the venue started to be used as an arts centre for Bloomsbury in 1977, and became a theatre, the Drill Hall, in the 1980s after many years of being used as a rehearsal hall (in the 1900s the Ballets Russes rehearsed there). From 1984, the Drill Hall particularly supported gay and lesbian theatre and art. Also home to Action Space (1968–81) an innovative combined arts company who made work in the community and whose aim was to change the relationship of the arts to society.

14. Nadine Meisner: 'Jacky Lansley and Rose English at the X6 Dance Space', *New Dance Magazine,* No.11 (London: X6 Dance Space, 1979), 20.

15. Marguerite McLaughlin: 'Juliet and Juliet a Duel – Romeo and Romeo a Duet, Action Space', *Performance Magazine,* Issue 4 (London: Performance Magazine, December/January 1980), 7.

16. Suzy Gilmour, Jacky Lansley, Anna Furse and Maureen O'Farrell (Helen Jives): 'Helen Jives in Edge City' (collective review statement), *New Dance Magazine*, No.9 (London: X6 Dance Space, 1979), 14.

17. Anna Furse: a dance and theatre practitioner since 1978, in experimental, community/applied, site-specific, repertory and international contexts. She has directed women-centred projects for companies as diverse as Bloodgroup, Graeae, Women's Theatre Group (Sphinx), Magdalena and the Royal Shakespeare Company. Anna was Head of Department of Theatre and Performance at Goldsmiths, University of London (2011–15) and is the author of *Theatre in Pieces* (London: Methuen Drama, 2011).

18. Suzy Gilmour: writer and actress; studied at Oxford University before working with artists at X6 Dance Space (*I, Giselle* [1980]; Helen Jives). Went on to form Bloodgroup, a women's theatre company with Anna Furse; wrote *Feasting on Air* (1991), directed by Furse, for Paines Plough Theatre Company. Now lives in Queensland, Australia where she continues to write.

19. Maureen O'Farrell: British actress, probably best known for her role in Linda La Plante's 1980s television drama *Widows*. Maureen studied dance and drama at Hull University before moving to London where she became involved in activities at X6 Dance Space. She later became a well-known teacher and dancer in Egyptian dance and in the late 1990s she gave up acting and moved to Egypt to continue this aspect of her work.

20. Quote from a discussion between two anonymous members of Zena Mountain's audience who attended her performance at the Drill Hall: 'The Zena Mountain Show', *New Dance Magazine*, No.9 (London: X6 Dance Space, 1979), 10.

3

OUT OF THIN AIR…

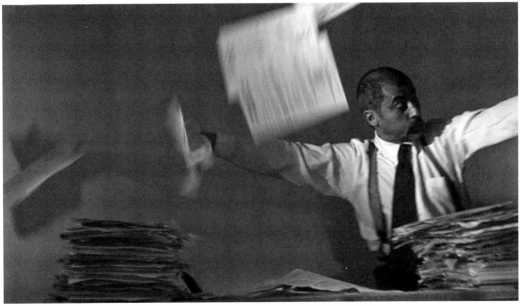

36 *The Life Class*

Looking back through my archives I am struck by an eclecticism that works through theatricality to conceptual minimalism and through various hybrid forms of dance and visual performance. It has not only been a grappling with form and content that has created this process but also an endless negotiation with context and a constant questioning of where the work fits; questions provoked by economic realities, aesthetic concerns and the political climate. Looking back from the perspective of where I am now, this hybridisation feels like it has been a strength.

In the 1980s I made several works which toured in the UK including *I, Giselle* (with Fergus Early), *The Impersonators, A Child's Play* and *The Breath of Kings*. Most of this work was developed at Chisenhale Dance Space,[1] which emerged from the radical studio X6 Dance Space after the extensive artistic community at Butler's Wharf had been forced out by developers. At this time, alongside my own practice, I was working as a freelance choreographer on mainstream theatre and film productions and Chisenhale became a creative home I could return to and regroup. I learnt a huge amount within these other sectors and had the opportunity to work with extraordinary artists and collaborators; *Breath of Kings,* for example, reflected how much I had absorbed from working with actors and my desire to push the boundaries of words and movement. However, I was often challenged by the confined role of the choreographer within traditional hierarchical film and theatre systems – where choreographers and movement directors were usually at the bottom of the creative team pecking order, despite everyone agreeing that a well-placed episode of movement could transform and lift an entire production. Nevertheless, this work enabled me to keep developing as an artist and helped to shape my ideas about interdisciplinary performance training.

We brought to Chisenhale our manifesto from X6, which was no less ambitious than 'opening dance up to the world' and making work that sprang from our personal and collective experience. I made pieces about gender, about being a mother and also about war. Looking back at these 1980s pieces they seem quite theatre-orientated and very content-led, as opposed to the postmodern work I was making in the 1970s at X6, which seemed much more about experimenting with form, or my recent work which has been more involved with abstraction and movement. In the 1980s I seemed to be exploring how to use postmodern strategies of quotation, parody, humour and fragmentation within a series of issue-based works which looked like 'dance plays' – it seemed as if my collaborators and I had created a new form of dance theatre – a form that was very successful with *I, Giselle,* which I made with Fergus Early and presented at the Drill Hall in London just as we moved to Chisenhale from X6.

I, GISELLE (1980) REVIEW EXTRACTS AND QUOTES

> In looking again at *Giselle*, we wanted to question the stereotypes of the original story, while still retaining its power and excitement. Above all we wanted to remove Giselle from her eternal victim role, give her a voice, allow her to triumph. In our story, Giselle very soon discovers Albrecht's duplicity, and is not taken in by him. It is not Giselle who goes mad, but Albrecht, and then his fiancée Bathilde, and finally everyone else. Giselle does not die, but chooses to join Myrtha, the Queen of the Wilis, as the Sorceress's apprentice. In the dance of death, it is Giselle who survives, all the rest who fade away. The other characters, too, have changed in emphasis. Giselle's mother, Berthe, is seen as a healer, a woman of strength […] Myrtha is seen as a powerful witch, very much in the tradition of Circe. For Albrecht, the role of Romantic hero becomes a trap he cannot escape, and Hilarion suffers a less severe fate than death – he is turned into a rabbit.[2]

This reinterpretation disrupts the values embedded in Giselle and in the Romantic style [...]
Within this reworking the gendered vocabulary of ballet is extended as Early performs the
steps of the ballet but with a different dynamic and body attitude. This anti-virtuosic language
and 'softer', alternative physicality may challenge conventional expectations of the male
dancing body.[3]

The new *Giselle* utilises a formidable range of dance and theatre techniques and the
integrated use of audio visual material. The work has evolved through workshops and
exercises in which all five of the cast attempted to grapple with the questions the piece
raised. Their varied personal skills have all contributed to the final form. Giselle, for example,
played by Suzy Gilmour, has written the songs which enable her to literally 'find a voice'.
To set the scene, the new work retains an 'overture' where aspects of the music are explored
and combined, and slides of the original and later productions of the ballet are used between
scenes to give the 'context of exploration'. Slides of the present piece are cut in to these
to make the point quite clear. Jacky feels that the new production says strongly that such
combination of apparently disparate elements is indeed possible, and may even be almost
necessary if the complexities of the issues raised are to be even approached.[4]

Press reviews also proved that the production had succeeded in raising several hoary issues.
Many articles were discursive and not directly critical, but it was clear that conventional ballet
critics were either nonplussed or hurt, some plainly felt threatened. Ballet however, it appears,
avoids dealing with social issues of contemporary relevance. Seeking to challenge sexism in
balletic archetype and pull it up by the root [...] may lead to surprisingly refreshing images of
women both as dancer and as performer.[5]

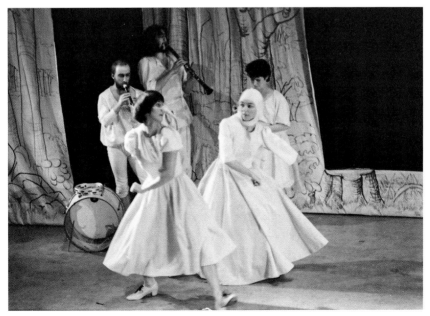

37 *I, Giselle*

38 *I, Giselle*

THE IMPERSONATORS (1982)

The Impersonators, which I also made at Chisenhale, was inspired by music hall and its history of standalone acts. I was fascinated by this culture, as I knew it had a deep influence on me. Several of my early teachers had performed in music hall and variety and I knew that ballet had originally been performed in the UK as acts in variety shows. There is also a long tradition of avant-garde and experimental theatre and performance art, which draws on the standalone act, and the idea of low and high art combining in the contexts of, for example, Dada and the Cabaret Voltaire.[6] Specifically, I explored the phenomenon of the Victorian and Edwardian male impersonators such as Hetty King[7] and Vesta Tilley.[8] Throughout many cultures men and women have always exchanged gender roles in the theatre, yet at that time, as part of my exploration of female empowerment in performance, I became fascinated by these very British nineteenth and early twentieth century male impersonators and wanted to explore who and what they were. I said this in an interview in 1987:

> We had done a lot of work in men's suits with Limited Dance Company and it had been intriguing to us that we actually felt more powerful in men's suits – it gave us permission to be more ourselves. I was also investigating the relationship between theatre and art, and how these different areas reflect a class difference. Art has traditionally been associated with the ruling classes, but the history of theatre in the UK has really been rooted in working class culture. I was on the hunt for female working class models – the working class female voice. Victorian music hall male impersonators seemed to provide the models I was looking for![9]

The process and research on *The Impersonators* was extraordinary and inspiring and the final performances had some powerful elements, despite the script now looking a little over wordy. The music was created by Sylvia Hallett,[10] who, like me, researched music hall extensively and created a haunting

39 *The Impersonators*

score of sounds and song fragments, including a virtuoso prologue in which the pianist played with her feet and elbows as a contortionist act.

With lightness and wit, cast members Vincent Meehan[11] and Betsy Gregory[12] brought their combined dance, cabaret and acting skills to *The Impersonators*. Their 'on stage' acts and 'back stage' dressing room banter juxtaposed and lifted the somewhat dark Victorian imagery of the piece. Betsy drew on research of Hetty King and Vesta Tilley to find her own dapper male impersonator, who cleverly embodied the central themes of the piece. This was matched by Vincent's delightful impersonation of the music hall artist Marie Lloyd[13] singing her signature song: 'As I take my Morning Promenade/Quite a fashion card on the promenade/Now I don't mind nice boys staring hard/If it satisfies their desire...'.[14]

A CHILD'S PLAY (1987)

Another dance play that I made during this period was *A Child's Play* which came out of my experience of becoming a mother and my anger and shock at the social invisibility of both children and their carers,

40 *A Child's Play*

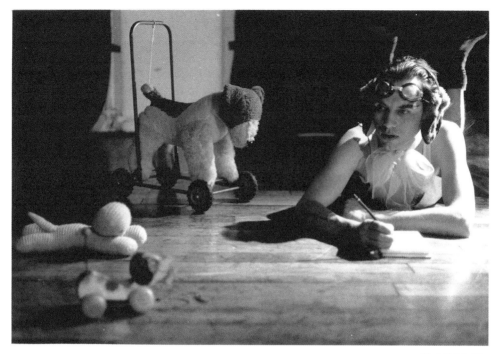

41 *A Child's Play*

of being told to change my daughter's nappy somewhere else – or take her out of public places in case she made a noise. It felt like people in the UK (like others, I had very different experiences elsewhere) were not attuned to the needs of children and I realised that I too had been guilty of marginalising women with children prior to becoming a parent myself. The piece was performed by a quartet of adults, including myself, playing at being children in dressing-up clothes. It was funny, dark and poignant; its structure was episodic and worked through ideas about the ritualised games of children, their private worlds and their neglect by adults.

We researched and talked about our own childhoods and brought early photographs to the process. There is something very touching about the image (40) of a small Steinvor Palsson[15] being supported by the old X6 maple wood floor, which was spirited away from Butler's Wharf and relaid at Chisenhale.

BREATH OF KINGS (1986)

Breath of Kings, which was first performed at the Dartington Dance Festival[16] and then at Chisenhale Dance Space, drew on my experience of working on plays in mainstream theatre. It was also a reflection on the Libya political crisis of 1986.[17] I used extracts from Shakespeare's *Richard II* to suggest parallels between historical and contemporary wars and between the principal protagonists involved in the disputes. Performing the role of Richard II as a woman – rather than a woman impersonating a man – I was supported by two silent male escorts, Gale Burns[18] and Fergus Early, who were supremely minimal while my performance was heightened. As they sat at a coffee table reading tabloid newspapers with headlines about the Libya crisis, I spoke Shakespeare's great pacifist's words from *Richard II*:

Wrath Kindled gentleman be ruled by me:
Let's purge this choler without letting blood:
This we prescribe, though no physician,
Deep malice makes too deep incision.
Forget, forgive, conclude and be agreed, our doctor's
Say this is no month to bleed.[19]

For a period, Chisenhale Dance Space gave me a place to belong, although eventually my freelance work – which included making a series of works with mid-scale dance companies such as Extemporary (*Speaking Part* [1982]),[20] New Midlands Dance Company (*Frank* [1987]),[21] Spiral Dance Company (*Impersonations* [1981])[22] and English New Dance Theatre (*The Queue* [1989])[23] – combined with my work in theatre and film, prevented me from immersing myself in the collective management of the space and my relationship with it became less strong. I am immensely proud that Chisenhale Dance Space has survived to this day – which I believe is, to a large extent, the result of its collective, artist-led ethos inherited from X6 Dance Space.

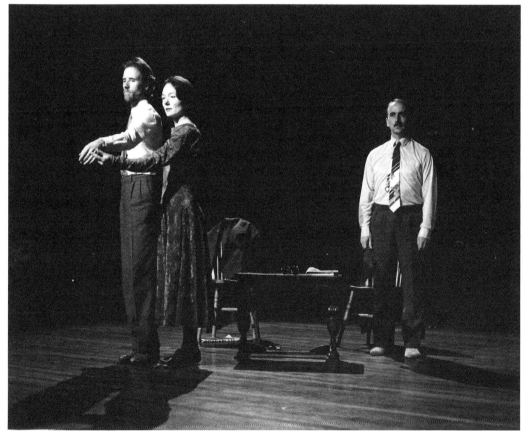

42 *Breath of Kings*

DO MY SHOES REFLECT THE QUALITY OF MY INTELLECT? (1998–99)

By the 1990s I had started to write about my practice more and had begun to form connections, as a visiting lecturer, with various academic institutions that were developing graduate and postgraduate studies in contemporary performance practice. Reflecting on this contextual shift I made a solo work called *Do My Shoes Reflect the Quality of My Intellect* (a title borrowed from a Limited Dance Company script) which I performed at various UK universities.

> Do my shoes reflect the quality of my intellect…? By framing my question in such a way I
> invite you the spectators to look upon me, the performer, and to think about what I as a body
> in this space, as a female body in this space, represents and mean.[24]

The coherence of my 'character' – a kind of comic professor giving a bizarre lecture on Derridian metaphysics of presence and absence[25] – enabled me to explore the idea of the spectral dancer through the contradictory positioning of myself as a very present and visceral dancer. My 'set' consisted of two black flats in the centre of the space with a four-foot gap between them; this gap was explored extensively as I played with appearance and disappearance and the 'invisibility' of a very visible quick change behind one of the flats. Part of my lecture involved a series of slides of single words such as LACK, PRESENCE, ABSENCE, OTHER, SCOPOPHILIA, made comic with different typefaces. This framing of words well-used within cultural theoretical discourse was not an attempt to ridicule the ideas they represented, but more to create a space that looked at the relationship between linguistic definition and embodied definition and the negotiation that is required between unstable and often quite temporary cultural prescriptions.

Different types of shoes were introduced at various moments in the performance to demonstrate these ideas – and as part of this shoe text I introduced a pair of tiny baby shoes to explore the question of whether they were small enough for a baby to wear inside my body. I placed the tiny shoes in the approximate location of my reproductive organs while I did a very slow, minimal dance. I wanted the audience to engage positively with this internal/external female landscape and the images and ideas

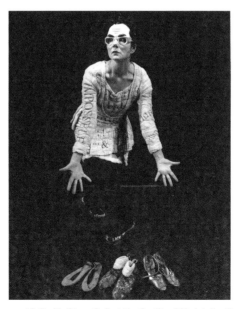

43 *Do My Shoes Reflect the Quality of My Intellect?*

surrounding the reproductive system; ideas that have become strangely complex within societies that seem determinedly unsupportive of the female body. Ultimately, this solo was exploring a number of complex spaces – that between theory and practice, between academia and art and the space for a female presence.

LES DIABLES (RESEARCH PROJECT 1998–99)

After a considerable gap during which I did not create any of my own work, owing to the demands of my lecturing and freelance work in theatre and film, it is interesting that my return to my own practice was in dialogue with two old ballet works. Throughout the period 1997–2003 I was involved in a series of R&D projects, which explored Michel Fokine's[26] 1911 ballet *The Firebird*. Seventeen years before, I had successfully deconstructed the Romantic ballet *Giselle* with Fergus Early (see *I, Giselle*) and had worked through, or so I thought, many of the issues concerned with revisiting classical works. *The Firebird* however, is not a Romantic ballet; it is a kind of early modern ballet and, although part of the ballet canon, is very different from *Giselle*. My work *L'Autre* (1997), which used the ballet *Petrouchka* as a primary source, had already drawn me towards the Fokine/Stravinsky[27] collaboration and I remained fascinated by the collection of languages and artistic strategies used in both ballets.

During the *Les Diables* R&D process I worked with four actor dancers: Vincent Ebrahim,[28] Fergus Early, Luke Burrough[29] and cris cheek (*sic*). Together we looked at the archetypal folk stories which had informed *The Firebird*: stories in which the seeking of fire as knowledge is a potent and reoccurring theme:

> Even more strange was the Baba Yaga's house. It sat atop huge, scaly yellow chicken legs, and walked about all by itself and sometimes twirled around and around like an ecstatic dancer. The bolts on the doors and shutters were made of human fingers and toes and the lock on the front door was a snout with many pointed teeth. Vasilia consulted her doll and asked 'Is this the house we seek?' and the doll, in its own way, answered, 'Yes, this is what you seek.' And before she could take another step, Baba Yaga in her cauldron descended on Vasilia and shouted down at her, 'What do you want?' And the girl trembled. 'Grandmother, I come for fire. My house is cold… my people will die… I need fire.[30]

Our character research specifically focused on the demons in the ballet story and as a result a wide range of philosophical, political, visual and performative ideas poured into the studio space. Out of this process four distinct characters emerged who, we decided, were neurotic and distressed, rather than evil:

> Dog Man Jake (Fergus Early) – A split being whose right arm was inhabited by a fierce dog. Fergus researched images from Vaslav Nijinsky's[31] ballet *L'Après Midi d'un Faune*[32] in which Nijinsky was a goat boy.
>
> Frame (cris cheek) – He had a special relationship with new technology. The television screen became a flickering fire that drew him in – because, like all the characters, he was cold. He constantly framed people and objects with a rectangular gesture.
>
> Skull (Vincent Ebrahim) – The only words he used were YES and NO. He wore an old mack and his daytime job was an immigration officer. He was an extremely shut down person who was a secret cross-dresser.
>
> The Trickster (Luke Burrough) – He wore a top hat as the decadent capitalist – an image borrowed from constructivist art. He played cards and took delight in abusing Skull, quoting the manipulative relationship between Nijinsky and Diaghilev.[33]

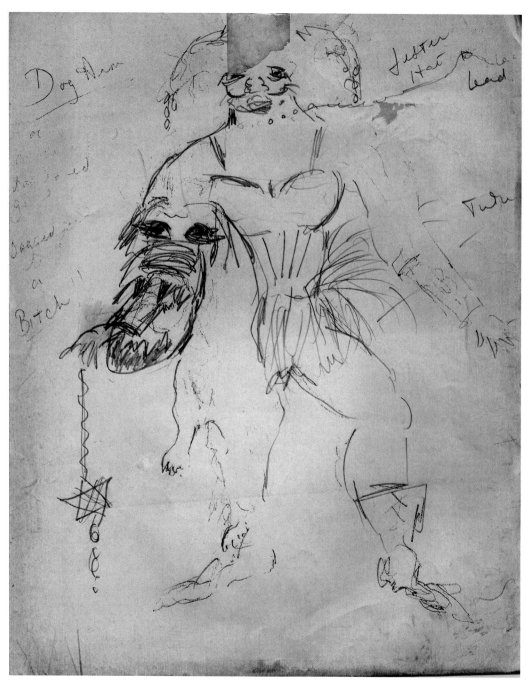

44 *Les Diables*

45 *Les Diables/The Life Class* (drawings by Jacky Lansley)

We also explored the central character, the Firebird, who is magical and distant, paradoxically quite cold and unattainable. Who is she? What is that? We decided that all the demons had some aspect of the Firebird within them, like Vincent's character, Skull, who wore a decaying pink tutu under his mack and made gestures which flickered like fire. As an experienced actor who had throughout his career primarily worked on text-based theatre, Vincent found the processes of our research very liberating; in a recent interview with me in which he was reflecting back on our work, he said:

> The memory that sits with me most vividly is that the work we have done together is very
> releasing in an imaginative sense – my imagination is kept charged and is not confined to
> a piece of paper with dialogue that you have to find a shape to – where you have to express
> yourself in a very literary way. In the work with you I found a much more instinctive line to
> producing a performance and I have continued to use these processes in other work; I think
> something that you instinctively know resonates for you and strikes a chord, you hold on to.
> Usually that is to do with a product and how it resonates with an audience, but in this case it
> was about how it resonated with me personally, because I found it was a personal expression
> of me, rather than me interpreting – it was something else; so in that sense I felt released. I
> felt like it was a genuine process of creating something and my imagination was allowed to
> run free and not be confined by a play, that is a script, that is a piece of literature… for me it
> was opening another series of doors of perception.[34]

The composer Michael Finnissy,[35] who had also been part of the early creative hub at the London School of Contemporary Dance and was by this point a well-established contemporary composer, worked on the project with us. Michael deconstructed and reworked the original Stravinsky score in a way which enriched the whole project; he writes of his work on the project:

> Stravinsky's music for *The Firebird*, like most of his early work, stems primarily from Russian folklore, or folk-song, and the more fantastical (or magical) inspirations of his teacher Nicolai Rimsky-Korsakov. In reworking, analysing, de-constructing and re-assembling I have used material from the 'Khorovod (roundelay) of the Princesses', Russian folksongs from Tchaikovsky's Collection (and arrangement) of fifty and a harmonic-sequence from the 2nd scene of Rimsky's opera *Kaschey the Deathless*. I have preserved both the rhythm and phrase-structure of the original, and tried to preserve its serene character, while nonetheless darkening the tone colour and 're-upholstering' the harmony, perhaps rendering it slightly less predictable.[36]

BIRD (2001)

Through two major R&D projects supported by the University of North London, Chisenhale Dance Space and the Arts Council, the company and I had collected a large amount of material and after a series of public sharings this material converged into another dance play titled *Bird*. The piece was presented at the Southbank Centre in London with a cast of professionals and third year students from King Alfred's College, Winchester (where I lectured at the time). Following are the programme notes I wrote for the first performances of *Bird*:

Bird – Notes from a Journey

Throughout my career I have been researching and experimenting with a form that attempts to bring together movement and voice, dance and acting, both literally within the practice and symbolically and psychologically, as I work with ideas such as the speaking body and the speaking dancer. The journey has not been neat, and has been determined by what resources have been available to me as an artist working within a hybrid area that is intent on blurring boundaries. When a stable studio environment is not available, nor the possibility of working continuously and organically with a company of performers, the physical language can become rough, pedestrian, fragmented and collaged but, as many choreographers of my generation have found, this can be interesting; particularly for dance which seems then to join the rest of society in this non-perfect state.

As a practitioner and teacher I have been interested in the ideas and practices which support this image of the total performer, the actor dancer. My research led me to Vsevolod Meyerhold,[37] the great Russian theatre director who inspired so much theatre in the twentieth century. His work revolved around the physical actor, and in support of this he developed his practice of Biomechanics, a physical training for actors. As someone who has worked across the boundaries of artistic disciplines, I was fascinated to discover that Meyerhold had worked with the choreographer Michel Fokine at the Maryinsky Theatre on his production of Gluck's opera *Orpheus* in 1911. Meyerhold also performed in Fokine's ballet *Carnaval* (1910) as Pierrot. They also both worked with the designer Alexander Golovine, and one can assume that they influenced and inspired each other. Fokine believed that creators of ballets should always endeavour to seek

out a form of dance language that best expresses the meaning. He believed in the expressive dancer and decried, even then, an overly gymnastic technique which allowed no room for expression.

It was Meyerhold who really developed this discussion concerning music drama and the rhythmic performance further. He believed that the actor must translate the musical picture into plastic form, and should therefore have a trained and disciplined body; he understood that visible and comprehensible action embodied by the actor implies choreographic action, and was conveyed through rhythmical progression not narrative progression; it was beyond story and plot, even beyond the action and the fragments which make up a show. It is therefore Fokine's concern with the dramatic and grotesque dancer and his interesting convergence with Meyerhold that drew me to his ballet, *The Firebird*, as a strong reference point for *Bird*. The ballet offered a starting point from which to go further back into the folk stories which informed the ballet's scenario and Stravinsky's score for the ballet; and further forward into a dialogue with contemporary themes. As Bird says, 'we borrow, re-use, invent…'[38]

Dance within the play is used as a metaphor for life; a life that seeks fire in order to be liberated from a frozen and sterile place. 'The Chorus', Bird's students of life, have been inspired by the traditional interlocking Russian dolls, which become more and more internal. The doll in many stories is a symbol of the inner life, a small and glowing facsimile of the original self. The creative team all found that the underlying sources were far more interesting than the rather neo-national symbolism of the actual ballet *The Firebird*, which had become, as a subject, a clichéd part of a Russian pre-packaged dream world. We also looked towards the radical futurist and constructivist art and theatre design that was happening at that moment in Europe and pre-revolutionary Russia, a culture that Meyerhold was central to. Nina Ayres's[39] bizarre and constructivist costumes reflect the period's obsession with new technology and industrialisation, juxtaposed with the archetypal 'little man' in a dilapidated suit. It is interesting that the original intention of *The Firebird*'s collaborators was to create a Skaska (Russian children's story) for grown ups.[40] I hope *Bird* is that.

The actress Sonia Ritter[41] played the role of Bird; she, like Kathryn Pogson[42] who played Bird in a subsequent film I made, called *The Life Class*, had a real gift for physical character and created an extraordinary, sardonic persona: 'Bird herself is the actress Sonia Ritter, rigged out in aviator suit and parachute pack but playing the part of an imperious ballet instructor, complete with gnomic philosophy delivered in a thick Russian accent'.[43]

Following is a quote from scene 3 in the script where Bird speaks to the audience:

Bird: I tell my students… my girls, that there are two kinds of tension – the kind that makes it impossible to function, and the kind that gets you up in the morning. This kind of tension is important. I am Bird. I used to be a prima ballerina now I dance in the street or in bars and tearooms with my friends and students. We make shows using whatever is available – we borrow, re-use, invent… we make shows out of thin air.[44]

The Chorus were six waiters in black suits carrying white table napkins; they were also Bird's students. As a mischievous band they framed and supported the actions of the central characters while serving drinks, rearranging their clothes, doing ballet bar, wiping the sweat off and massaging each other…

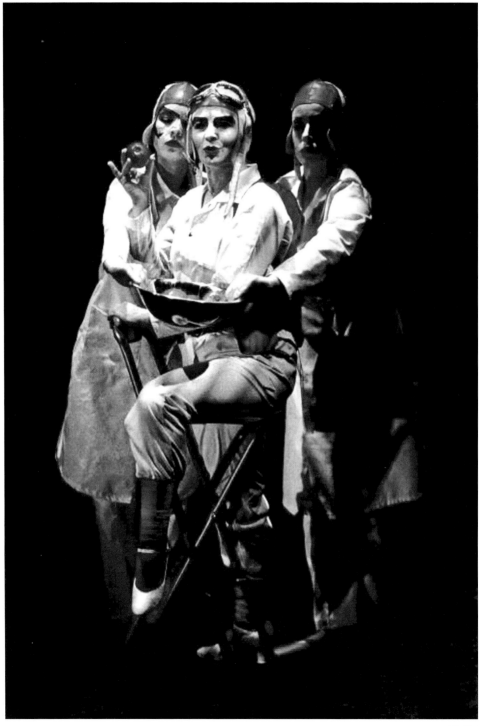

46 *Bird*

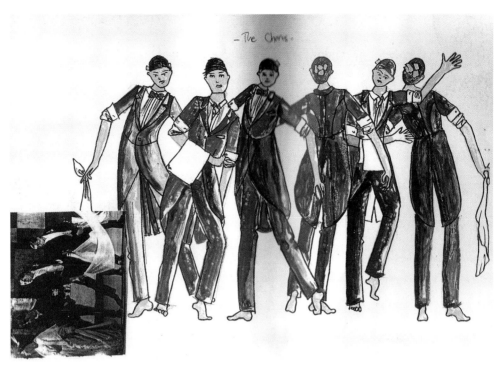

47 *Bird* (costume design for The Chorus)

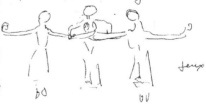

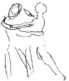

48, 49 (drawings by Jacky Lansley)

Following is a further review extract by the critic Jenny Gilbert in *The Independent on Sunday:*

The show is also sufficiently strange and wondrous to suggest – in a modest way – the true originality of its distant model. Better still, it's amusing and beautifully performed […] But this isn't a reworking of a classic in the manner of Matthew Bourne.[45] It's a collage of glancing fragments and scraps that add up to more than their sum. Interspersed in the fractured narrative are visual references to many other Diaghilev ballets (and I am sure there were more than I spotted) including the mirror image lesbians from *Jeux*, the performed posturing of *Spectre de la Rose* and the pyramid of tilted heads from *Les Noces*, as well as the tumultuous stamping climax from *The Firebird*.[46]

THE LIFE CLASS (2005)

After *Bird* I wrote a short film script, *The Life Class*, which explored many of the same themes and in 2005 I eventually made the film. The transition of the material into film was liberating and removed the process even further from the original ballet. The actor Vincent Ebrahim, who had worked with me on the early *Les Diables* R&D projects, played a leading role and contributed an enormous amount to the process. The plot of the film had already crystallised into an archetypal story about a small, dilapidated Chaplinesque character challenging a corporate culture – in our story represented by a huge pharmaceutical company who wouldn't allow their employees to engage in any 'alternative' activities – especially dance. Our protagonist, called Vaslav, after the great Nijinsky, loves to dance, but is prevented from doing so by his employers until he rebels…

The photographer Hugo Glendinning has a studio next door to mine in Shoreditch, London and over the years has taken many beautiful photographs of my live work. In 2003 I gave him the script of *The Life Class* and he responded very positively – its heightened imagery and episodic form, that included very little dialogue (I have since learned that even 'a little' dialogue can be too much in a film), appealed to him and I was delighted when he agreed to work on the project with me. Hugo and I discussed many possible locations and finally decided that we would use the studio as a central metaphor – and that our own studios, with surrounding stairways, corridors, basement, car park and entrances, would offer enough opportunities for transformation, while suggesting the idea of containment in another world.

I had introduced into the script a dog called Wolf embodied by a brilliant dog actor called Poco. Wolf was Bird's dog and symbolised the archetypal wild. As part of my research I found myself drawn to images of the great performance artist Joseph Beuys[47] (whom I had worked alongside with Limited Dance Company as part of Edinburgh Arts 74) and his action *I Like America and America Likes Me* (1974), in which he spent three days living in a gallery space with a coyote. The coyote is sacred to Native Americans, and represented an aspect of the country's past that Beuys was honouring. Each day of the action, he made two piles with the daily newspaper *The Wall Street Journal*. These would be duly torn or urinated on by the coyote.

Bird was played by the actress Kathryn Pogson – an outstanding classical actress who loves dance and movement – with whom I had first worked on *The Lucky Chance* by Aphra Behn,[48] directed by Jules Wright[49] at the Royal Court Theatre in 1985. Bird is a dance teacher and Vaslav wants to attend her class, a class in which symbolic eggs and apples are thrown about, quoting from the ballet's imagery and the folk stories which inspired it. Bird is a kind of Baba Yaga character, an older wise woman who has a

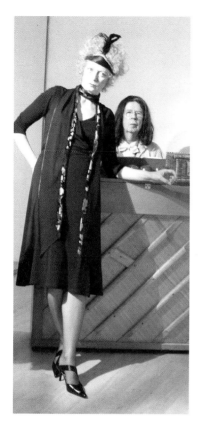
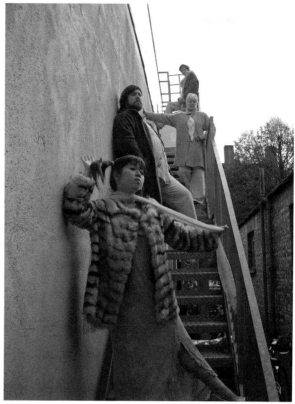

50, 51 *The Life Class*

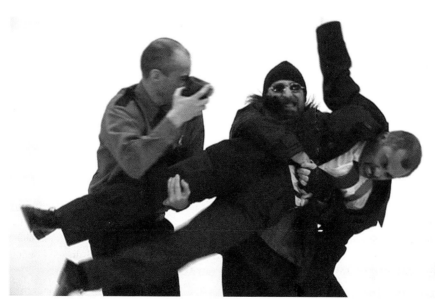

52 *The Life Class*

53 *The Life Class* (location: Dance Research Studio)

wild wolf as a pet. Wolf mysteriously keeps tabs on everything, including the surveillance officers who spy on Vaslav and follow him to the studio from the corporate office. There are underlying themes in the film about the relationship and differences between live performance and film, about power and oppression and about the surveyor and the surveyed. The camera is used as a scrutinising gaze, spying on the interiority and invisibility of the creative dance hub. In one episode we watch the security guard watching his monitors and seeing Vaslav subversively dancing in his office and running off to join Bird's class.

It was very challenging and rewarding to make two short films out of *The Firebird* research process. The first was a documentary film of the *Les Diables* R&D titled *Through the Fire*, filmed during our residency at the University of North London (1998); the second was *The Life Class* (over the last decade I have made several more short creative and documentary films). Working on these films honed my editorial skills and my work with performers within the medium of film. It is also satisfying to have creative material that exists outside of oneself in a permanent form. It is something one can return to with changing eyes and perception over the years – and with affection for the flaws one sees.

There has been a fair amount of academic focus on the very early modern ballets by Vaslav Nijinsky, Bronislava Nijinska[50] and Michel Fokine – and a considerable number of reworkings of these ballets by contemporary artists. The brilliance of Bronislava Nijinska's *Les Noces* (1923) deserves this attention – it is a work that cleverly synthesises the social, cultural and historical context from which it emerged; it manages to fuse a modernist minimalism with theatrical narrative in a way that almost no other live performance work has achieved through the last century. My own motivation to investigate these early works came from a desire to understand them better. They were, after all, produced in an extraordinarily innovative period when different art forms and artists were working together as part of a modernist cultural zeitgeist.

As a young student and ballet dancer, my fellow students and I were seldom given the background historical and artistic information about the ballets we performed. It was somehow just

54 *The Life Class*

assumed that it was all embedded in the technique. I think that part of my revisiting these early works came from a need to fill in the gaps – and to understand that successive radical cultural movements, through the various art forms, are linked and share common ground. This process of re-entering ballet from a different perspective, therefore, was part of both an artistic and personal journey. However, I do believe there are tricky and complex issues to navigate when embarking on a postmodern deconstruction – which may parody, reinvent and quote its antecedent. The process itself can revitalise and make attractive the very thing that it is questioning and deconstructing and as I write this book I am thankful, in a way, that I am no longer interested or needing to revisit the ballet canon. This investigation of ballets in my early works was a crucial and important part of my own development as a choreographic artist – but I felt liberated when I understood that I no longer wanted to look back there. The process of making *The Life Class* somehow took me beyond narrative (again) and towards movement and form. It was as though the metaphors of wildness and simplicity within its story really did nurture a desire for those things – which my next work *Holding Space* (2004) endeavoured to explore.

In each of the following five chapters I reflect on a single work (apart from Chapter 5, which looks at two works, *View from the Shore* and *Anamule Dance* [both 2007], which were performed as part of the same programme). I developed all these works, each taking between one and three years, at my base, the Dance Research Studio in London, over the period 2003–12.

Notes
1. Chisenhale Dance Space: established in 1981 in an old veneer factory in East London by members of the X6 Collective and others. Chisenhale continues to be an artist-run dance studio and performance space offering project support for body-based work of all kinds and a wide range of community and professional classes and workshops.

2. Fergus Early and Jacky Lansley: extract from programme notes for *I, Giselle* (1980). Courtesy of the artists.

3. Vida L. Midgelow: 'Reworking the Ballet – (En) Countering the Canon', in *Reworking the Ballet – Counter-Narratives and Alternative Bodies* (London: Routledge, 2007), 9–35 (16).

4. Lynn MacRitchie: 'I, Giselle' (Review), *Performance Magazine*, No.8, November/December issue (London: *Performance Magazine*, 1980), 10-11 (10).

5. chris cheek (sic): 'A leap in the dark: Breaking Out' (Review of *I, Giselle*), *The Guardian*, January 16th, 1982.

6. Dada (Dadaism): art movement of the European avant-garde in the early twentieth century. Dada in Zurich, Switzerland, began in 1916 at Cabaret Voltaire, spreading to Berlin shortly thereafter. The term anti-art, a precursor to Dada, was coined by Marcel Duchamp around 1913 when he created his first readymades. Dada, in addition to being anti-war, had political affinities with the radical left.

7. Hetty King (1883–1972): English music hall performer whose career spanned the two world wars; she often appeared as a soldier or sailor and her male impersonator act was known as the 'Swell'.

8. Vesta Tilley (1864–1952): English music hall performer who became one of the most famous male impersonators of her era. A star in both Britain and the USA for over 30 years her popularity reached its all-time high during World War I when she performed characters like 'Tommy in the Trench' and 'Jack Tar Home from Sea'.

9. Jacky Lansley: 'Interview with Jacky Lansley' (interviewer Andy Solway), *New Dance Magazine*, No.39 (London: X6 Dance Space, 1987).

10. Sylvia Hallett: composer, improviser and teacher. She has played in many international festivals since the late 1970s, working with musicians Lol Coxhill, Maggie Nicols, Phil Minton, Evan Parker, David Toop and the groups Arc, the London Improvisers Orchestra and the London Hardingfelelag. She also performs solo and in duos with Clive Bell, Mike Adcock and Anna Homler. Dance projects include collaborations with h2dance, Miranda Tufnell, Emilyn Claid and Eva Karczag. Other projects with Lansley include *Mirror Mirror* (1981) and *About Us* (2016/17). Sylvia has released three solo CDs including *White Fog* (2001), featuring the bowed bicycle wheel.

11. Vincent Meehan: dancer, actor, cabaret artist and Alexander Technique teacher; has lived and worked in both the UK and the USA and was a founder member of the gay theatre group the Bloolips. He worked on several other projects with Lansley at X6 Dance Space in the 1970s, including *Dancing Ledge* and a duet *Dance and Politics* (both 1977), as well as performing in her work *The Impersonators* (1982) at the Drill Hall.

12. Betsy Gregory: Born in the USA, she came to London in 1972 to train at the London Contemporary Dance School and has worked in the UK dance sector for 40 years. As a performer she also worked extensively with the Ian Spink Group and was a founder member of Second Stride. After studying arts administration she became Associate Director at The Place and later joined Dance Umbrella where, in 2007, she succeeded Val Bourne as Artistic Director.

13. Marie Lloyd (1870–1922): English music hall singer, comedian and musical theatre actress. Known for her performances of songs such as 'The Boy I Love Is Up in the Gallery' (1885) and 'My Old Man (Said Follow the Van)' (1919) and for her use of innuendo and double entendre. She was affectionately called the 'Queen of the Music Hall'.

14. 'As I Take My Morning Promenade' (1910): music hall song written and composed by A. J. Mills and Bennett Scott. Performed by Marie Lloyd.

15. Steinvor Palsson: Icelandic dancer and choreographer based in Edinburgh. Performance work includes Spiral Dance Company (where she worked with Lansley on *Impersonations* [1981]), Tango Tiempo, the Imminent Dancers Group, Giselle Enterprises (on Lansley's *A Child's Play*), Company Chordelia and Scottish Opera. Her extensive choreographic credits include collaborations with Matthew Hawkins. Steinvor works for Scottish Opera's Outreach Department as Movement Specialist for the Alzheimer's Scotland Project in Dundee, and teaches at Dance Base, Dance House and the Royal Conservatoire of Scotland.

16. Dartington Dance Festival: annual festival at the Dartington College of the Arts in the late 1970s and early 1980s, which provided a platform for independent experimental dance work from the UK, the USA and Europe. It was initiated and organised by the US dancer, choreographer and teacher Mary O'Donnell Fulkerson, who is credited as the founder of Release Technique (and with whom Lansley made and performed a duet *Night Falls* in 1985).

17. Libya crisis: on 15 April 1986, President Ronald Reagan authorised the US bombing of Libya, code-named Operation El Dorado Canyon. The air strikes were carried out by the US Air Force, Navy and Marine Corps in response to the 1986 Berlin discotheque bombing. The target of the attack – Muammar Gaddafi – was not among the many reported Libyan casualties.

18. Gale Burns: poet; studied at Cambridge University and Dartington College of Arts; early member of Chisenhale Dance Collective. He is writer in residence in London at both Sydenham Arts Festival and Kingston University, teaching MA and MFA creative writing students. He convenes the Shuffle poetry series in London, and was a 2012 Hawthornden Fellow. His poetry is widely published.

19. William Shakespeare (1564–1616): extract from *Richard II*, Act 1, Scene 1.

20. Extempory Dance Company (1975–91): founded by a group of graduates from the London School of Contemporary Dance (LSCD). In 1981 Emilyn Claid was appointed Artistic Director (after Paul Taras). The company commissioned many new works, including *Speaking Part* (1982) by Lansley for the dancer Corrine Bougaard.

21. New Midlands Dance Company: UK regional dance company which pioneered work in prisons, hospitals and schools working often with disabled children and adults. The company commissioned many choreographers, including Lansley, who made *Frank* (1987) for the dance practitioner Tim Rubidge, which explored an archetypal 1980s businessman who takes his shoes off and dances.

22. Spiral Dance Company: UK regional dance company based in Liverpool in the 1970s and 1980s founded by the dancer and choreographer Irene Dilks. Choreographer Tim Lamford became artistic director in 1981 and in the same year commissioned Lansley to make an interdisciplinary work, *Impersonations*, which explored male and female impersonators from Victorian music hall and the tradition of the standalone act.

23. English Dance Theatre (1980–89): UK regional dance company based in Newcastle at Dance City. Lansley was Artistic Director (1987–89), and renamed the company English New Dance Theatre. While with the company she made *The Queue* (1989), collaborating with composer Ilona Sekacz and designer Moggie Douglas. Performers were Tim Rubidge (then Artist in Residence), Mary Steadman, Bruno Roubicek, Nigel Warrack, Pearl Jordan and Martha Stylianou.

24. Jacky Lansley: Extract from the script of *Do My Shoes Reflect the Quality of My Intellect?* (1998–99). Courtesy of the artist.

25. Jacques Derrida (1930–2004): French philosopher, born in Algeria. Derrida is best known for developing a form of semiotic analysis known as deconstruction, which he discussed in numerous texts including '*Of Grammatology*' (1967) and '*Writing and Difference*' (1967). He is one of the major figures associated with post-structuralism and postmodern philosophy.

26. Michel Fokine (1880–1942): Russian choreographer who aspired to move beyond stereotypical ballet traditions; he was resident choreographer for Diaghilev's Ballet Russes from 1909 to 1912, where he created such seminal works as *Petrushka* (1911), *Le Spectre de la Rose* (1911) *The Firebird* (1910) and *Les Sylphides* (1908). He later moved to Sweden and then the USA, choreographing for many companies.

27. Igor Stravinsky (1882–1971): Russian (and later, naturalised French and American) composer, pianist and conductor. He first achieved international fame with three ballets commissioned by the impresario Sergei Diaghilev and first performed in Paris by Diaghilev's Ballets Russes: *The Firebird*, *Petrushka* and *The Rite of Spring* (1913). His Russian phase continued with works such as *Renard* (1916), *The Soldier's Tale* (1918) and *Les Noces* (1923). In the 1920s he turned to neoclassical music with works tending to make use of traditional forms. In the 1950s his compositions shared traits with his earlier output: rhythmic energy and the construction of extended melodic ideas out of two or three note cells.

28. Vincent Ebrahim: South African actor who, after immigrating to the UK in 1976, worked in community theatre with companies such as Common Stock and Joint Stock and later with Tara Arts. He has done productions with the National Theatre and the Royal Shakespeare Company and worked extensively for radio and TV, including *The Kumars at No. 42*, *Hollyoaks* and other well-known series. In 2013 he appeared in the South African feature film *Material* for which he won a Safta award.

29. Luke Burrough: dancer and teacher who worked with Green Candle Dance Company, Retina, Jacky Lansley and Turning Worlds dance companies before joining the Jasmin Vardimon Company in 1997. He continues to work with Vardimon and has been involved with the creation of many of the company's productions and education programmes.

30. Clarissa Pinkola Estes: 'Nosing Out the Facts: The Retrieval of Intuition as Initiation', in *Women Who Run with the Wolves* (London, Sydney, Auckland and Johannesburg: Rider, 1992), 74–114 (77).

31. Vaslav Nijinsky (1890–1951): principal dancer with Diaghilev's Ballets Russes and pioneering choreographer of works such as *L'Apres-Midi d'un Faune* (1912) and *The Rite of Spring* (1913).

32. *L'Apres-Midi d'un Faune:* choreographed by Vaslav Nijinsky for the Ballets Russes and first performed in the Théâtre du Châtelet in Paris with Nijinsky performing the main role. Both the music – *Prélude à l'après-midi d'un faune* by Claude Debussy – and the ballet were inspired by the poem 'L'Après-midi d'un faune' by Stéphane Mallarmé. The costumes and sets were designed by the painter Léon Bakst.

33. Serge Diaghilev (1872 –1929): Russian art critic, patron, ballet impresario and founder of the Ballets Russes. The company included Anna Pavlova, Adolph Bolm, Vaslav Nijinsky, Tamara Karsavina and Vera Karalli. He commissioned modernist composers and designers including Igor Stravinsky and Pablo Picasso.

34. Extract from an interview with Vincent Ebrahim (interviewer Lansley) in the summer of 2015 at the Dance Research Studio. The interview covered a wide range of experiences from the actor's work in film, television and theatre, including an in-depth discussion about his work with Lansley on *Les Diables* and *The Life Class*.

35. Michael Finnissy: contemporary composer who was part of a radical group of artists working from LSCD in the early 1970s. Works such as *Shameful Vice* (1994) and *Seventeen Immortal Homosexual Poets* (1997) reflect his engagement with political and social themes. Finnissy has taught at the Royal Academy of Music, the University of Sussex, and is currently Professor of Composition at the University of Southampton.

36. Michael Finnissy: extract from a letter to Lansley about the *Les Diables* music R&D (1998). Courtesy of the author.

37. Vsevolod Meyerhold: radical Russian theatre director whose concepts were elaborated on in his book *On Theatre* in 1913. He founded the Meyerhold Theatre in 1920 which existed until 1938. He collaborated with prominent writers such as Mayakovsky (*The Bedbug*, 1929) and inspired early film-makers such as Sergei Eisenstein. He developed the system of Biomechanics – a physical training for actors which focused on gestures and movements as a way of expressing emotion physically. He was arrested and executed in 1940 during the Stalin regime which repressed all avant-garde art and experimentation.

38. Extract from the script of *Bird*, Scene 3, written by Jacky Lansley (2001). Courtesy of the artist.

39. Nina Ayres: theatre designer and creator of props, costumes and puppets. She has worked on a wide range of film, television and theatre productions both in the UK and abroad. She has also worked in large and small-scale community settings and has had a long-term relationship with Green Candle Dance Company (*forWard motion*, 2000; *Mina's Story*, 2002; *Jack Be Nimble*, 2004; *Falling About*, 2009).

40. Extract from the programme notes for *Bird*, by Jacky Lansley (2001). Courtesy of the artist.

41. Sonia Ritter: actress, known for her work in *Titus Andronicus* (RSC, 1988), *Oscar and Lucinda* (1997), *Touched* (1998) and *Sylvia* (2003). She is a founder member of the Lions Part and has coordinated their seasonal theatre-based festivals October Plenty and Twelfth Night on Bankside, for which she adapts and directs early modern playscripts. Sonia also lectures at Coventry, St Mary's London, Birmingham and East 15 (Essex) Universities.

42. Kathryn Pogson: TV, stage and film actress, known for *Brazil* (1985), *The Company of Wolves* (1984) and *Millions* (2004). She has worked extensively with the RSC, the Globe, the Old Vic and other major UK theatres in leading roles. She also worked with the Women's Playhouse Trust, including *The Lucky Chance* (1984) with Lansley as choreographer. She is a guest teacher at the London Dramatic Academy.

43. Jenny Gilbert: 'There's Weird and Wondrous Life in the Old Girl Yet' (review of *Bird*), *The Independent on Sunday*, March, 2001, 6.

44. Extract from the script of *Bird*, Scene 3, by Jacky Lansley (2001). Courtesy of the artist.

45. Matthew Bourne: British choreographer, theatre director and dancer. Artistic Director of Adventures in Motion Pictures (1987–2002) and now Artistic Director of New Adventures which he launched in 2002. Both companies have toured his works internationally, including *Swan Lake* (2004), *The Car Man* (2007), and *Play Without Words* (2002).

46. Jenny Gilbert, 'There's Weird and Wondrous Life in the Old Girl Yet' (review of *Bird*), *The Independent on Sunday*, March 2001, 6.

47. Joseph Beuys (1921–1986): German performance artist, sculptor, installation artist, graphic artist, art theorist and pedagogue of art. His extensive work is grounded in concepts of humanism and social philosophy and culminates in his 'extended definition of art' for which he claimed a creative,

participatory role in shaping society and politics. His career was characterised by passionate, even acrimonious public debate. He is now regarded as one of the most influential artists of the second half of the twentieth century.

48. Aphra Behn (1640–1689): British playwright, poet, translator and fiction writer from the Restoration era. As one of the first English women to earn her living by her writing, she broke cultural and gender barriers and served as a literary role model for later generations of women authors.

49. Jules Wright (1948–2015): Australian theatre director and art curator who came to the UK in 1975. She directed her first main stage production at the Theatre Royal, Stratford East and in 1979 was appointed Resident Director at the Royal Court Theatre, and soon after became Artistic Director of the Theatre Upstairs and Associate Director of the Royal Court. With others she created the Women's Playhouse Trust with the aim of establishing a mainstream theatre for women's work. Lansley worked with her as a choreographer on *The Lucky Chance* (1984), *Beauty and the Beast* (1985), *Beside Herself* (1990) and *Miss Julie* (1986). Jules launched the Wapping Project in 1993 – a unique urban venue for visual and performing arts.

50. Bronislava Nijinska (1891–1972): Polish dancer, choreographer, teacher (and sister of Vaslav Nijinsky) who played a leading role in the pioneering movement which turned against classicism. Her choreography includes *Les Noces*, *Les Biches* (1924), *Le Train Bleu* (1924) and *Bolero* (1928) for the Ida Rubenstein Company. Her students included the ballerinas Maria and Marjorie Tallchief and the dancer/actress Cyd Charisse.

4

HOLDING SPACE

55 *Holding Space*

Drawing on my previous experience of finding and managing independent dance spaces, in 2002 I created another home in a space which I call the Dance Research Studio[1] and it has been interesting, since moving in, to observe the changes in my working process and approach to form. I am no longer struggling as a peripatetic artist to constantly adapt to the demands of the locations in which I find myself, whether theatre, school, university, gallery, hired studio, outdoor location, regional dance company, film set, etc. This diversity of location gave me a discipline regarding site-specific work, but also an enforced eclecticism as I worked to survive as a choreographer and performance artist without a studio base. When I moved to the Dance Research Studio it gave me the opportunity to explore movement and form in a deeper way and a group of outstanding performers and collaborators gathered around the work. Everything now takes a long time – often two to three years to complete a project. I don't believe this is the only way to work and my process is changing again, but for a long while the concept of *no rush* has been very important.

Working with space is a primary process in my choreographic practice and within this process every space we work in becomes site-specific. The viewer is not only looking at, empathising with, or perhaps idealising the performer as the central concern of the performance; they are also looking at space – the space the figure is in relationship to and therefore, the space they themselves are occupying. *Holding Space* (2004), which explored these ideas, was constructed as a series of episodes which I called 'chapters' to emphasise the idea of language making and the discreteness of each part within the piece. As I mention at the beginning of the book, I have attempted to describe these 'chapters' through a form I call 'Writing Choreography', which uses present time to describe and reflect on the visceral reality of the live choreographic work.

Chapter 1: PARALLAX – the apparent displacement or difference of position, of an object, as seen from two different stations or points of view.

Music: Schubert, 1st Allegro – Sonata in C minor.

[The Copernican model – created by the astronomer Nicolaus Copernicus – completely reconfigured our perception of the universe by placing the sun, not the earth, at the centre of the solar system – a model called the Heliocentric System which was published in 1543. This major paradigm shift, which was not fully embraced until 100 years after Copernicus's death, fuelled the Enlightenment and was a major catalyst in the flowering of modern philosophy, art and science. The Freudian revolution emphasised the importance of this question of place, in which man assigns himself at the centre of the universe and it is not surprising that choreographers are interested in exploring questions concerning space, perception and subjectivity.]

The dancers move across the canvas in a straight path in profile to the viewer. They stride across the space in a kind of marching image, locked into the bold chords of Schubert's music. The dancers wear simple white streamlined clothes suggestive of everyday, yet abstracted. In this first movement there is a neutrality of purpose and focus – the dancers vibrantly create the moving picture while being totally embedded within it. The journey is carefully constructed in the frame of the space; the purpose of this first movement is to create a visual and aesthetic discipline for the viewer. All is line and angle. The spatial relationships between each dancer and between the piano, the pianist and the dancers are carefully made

and placed. There are dancers standing (waiting) on the edge of the frame – which is part of the visual field. All is geometric and in vertical, saggital, horizontal planes.

There is a sense of ritual to the movements. Small, mundane and everyday movements are made explicit, vital, through a borrowed classical style. This chapter establishes the language of the piece – an abstract minimalism – making it clear to the audience that they are going to have to use their imagination; they are not going to be entertained. The dancers are holding the space.[2]

Chapter 2: HER

Music: Schubert, Adagio – Sonata in C minor

The second chapter of *Holding Space* takes the form of two duets which at times become a quartet. The duets are performed by a younger and an older couple – suggesting a Mother and Daughter, a Son and Father or simply the same 'characters' at different stages in their lives. The women take centre stage – the narrative seems to be about them and the two men are in supportive roles. The abstraction of the first movement has created 'a room' for a more emotional, tender quality to enter the space. The younger woman puts on a long black velvet coat – the symbolic colour of grief and death. Tania Tempest-Hay,[3] who creates this role, explores the 'drama of the coat' – how it moves, its presence, texture, shape – and how these qualities affect her movement and her feelings. The coat becomes architectural as she creates tent-like structures within which she can hide. This concealing becomes a psychological metaphor – she hides her face. The young man, Gareth Farley,[4] approaches and quietly supports her – their duet works through a minimalist choreographic language towards emotionality.

The older woman, Sandra Conley,[5] puts on a small elegant black cardigan which has a slight period quality about it. These black garments create a shift towards narrative and permission for character and emotional content. Here there is equality – remembering too that Sandra has 20 years more experience than Tania – and the possibility of their different and parallel skills combining to create a dance artwork. Fergus Early, the older man, combines both the classical and contemporary experience within his performance, echoing the styles of both the women. Sandra and he are well matched and of the same generation and coming out of the same classical school. It is very moving to watch the wisdom in their bodies.

My process is often about framing everyday random moments in a way that holds the quality of their original contexts. In support of this I collect images, gestures, objects and words which the dancers and I can draw on to support the research and choreographic development. If I give a movement to a dance artist that has come from my personal experience, I need to support their exploration of how to inhabit that movement and make the material their own.

The elbow is dropped into the cup of a hand…

I am interested in how the delicacy, harmony and grotesque qualities of everyday gestures can be synthesised into something of meaning and eloquence; and to explore how the small and seemingly insignificant is important, particularly against a backdrop of complex global concerns.

An arm circles the head over a curved body…

This is a gesture I gave the performers. It was and is a movement that I consistently return to – I have tried to understand where it comes from and the most likely source is that it is a protective gesture. Somewhere I harbour a feeling about needing to protect my head.

> Tania creates a V shape with her arms – the elbows are touching and her forearms thrust forward – hands facing upwards as though asking for something…

This gesture is a reference to the choreography of the historical ballet *Mars and Venus* created by the eighteenth-century ballet master John Weaver[6] and reconstructed by Mary Skeaping[7] for 'Ballet for All' in 1969.[8] I re-created the role of Venus and have never forgotten the powerful feeling of embodying this gesture as a challenge to Mars. It is an angry gesture, almost contortionist in the effort to place both elbows together which gives it its dramatic power. It is an exquisite architectural shape which holds the space in its angles.

> Chapter 3: LACUNA – meaning an empty space or missing part, especially in an ancient manuscript; a gap, a cavity or deep depression.

> The performers transform, donning hats – taking the lead from Sandra Conley who uses the actual mirror of the Clore Studio to study her hat. The Lacuna is silent – a breathing space in which the ensemble follow Sandra, who walks around the space exploring the impact of her hat. The others seem to follow her, asking for a clue about what they are doing; she reluctantly leads. There are hints of storytelling here.

> Chapter 4: STUDIO-US

Music: Schubert, Allegro – Sonata in A major

> The performers travel through different episodes constantly moving. Once the allegro movement starts it never stops and has a cumulative and relentless quality. A central image in this movement is of dancers reading books – in duets, quartets, solos – as a metaphor for the thinking dancer, the researching dancer, the speaking dancer. It is a playful, satirical image which contradicts stereotypical images of dancers as people without minds. The audience does not know what they are reading, but there is study of some kind going on as part of an intricate dance language that uses ballroom, court dance, ballet, contact improvisation, the odd circus trick, running, leaping, standing still and partnering. The dancers seem to be searching for answers to questions – this questing repeatedly transforms into a chorus line as the six performers walk forward towards the audience with quizzical looks, their arms outstretched, shoulders hunched; they stand arms folded, perhaps a finger on the chin contemplating their viewers as if to ask 'Who are you?' 'What are we all doing here?'

The Clore Studio is only a 200-seater which allows for an intimacy between the audience and the work, but the performance space itself is rather huge and airy, which also allows for distance and perspective and the space to include, for example, the grand piano in an almost central position. It also provides 'off' spaces or 'rooms' where the dancers can visibly wait or change their clothes as part of the

56 *Holding Space*

process of holding and transforming the space. The stepping in and out of performance is important as it reminds the audience of the work and studiousness involved in what they are watching and of their own role as a 'studious' audience. At a particular celebratory moment within the allegro the curtains, which cover the full-length mirror at the back of the space, are drawn to reveal the whole audience watching themselves watching the piece. The simplicity of drawing the curtains is extremely powerful and reminds us how even the most familiar spaces have both unique and mundane features which can be exploited to good effect.

THE PERFORMERS

> Conley and Fergus Early are more reticent on the surface but also seem more complex underneath – as if their bodies contain, rather than display, the depth of their experience.[9]

At the time of making *Holding Space*, Sandra Conley was a principal character dancer with the Royal Ballet Company. Both Fergus and Sandra learnt their craft within the Royal Ballet at a time when emotional and character skill in performance was celebrated, a legacy from the great actor dancers of the first half of the twentieth century such as Robert Helpman, Leonide Massine, Anna Pavlova, Moira Shearer and Margot Fonteyn. The ballet dancer then seemed more of a rounded performer, whereas now the focus in ballet seems more on technical virtuosity, rather than performance skill. Sandra discussed how she had never performed in an intimate studio space before; that she had only performed for the large proscenium stage. The actual and metaphorical communication with the audience – the deliberate act of visiting them up-close – was, I believe, challenging for her and it was fascinating and exciting to watch her translate her enormous wealth of experience into the *Holding Space* material.

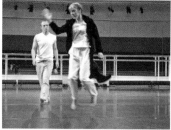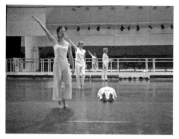

57, 58, 59 *Holding Space*

What do they see in each other? In themselves? The question remains unanswered,
but its implications flood the stage with thoughts and feelings about age and experience.[10]

In the adagio (Chapter 2: HER) Sandra danced with Tania Tempest-Hay. Tania is an experienced,
contemporary, Laban-trained dancer who infused the work with an abstract potential and quiet
intensity. She did not attempt 'character' work or storytelling as Sandra, Fergus, Gareth and Lucy Tuck[11]
did and yet she had a matching and powerful emotional presence which, drawing from my own
performance background, seems to be connected to a balance of energy and focus and a conceptual
understanding of the material one is performing. The fact that Tania was 'neutral' was at times
tremendously liberating to me as a choreographer: together we could explore the narrative within the
movement rather than the movement somehow serving the narrative; she was very at home in the
intimate studio environment and commanded the space.

Gareth Farley is an actor who knows how to inform movement with meaning and story while
holding the structural and choreographic form. He is not acting yet there is an emotional layer to his
work which is sometimes hard to achieve with dancers. Gareth has an instinctive sense and feeling for
movement and somehow (without very much training) he is a very good partner. He and Lucy Tuck,
who has a background in musical theatre, had previously worked together on several theatre productions
and brought this collaborative and other experience to the project. Lucy was enthralled at the idea of
participating in a 'pure' dance piece and the fact that she did integrate fully as a strong and refined
dancer able to strip away, when necessary, character, narrative and theatrical paraphernalia is remarkable.
She allowed the movement to speak and understood the importance of the visual frame. Both Gareth
and Lucy had also been involved in an earlier research project with me titled *Coats and Plays* (2003), in
which Gareth 'danced' on stilts. They brought a playful humour to *Holding Space* and a confident, actorly
presence.

> *Holding Space* does indeed seem to take some ordinary passers-by – a diverse group of
> people – and makes a dance for them, based on simple gestures and unprepossessing
> moves.[12]

Robin Eun-ha Jung[13] is from South Korea. After studying and performing in New Zealand she came to
London to develop her career as a dance artist and teacher. She was the only dancer that I had not
previously worked with and I invited her to join the project through a workshop audition process at the
Dance Research Studio. Robin had a strong athletic energy and brought a fresh exuberance to the work.
As the youngest member of the ensemble she integrated beautifully and with great discipline.

THE MUSIC

Schubert's last three piano sonatas did not appear in print until 1839, 11 years after his death, as publishers regarded them as too difficult, wanting more of his successful salon music. It was the rich complexity of themes within the three movements I selected from two of the sonatas which inspired *Holding Space*. The music provided an intriguing emotional world for the work, which allowed the choreography to inhabit a more abstract space. We placed the grand piano in the middle of the space and the pianist, Philip Gammon, became a central, rather than supporting, visible performer. At several moments the performers clustered around Philip, as though observing and listening to him – this proximity encouraged the idea of dialogue between the music and dance. At the time of making *Holding Space*, Philip was Principal Pianist with the Royal Ballet Company, having had an association with the RBC since the 1960s as both a soloist and conductor. I met him during my brief spell with the company in about 1969/70 and so it was delightful and interesting that we could work so well together after that much time. We went on to work together again in my film *The Life Class* (2005, see Chapter 3) in which Philip played music from Michel Fokine's 1911 ballet *The Firebird* as an eccentric rehearsal pianist, to great effect.

THE STUDIO

> When they're not participating in the central action, the dancers often simply walk around the edges of the studio.[14]

What does the studio mean, particularly within the context of the Royal Opera House (ROH)? ROH2,[15] with whom we co-produced *Holding Space*, was then the alternative wing of the ROH and following is their own description of their role:

> The ROH2 programme of work complements, without duplicating, the repertoire on the main stage; increases the range and diversity of the art and the artists presented at the Royal Opera House, attracting a more diverse audience; provides a 'laboratory' for the Royal Opera House and its art forms, encouraging creativity, collaboration and experiment.[16]

The use of the word laboratory is interesting as it suggests research, process, experiment – these are not approaches that we particularly associate with the ROH which, because of its institutional status, cannot often afford to take many risks. In 2004 the new ROH spaces, the Clore Studio and Linbury Theatre, had only recently opened and, under the artistic programming of Deborah Bull[17], it really did feel as if there was much good intention to forge external links and bring in experimental companies from outside. I, of course, had a history of working within the studio environment at X6 Dance Space, Chisenhale Dance Space the Dance Research Studio and numerous visits to independent studios across the UK, Europe and the USA. These spaces are not just about scale or being cogs in a hierarchical structure which ultimately serve the big stages. They are about an alternative ethos and practice; about different aesthetics, approaches and politics; and because of this they tend to constantly struggle with issues of funding and visibility. We attempted to bring this alternative ethos to the ROH and infuse its own studio space, the Clore Studio, with a genuine quality of investigation through the work's conceptual and formal languages. The audiences were challenged as the dancers stepped forward to ask the question, 'what are we doing here?'

Space seems like nothing and emptiness (and yet there is virtually no space on the planet that is not bought and sold). Having my own studio where impulses can be worked, mess can be made and collaborations can flourish has been revitalising and liberating. It has allowed me to trust the so-called insignificant and find inspiration in the nothing as well as the something. It has taken me a long time to find this space and I intend to hold on to it.

Notes

1. Dance Research Studio (DRS): founded in 2002 by Jacky Lansley to support her own choreographic practice; since then the studio has developed a community of associate artists and become an important part of the independent dance sector within the UK. It provides a wide range of professional development activities, including the Speaking Dancer: Interdisciplinary Performance Training (SDIPT); mentoring and residencies for intergenerational artists; and curating cross-disciplinary research projects such as *Crossing Paths* (2016) and *About Us* (2017).

2. All the 'chapter' sections in bold are a form of writing from memory which Lansley calls 'Writing Choreography' and which aim to get closer to the live work and the choreographic process. (See 'Inward', endnote 5).

3. Tania Tempest-Hay: Laban-trained dancer, choreographer and Pilates teacher. She formed Instep Dance Company which toured the UK and danced in Ireland for Dance Theatre of Ireland and Daghdha dance companies. She danced with Action Syndicate and Clare Baker in the UK and in Australia with Dean Walsh. She has created her own solo and duet work, including works with collaborator Roger Smith. She worked with Jacky Lansley on *Holding Space* and *View from the Shore* (2007).

4. Gareth Farley: actor and drama teacher; as a performer he has worked in many forms of theatre, including physical theatre, cabaret, children's theatre and street theatre in a wide variety of contexts. He has also worked with the Royal Shakespeare Company and on television for the BBC. Gareth now lives and works in South Korea as Head of Drama at North London Collegiate School, Jeju.

5. Sandra Conley: former ballet dancer and principal dancer with the Royal Ballet. She created many roles in ballets by Kenneth MacMillan, Antony Tudor, Frederick Ashton and John Neumeier. In her later career, she was a character artist with the Royal Ballet and performed roles such as the nurse in *Romeo and Juliet* and the Empress in *Mayerling*.

6. John Weaver (1673–1760): English dancer and choreographer who became a specialist in comic roles and created the first pantomime ballet, the burlesque *Tavern Bilkers* (1702). His work, *The Loves of Mars and Venus* (1717), dealt with themes from classical literature and required a significant amount of mime gestures to tell the story. He is considered a major influence on subsequent choreographers Jean-Georges Noverre and Gasparo Angiolin. His books include a translation of Raoul Auger Feuillet's *Orchesography* and *A Small Treatise of Time and Cadence in Dancing* (1706).

7. Mary Skeaping: dancer, choreographer and dance historian; she toured as a dancer with the companies of Anna Pavlova and Nemchinova-Dolin. She was ballet mistress for Sadler's Wells Ballet from 1948 to 1952 and director of the Royal Swedish Ballet in Stockholm in 1953–62, where she also re-created several early court ballets in the eighteenth-century theatre at Drottningholm. For the Royal Ballet's 'Ballet for All' she re-created the eighteenth-century ballet by John Weaver *The Loves of Mars and Venus* (1969).

8. 'Ballet for All': founded by Peter Brinson in 1964, 'Ballet for All' was an offshoot of the Royal Ballet Company which aimed to demonstrate, explain and interpret the principles and history of ballet to a wide audience across all parts of the UK. Featuring Royal Ballet dancers and freelance actors, the company developed a unique style of 'dance plays' that aimed to be both entertaining and educational.

9. Sanjoy Roy: '*Holding Space*' (Review), *Dance Now*, Autumn (London: Dance Books Ltd, 2004), 107–09 (108).

10. Sanjoy Roy, *Dance Now*, (108).

11. Lucy Tuck: actress and dancer; she has worked across mainstream, regional and fringe theatre, including female-fight company Broads with Swords, Travelling Light Theatre Company and the Royal Shakespeare Company. She joined Foursight Theatre in 2005 and collaboratively devised and performed in several of their productions. She relocated to Bristol where she has worked with the Bristol Old Vic and the Chocolate Factory. Works with Jacky Lansley include: *Coats and Plays* (2003), *Holding Space* (2004), *Crossing Paths R&D* (2016).

12. Sanjoy Roy, *Dance Now*, (109).

13. Robin Eun-ha Jung: Born in South Korea; studied Contemporary Dance at New Zealand School of Dance. She danced with Footnote Dance Company and appeared in various projects in Europe including *Holding Space* with Jacky Lansley, a commercial work by Liam Steel and *Faust* with Opera de Lille. She has guest lectured at: UNTEC (NZ), The Place (UK), and Korea National University of Arts and currently lectures on human consciousness and meditation. Robin is a graduate from the University of Canterbury with a degree in psychology and Japanese.

14. Sanjoy Roy, *Dance Now*, (109).

15. ROH2 (2001–12): Royal Opera House contemporary programming branch which developed out of the Artists' Development Initiative, established by Deborah Bull in 1999. Its aim was to include and develop the creativity of independent artists and small-scale companies within the ROH and share its resources. The programme included new commissions and productions, festivals, and associateships for individual artists and companies.

16. Extract from ROH2 marketing information included in the *Holding Space* programme, June 28th, 2004.

17. Deborah Bull: previously principal dancer with the Royal Ballet and Creative Director of the Royal Opera House. Since 1998 she has been a presenter and writer for a wide range of projects across television and radio. In 2012 she joined Kings College to direct its interdisciplinary collaborations within the cultural sector. She is the author of four books.

5

VIEW FROM THE SHORE

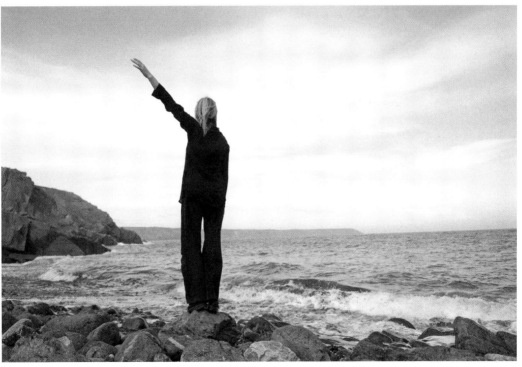

60 *View from the Shore*

In 2002 I started to spend nearly a quarter of my year in Cornwall as I had access to a more permanent base there after 30 years of being a tourist. Being able to witness the magnificent show of the sea, to breathe the Atlantic freshness and experience the wild weather, put me more in touch with the natural environment and continued to nurture my deeper relationship with movement. Somehow the nuances of postmodern culture become less relevant when in this Cornish environment; everything around one is so much older, so much beyond these discussions and one really does have to listen to the call of the wild. There is no doubt that an urban/rural dialogue has inspired the work I have been involved with in more recent years.

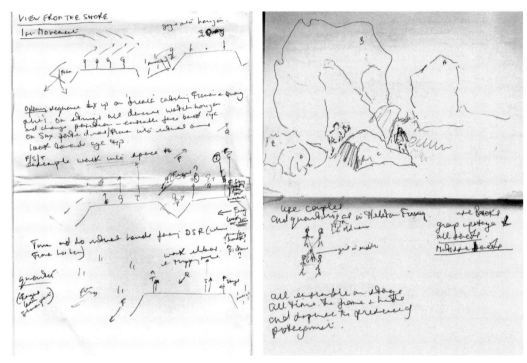

61, 62 *View from the Shore* (drawings by Jacky Lansley)

Once I decided to make *View from the Shore* (2007), the process happened slowly in phases throughout 2005–07. Early in 2006 I found an ally in Tim Brinkman, then the Director of the Hall for Cornwall in Truro, who suggested that we co-produced the project. Tim was very interested to promote dance, which under his direction had become the theatre's strongest strand of programming. There were several improvised sessions in the Cornish landscape, where the performers and I worked with the architecture of caves and rocks and memorably, in 2007, I invited Hugo Glendinning to photograph the dancers Fiona Chivers,[1] Tania Tempest-Hay and Fergus Early in the beautiful Kennack Sands and Kynance Cove on the Lizard Peninsula. The result was a series of striking images in which the dancers are sculpturally integrated with the environment. Hugo also made a beautiful simple film of the sea, which became a backdrop for episodes in the live performances.

At the core of *View from the Shore* was an idea to explore the choreographic process of framing and organising perspective within a live dance performance; to explore 'view' as a broader concept and to pursue the epic task of translating a wild coastal environment into the theatrical space:

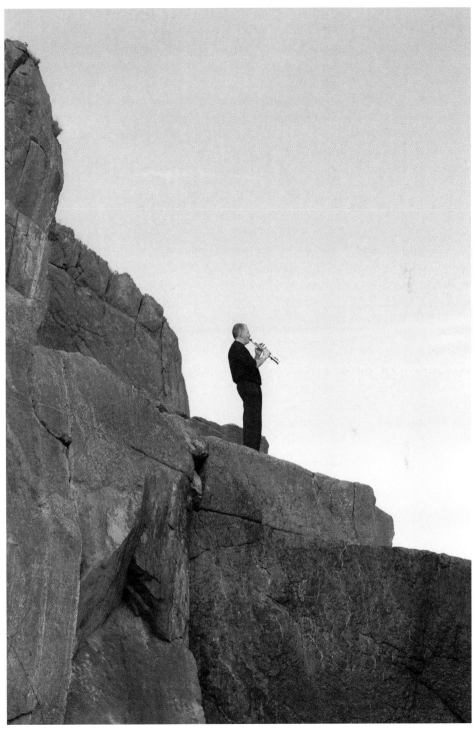

63 *View from the Shore*

[W]e climbed the rocks and explored the spaces between them; we made conscious our experience of being on the edge between land and sea, how it affected our senses, our kinaesthetic awareness and emotions. As millions before us we observed the ancient presence of the rocks and the particular and wonderful juxtaposition of the constantly moving sea against the resisting stillness. We then took these experiences back into the studio – as a painter, sculptor, author might do. *View from the Shore* is not a narrative dance work, but I have tried to explore through its abstraction a sense of timeless sea stories, and a sense of community. My use of choreographic repetition of shapes and movements, almost ritualistic at times, explores an idea of the cycles and patterns of human existence. Formally, too, I hope the work invites the audience to consider perspective and to ask the questions – whose view, and what view?[2]

As an independent choreographer one is often working in the gaps and interstices, borrowing contexts whenever and wherever one can – raiding the different fields of dance, theatre, performance art, visual art, writing and film-making. It is interesting, therefore, that the emphasis in the process of producing *View from the Shore* became primarily 'theatrical', which I think was due to the ethos of the venues we were working with – and there not being enough time to sift and shape the narrative content as much as I would have liked. While I am immensely proud of what we achieved, in retrospect there was some shifting away from the project's core concerns in the visual and conceptual; this balancing of theatrical and visual artistic languages is, for me, a familiar and continuing discussion.

THE MUSIC

The composer Lindsay Cooper[3] had given me a copy of her *Concerto for Sopranino Saxophone and Strings* (1992) several years before and I knew then that one day it would inspire a new choreographic work. Lindsay had been diagnosed with multiple sclerosis in the early 1990s and for a number of years she had not been able to compose new material. It was, therefore, very positive that I was able to use her magnificent score and contribute to a continuing professional presence of her music. By coincidence Tim Brinkman had introduced me to Dave White who was the director of the Cornish Sinfonia. Dave had known Lindsay when they were both teenagers in the National Youth Orchestra and he remembered her as a dynamic and vibrant young woman and artist. He was saddened to meet Lindsay in such different circumstances, although absolutely delighted and moved to play her beautiful music. He was joined by other members of the Sinfonia: Barbara Degener (cello), Alistair Taylor (keyboard), Oliver Lewis (violin); Dave himself played the saxophone. The musicians were placed in a very prominent position; Dave, as the solo voice of the saxophone, stood to play at particular points and the dancers walked and stood very close, even amongst the musicians, creating a linked ensemble of musicians and dancers.

Lindsay's concerto was commissioned by the European Women's Orchestra, which also gave the first performance in 1992. The piece was written for an orchestra consisting entirely of strings collaborating with a single instrument, the sopranino saxophone. Lindsay's piece evokes a universal spirit; she says of her work: 'Knowing how important the breath is to all living beings particularly in the playing of wind instruments, I decided to begin and end the piece with amplified breath'[4].

Dave White and I discussed for many months how we could achieve the quality of Lindsay's concerto with an arrangement for only four musicians, which, with Lindsay's gentle support, we succeeded in doing. Structurally the concerto is one continuous movement with five discernible sections, which I also used as a choreographic structure. It follows the classical tradition and incorporates a

cadenza between the third and fourth sections; unlike other classical concertos the cadenza is genuinely improvised and clearly demonstrates the influence of jazz in Lindsay's work.

The music is emotional and speaks of loss and hope which I chose to echo within the choreographic language. I too wanted to tell stories of the sea and of human struggle and survival and these narrative meeting points created moments of release and tension in the work. The music is a kind of figurative modernist soundscape and while I attempted to abstract the body in space, it kept being reframed by the music's narrative imagery. I understood that there was a story to be told that was timeless. There seemed to be no point in ignoring or working against this pull – this would not serve the music or the choreography well.

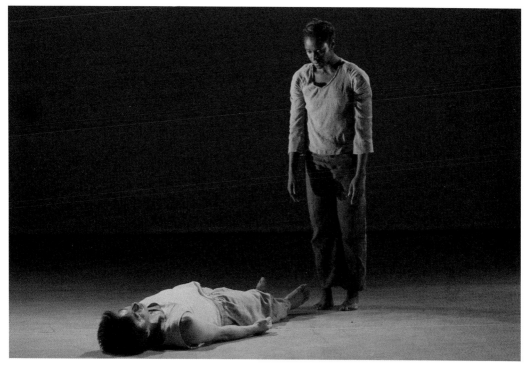

64 *View from the Shore*

THE PERFORMERS

The five performers – Sheron Wray,[5] Fiona Chivers, Tania Tempest-Hay, Fergus Early and Quang Kien Van[6] – brought a diverse range of experience, techniques and qualities to the work. When the project finished I invited them to write about their experience of the work and following is an extract from a piece by Fergus Early, which conveys the depth of involvement by the performers and the importance of their artistic contribution:

> The part I played in *View from the Shore* – not a character, but one of five dancers who might have been a family, members of a small coastal community, but again at times might have been waves, birds, flecks of spray or even rocks – had a certain patriarchal feeling. The oldest

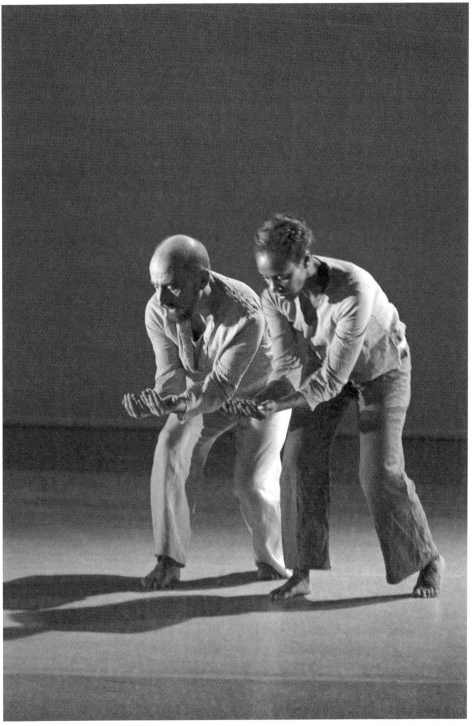

65 *View from the Shore*

of the cast by nearly 20 years, I spent periods of time, particularly near the start and end of the piece, standing and looking. Jacky suggested to me that I was an elder, a man of some responsibility for the continuance of what was probably a precarious existence on the edge of the land. In the middle of the piece I participated fully, particularly in a duet with Sheron Wray, a marvellous dancer who takes an instinctive grasp of the emotional core of what she is performing and commits herself to the choreography with a strength and passion that is a joy to work alongside. This duet had a sense of tragedy and loss and built into a ferocious intensity. After it came a more joyful and exuberant section which ended with the death of a young man – perhaps a memory of the loss that was the subject of the duet. Finally I returned, like the rest of the cast, to standing and looking.

In a curious way, the standing was the most profound part of this performing experience. At the beginning we were discovered on stage, standing, each with her or his own viewpoint. In standing, I had time to think about my spine, the tensions in my neck, the angle of my pelvis, the exact placing of my weight on my feet. Through the rehearsal period I had suffered a stiff neck which I had put down to a particular roll I did one day. In performance, with the full attention of an audience, looking across stage at blinding side lighting, I began to find that there was a small area of collapse in my thoracic spine. Somewhere between my shoulder blades I just wasn't standing up. If I stayed locked in this collapse, this tension, then my neck hurt, no matter what I did. If I began to release it, to allow myself to give my upper back its full length and width, flowing into its natural curve, my neck would adjust itself to a place where it felt balanced and unstressed. As the piece unfolded and I came back to standing in a state of great tiredness and sweatiness, I again had an opportunity to monitor my spine and posture. I translated the physical fact into the poetic metaphor. Somehow my contracted thoracic spine was also the distress visited on me by the death of someone… a friend, a son, a brother – and I had a responsibility within this community to stand up, to deny even the smallest collapse in the face of tragedy, because our existence, against a backdrop as implacable as the sea, depended on each one of us holding firm, being fully there, resisting the distress that threatened to bow and weaken us.[7]

ANAMULE DANCE (2007)

We had all nations in New Orleans […] but with the music we could creep in close to other people.[8]

View from the Shore was also the overall title of a programme, which included another new work, *Anamule Dance*. Inspired by the composer Jonathan Eato's[9] enthusiasm, I became fascinated by Jelly Roll Morton and the broken quality of the 1938 Alan Lomax recordings of Morton that Jonathan introduced me to. Following are some notes that Jonathan wrote for our project programme:

Anamule Dance is named after an early Jelly Roll Morton composition that features in tonight's programme, and began as a series of conversations between Jacky and myself regarding the musical and social environment in turn of the century New Orleans. These conversations inevitably focused on the key entertainment neighbourhood of New Orleans

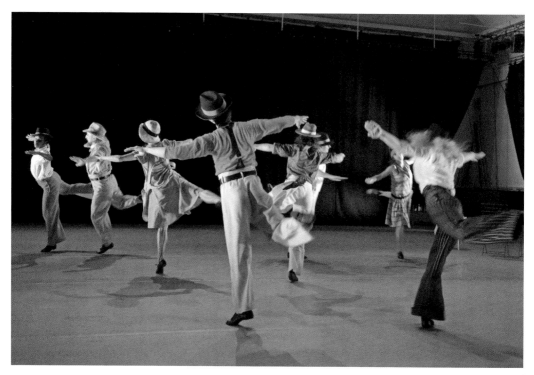

66 *Anamule Dance*

at the time, known as Storyville. What is perhaps often overlooked amidst all the tales of the birth of jazz in and around the bordellos, speakeasies, and 'sporting houses' of Storyville, is that many of these establishments employed a solo pianist. These 'piano professors' laid claim to their academic titles by combining a prodigious capacity for improvisation with their own potent mix of ragtime, popular ballads, blues, and jazz. Step forward Ferdinand 'Jelly Roll' Morton, one of the key figures in jazz, having recorded some of the seminal early sides both solo and with his Red Hot Peppers. There are, however, no known recordings of his solo 'piano professor' work in situ, and so consequently we have no document of this music operating as a functional music, i.e. a music that served a social rather than purely artistic function. What we do have, however, is over eight hours of recordings made by folklorist and musical anthropologist Alan Lomax for the Library of Congress in 1938. In these recordings Jelly Roll Morton looks back to turn of the century Storyville, singing, playing, and recounting the early days of jazz music. The use of 21st century technology has enabled me to map the rhythmic characteristics of Morton's playing onto various elements within the music that I have composed, to creatively exploit the differences in sound quality between Lomax's recordings and those made today in the Music Research Centre,[10] and layer the sound of Morton's voice onto and around the new score. This is not only a celebration of one of the major figures in twentieth-century music, but also of the technology that allows us to hear him sixty-five years after his death.[11]

I worked with an episodic form, which mirrored the fragmented Lomax recordings of Jelly Roll talking, playing and singing. I was inspired by his understatement and ability to make the ordinary beautiful. As he says: 'You can't make crescendos and diminuendos when you are playing triple forte […] you got to be able to come down in order to go up',[12] and the movement language we created did reflect this idea of doing less, or almost nothing. All the cast found a way into this process, although Sheron Wray excelled in the way she inhabited the music and brought to the work her experience and knowledge of jazz which was invaluable to the whole piece. The choreographic language, supported by Nicola Fitchett's[13] exquisite period costume designs, was a melange of everyday gestures, lindy hop, Busby Berkley chorus lines, the Cake Walk, hat work, comedy mime, improvised movement, loose ballet and 'sparkling feet'. We called a particular ensemble movement the 'Cheeko Walk', named after my very cool, relaxed cat Cheeko who loved being in the studio with dancers. He would demonstrate rolling and show off his released muscles!

Structurally we followed the songs 'Winin' Boy Blues', 'Call of the Freaks', 'Benny Frenchy's Tune', 'The Dirty Dozen', 'Make Me a Pallet On the Floor' and 'All That I Ask Is Love' (which was sung live by performer Tim Taylor)[14] and developed scenes for the 'gaps' in-between. These gaps *were* the choreography and as important as the songs and dance 'numbers'. They created a sense of place and atmosphere that quoted the street, the barber shop, the gossip corner – a sense of the off spaces or the riffs which Jelly Roll describes as 'beautiful ideas in breaks'.[15] The performer Lucy Tuck, who was in the audience, wrote of these breaks:

> Off-centre and providing a constant but understated working space, was a Barber's Shop. I delighted in the world created here – the yellow parameter of light projected on to the floor, seemed to give hint to the streetlight it maybe stood under. I liked the functionality of the shop's presence and the transformations it gave the performers as they passed through it, receiving treatment unselfconsciously – on one occasion giving a re-style from a 1930s slick to a modern Mohican, hilariously incongruous with the time and setting. The old-style microphone that stood downstage on the right, now came into its own when a male performer took up position behind it and sang unaccompanied. I felt a rush of delight, this piece constantly challenged the audience in its viewing of it as a dance piece alone.[16]

At the time, the casting process for *Anamule Dance* drew my attention to the invisibility of experienced dancers of colour in the UK. In 'Voicing Black Dance: The British Experience', the writer Funmi Adewole[17] identifies the lack of context and archival material for Black British dance:

> The importance of archiving to the inclusion of Black people in British cultural life cannot be overemphasised. Despite having a long, rich history, there are currently very few traces of past Black cultural activities that could serve as starting points for students and researchers.[18]

As a movement involved in political and cultural change 'Black Dance' had, since the 1970s, some organic alliances with – and was part of – the Independent and New Dance sectors which have always had wider political concerns than the traditional repertory companies. These are the sectors that have nurtured community and education work, research programmes, independent studios and small–mid-scale performance venues and festivals, enabling many to enter the world of dance as performers, teachers, academics, mentors, film-makers, writers and choreographers. Many artists of colour have been

part of this momentum – and even more so now as younger practitioners are entering and defining the field. This more alternative context has enabled a much needed discussion and analysis concerning the embodiment of oppression in some dance techniques, styles and cultural stereotypes, both for artists of colour and for women. In her investigation of the genealogy of the Mulato Body, the writer and academic Melissa Blanco Borelli provides an analysis of how archetypal body narratives can be realigned:

> I argue that it is through those acrobatically skilled hips of hers that she finds an opportunity for self-authorship, pleasure, and discursive contestation. Through her embodiment and performances of what I call hip(g)nosis, the *mulata* can step outside the limits of tragedy.[19]

Despite persistent and very real differences in experience, issues concerning invisibility and marginalisation tend to shadow all independent dance practitioners in the UK, from whatever cultural or ethnic background, as we compete with mainstream subsidised and commercial sectors at various levels – and there is only so much pie to go around! At the Dance Research Studio I am teaching and working with a new generation of artists, some of whom are making exciting new work driven by their personal and political awareness of racism and sexism. These young artists are drawing on cross-disciplinary strategies in their urgency to find new and relevant forms to speak about their experience. Often too there is a rejection of labels, such as 'Black Dance', as being too confining artistically and socially; following are some words by Project O (Alexandrina Hemsley[20] and Jamila Johnson-Small[21]) whose practices are articulating and reframing some of these issues:

> Pauses for thought are common occurrences in the creative process, but as we develop Project O these pauses often shift us into uncomfortable positions of otherness. These marginalised spaces are not where we thought we were, nor where we want to be. The invisibility of certain aspects of our experience as mixed, black and female is shocking and we are left isolated.[22]

The issues surrounding *Anamule Dance* were complex, made more so by placing the work in the Clore Studio at the Royal Opera House (following performances at Hall for Cornwall), which, despite all our efforts to reframe the space as our own and exploit its beauty and resources, nevertheless was the Royal Opera House and all that implied, socially, culturally and politically. Despite these complexities I feel very positive about *Anamule Dance* and I look forward to remounting it within a wider context of cross-cultural discussion and collaboration. Following is an extract from a review by the freelance writer and critic Estelle Ricoux which I feel encapsulates some of the overall essence of *Anamule Dance* and the programme as a whole:

> The choreography celebrates an attitude to life through its anecdotal quality and wealth of details, a sense of optimism despite living on the bread line. This evocation of a bygone New Orleans is haunted by recent images of the city swept by Hurricane Katrina, showing survivors in their inundated homes, putting on the same brave face despite the odds; linking both parts of the performance is the desire to position oneself on the contours of an edge, where dancers and audience alike can physically reflect on a flow of feelings. The varied group of people onstage reminds us of the social and political role that dance can have in bringing people together. Confronted with the engulfing presence of the sea, the only outlet here is the political and emotional force of the community.[23]

Notes

1. Fiona Chivers: performer, theatre set and costume designer working across genres: dance, opera, theatre, site-specific and creative learning. She previously performed the role of the girlfriend in Mathew Bourne's *Swan Lake* (1995) and performed with a variety of contemporary companies including C-Scape Dance Company and Kneehigh Theatre Company – based in Cornwall – for whom she also worked as a designer.

2. Extract from programme notes for *View from The Shore* (2007), by Jacky Lansley. Courtesy of the artist.

3. Lindsay Cooper (1951–2013): musician and composer in theatre, film, pop and improvised music. Member of the experimental rock group Henry Cow (1974–78) and co-founder of the Feminist Improvising Group (FIG) with artists Maggie Nicols, Sally Potter and Georgie Born. As a composer she created many works, issued on several collections, including her song cycle *Oh Moscow* (1989), the music score for Sally Potter's film *Orlando* (1992), *Sahara Dust* (1992, with voice artist Phil Minton), *Concerto for Saxophone and Strings* (1992), *A View From The Bridge* (1998) and *Pia Mater* (2003).

4. Lindsay Cooper, quoted in sleeve notes to *A View From the Bridge* (CD, London, Impetus, 1998).

5. Sheron Wray: dancer, teacher, choreographer and theatre director. She studied under Jane Dudley at the London School of Contemporary Dance, later performing with London Contemporary Dance Theatre and Rambert Dance Company. She formed her own company JazzXchange in 1992. She was awarded a Nesta Fellowship in 2003 and is presently Associate Professor of Dance at the Claire Trevor School of the Arts at the University of California, Irvine.

6. Quang Kien Van: dancer, choreographer and teacher; trained at Central School of Ballet, London and went on to perform with Adventures in Motion Pictures, Skanes Dansteater, the Peter Schaufuss Ballet as a founder member, and with Cirque du Soleil in Las Vegas. Since relocating back to London, he has danced with the Michael Clark Company, Darkin Ensemble and with Jacky Lansley in *View from the Shore*.

7. Fergus Early: *On Standing Still: A View from the Floor* (London: Dance UK Magazine, issue 67, 2007), 14–15.

8. Jelly Roll Morton (1890–1941): American ragtime and early jazz pianist, bandleader and composer who started his career in New Orleans, Louisiana. Widely recognised as a pivotal figure in early jazz, Morton is perhaps most notable as jazz's first arranger, proving that a genre rooted in improvisation could retain its essential spirit and characteristics when notated. Quote from *The Alan Lomax Recordings* (1938), published by Rounder Records as 'The Complete Library of Congress Recordings', USA, 2005.

9. Jonathan Eato: musician and composer whose work has been performed internationally. He is a lecturer in music at the University of York, UK. He has worked closely with the percussionist Craig Vear in the improvising duo ev2, with the choreographer Hannah Bruce and with Lansley on *View from the Shore*, *Guests* R&D (2010) and *Guest Suites* (2012). He works extensively in South Africa and in 2012 produced *Black Heroes*, a recording by the legendary South African pianist and composer Tete Mbambisa.

10. The Music Research Centre: promotes and supports creative research into the use and application of technology in music. It is attached to the Music Department of York University and houses professional-standard acoustic and recording facilities, exclusively for postgraduate student and research use.

11. From Jonathan Eato's programme notes for *Anamule Dance* (London: Dance Research Studio, 2007), 6.

12. Quote from *The Alan Lomax Recordings* (1938).

13. Nicola Fitchett: designer in theatre, film, television and dance (with Jacky Lansley, Mark Bruce, Maggie Morris, the London Children's Ballet and Stan Won't Dance). She is a wardrobe mistress for Central School of Speech and Drama and is an Associate Designer of Claque Theatre – projects there include the International Festival of the Sea and community plays in Shaftsbury, Guelph, Tonbridge and Withyham.

14. Tim Taylor: interdisciplinary performer, theatre maker and teacher. He has worked with practitioners including Luke Dixon, Jane Turner, Ian Spink, Sian Williams and The Kosh, Ultz, Bill T. Jones, Matthew Hawkins and with Lansley on *The Life Class* (film, 2005), *Anamule Dance* (2007), *Guests* R&D (2010) and *Guest Suites* (2012). He is an Associate Artist of the Dance Research Studio; a member of the Conway Collective; and Head of Dance at Morley College, London.

15. Quote from *The Alan Lomax Recordings* (1938).

16. Lucy Tuck: extract from her feedback to the company (2007). Courtesy of the artist.

17. Funmi Adewole: performer, writer and lecturer. Her research focus is the development and practice of dance that draws on African and Diaspora dance forms. She began her career as a journalist in Nigeria, becoming a performance practitioner in the 1990s on arrival in the UK. She has toured with Horse and Bamboo Mask and Puppetry Company, Ritual Arts, Adzido Pan-African Dance Ensemble and the Cholmondeleys. She now performs mainly as a storyteller, combining text with movement in community and educational contects.

18. Funmi Adewole: 'Raising the Level: The ADAD Heritage Project', in *Voicing Black Dance: The British Experience 1930s–1990s*, ed. Funmi Adewole, Dick Matchett and Colin Prescod (London: Association of Dance of the African Diaspora [ADAD], 2007), 12–15 (14).

19. Melissa Blanco Borelli: 'Introduction', in *She Is Cuba – A Genealogy of the Mulata Body* (Oxford: Oxford University Press, 2016), 5–28 (7).

20. Alexandrina Hemsley: artist, writer and teacher based in London; her practice is collaborative and interdisciplinary and draws on embodied and improvisatory disciplines. Alexandrina is one part of duo Project O, with Jamila Johnson-Small. Her most recent works: *Bounty Bars and Oreo Cookies* with Katarzyna Perlak, *Black Holes* with Seke Chimutengwende and Project O's *Voodoo* – have aimed to engage with cultural frameworks that reclaim and celebrate her identities as a mixed-race woman.

21. Jamila Johnson-Small: artist, writer and teacher based in London; she creates dances that aim to make gestures towards decentralised power and non-hierarchical structures. Her work is produced through body-based research and she considers an engagement with power and politics as inevitable. She works as Project O with Alexandrina Hemsley, immigrants and animals with Mira Kautto and has worked with The Rebel Man Standard.

22. Jamila Johnson-Small and Alexandrina Hemsley (Project O): *A Contemporary Struggle* (London: Project O and the Live Art Development Agency, 2013), 9.

23. Estelle Ricoux: extract from a review commissioned by Dance Research Studio (2007). Courtesy of the artist.

6

STANDING STONES

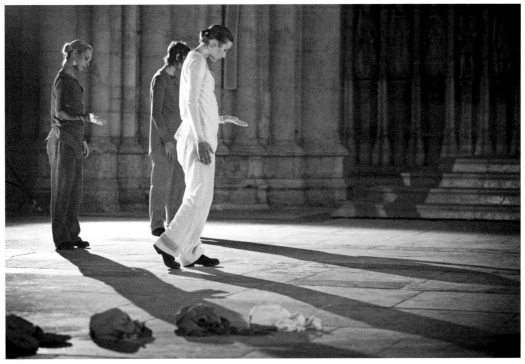

67 *Standing Stones* (York Minster)

In 2007 I was approached by a UK company based in Leeds, Ascendance Rep,[1] to choreograph a work for cathedrals. After an initial dialogue about the grand and site-specific nature of cathedrals, the company agreed to fund me to spend several months visiting each cathedral – some 16 in the UK – for the purposes of research and inspiration. I also decided that I would work with the Mozart Clarinet Quintet.

I wanted to root the cathedral piece in ideas and images beyond modern religions, a reason for the work's title, *Standing Stones* (2008), and to find a more ancient, humanistic spirituality as a starting point. As part of my research process, therefore, I visited several cave sites, including Lascaux, in the Dordogne, France, to see and experience first-hand the ancient cave paintings. The paintings at Lascaux date from the Upper Palaeolithic period, about 18,000 BC, and some in other nearby caves from as early as 30,000 BC. The exquisite and detailed paintings of oxen, horses, red deer, lions, eagles and antelope, created with organic colours of charcoal greys, ochre and pink, are breath-taking and timeless. The depiction of traps and arrows suggests that the pictures had magical significance in hunting rituals and a curious sight is the difference between the cartoon-like stick human beings, the hunters, and the naturalistic paintings of the animals that are being hunted. It is as though the human is completely insignificant in relation to the sacred, life-giving animals they are hunting; as though it is irrelevant to look at the human body, which is not watched and tracked for days like the animals that are crucial to human survival. It was necessary for these ancestors to observe every detail of the animal's body; to understand its muscular and skeletal systems, its reflexes and sensory activity. Within this moment it is the animal and its environment which is worshipped and revered – not the human who is reduced to a little stick creature with a tiny sketched bow and arrow.

How different from the modern era in which we humans dominate and are the constant subject of our own narcissistic thoughts and desires. Where and what is the art of the moving body within all of this? How actually do we look at each other? I had a feeling, which I share with many, that these images had been preserved and buried in caves, in order that modern man could see them as a reminder of what is important. They certainly provide a beautiful symbol of the importance of art making for human beings and I wanted to try and bring something of the stillness and simplicity of these ancient caves to cathedrals of this era.

THE ARCHITECTURE OF SPACE

As part of the common architectural theme of transept, nave, choir and chapter house, cathedrals present gothic heights, theatrical stages, amphitheatres, corridors, passages, entrances and exits. They also all carry the architectural marks and designs of the eras in which they were built and rebuilt; a range that covers at least a millennium from, for example, the eleventh-century medievalism of York Minster to the modern Guildford Cathedral built in the twentieth century. In the quest to survive and be open, cathedrals also now combine the commercial tourist industry with the sacred, quite literally side by side. When I first visited York Minster with the dancers Katie Keeble,[2] Ayano Honda,[3] Paul Wilkinson,[4] Daniella Ferreira[5] for research and inspiration, they instinctively ran along the corridors divided by the enormous pillars in the central nave and made physical shapes amongst the pillars to the delight of the tourists passing through – who themselves were framed by the beauty and dignity of the towering building.

Many of the cathedrals seemed cluttered with Christian religious paraphernalia – icons, statues, art from different periods and genres, banners, prayer books, etc. The question was how could I work within these massive, complicated – both physically and historically – environments? How could we prevent the dancers from disappearing into this visual complexity? My task was huge and drawing on my site-specific experience I visited each cathedral, making drawings, taking photographs and negotiating

68, 69 Cave paintings from the Upper Paleolithic period (Lascaux)

70 Carlisle Cathedral (drawing by Jacky Lansley)

71, 72 Gargoyles (York Minster)

my way through conversations with deans, vergers, cathedral administrators, cleaners and security personnel, including the York Minster Police, a special constabulary which has been in existence since 1106, in various forms, to protect the cathedral, and whose duties include the responsibility of 380 sets of keys. At times it did feel that I was borrowing the present, rather restrained Christian locations as portals to something much older and more human; and that I was constantly trying to get beyond, over, between and through doors… so finding the keys was important!

A sensitive theme of negotiation was the seating, which mostly consisted of pews but sometimes freestanding chairs. The question was always whether they were fixed or movable – and if they were moveable how many rows could be moved and where would they be stored temporarily. The spacing of the piece was crucial – and part of the choreographic language. Like most non-theatrical spaces cathedrals have no facilities for performers; no dressing rooms or warm-up spaces and, as to be expected, we constantly had to negotiate our rehearsal and warms ups around daily prayers and services. The floors are predominantly old flagstones, with some timber areas here and there and, of course, pitted and uneven from centuries of use. We had decided very early on that the dancers would wear soft trainers with a good flexible sole to protect their feet – however, I felt it incumbent on me to check out the floors in detail and even take photographs of areas which the stage manager would have to tape off. The buildings were also usually freezing cold; and so as part of my aesthetic and spacing research, I took the opportunity to check on all these practical and vital issues. After each visit I would write up simple notes for the company, with appropriate photographs. Following is a short example of one of the smaller cathedrals:

St Mary's Episcopal Cathedral, Glasgow
Jacky visited on 9 March and met the Reverend and event organiser briefly (very positive).

Notes:

- It was confirmed that we have only the day of performance (all day; time of arrival tbc), Wednesday 25 June.
- Fixed seating/pews.
- Will have to work across transept (centre and south transept as you face altar; north transept area cluttered – although we will want access to that also).
- Quite small approx 36ft depth; approx width of the transept usable 46ft. There is a pillar but the appearance/disappearance of dancers (lit properly) will be a feature of the piece.
- There is a nice largish hall to the side with a timber floor we can use as warm-up and dressing-room space.
- They have a large music mail-out to be exploited, plus quite a lot of other cultural events (seemed very lively). Organiser keen to discuss this with the company.

Cathedrals are, in some ways, natural theatres, with the congregation/audience facing east towards the 'stage' at the top of the nave, and this became my choice of perspective for the performance in most of the cathedrals, as it seemed perverse to ignore such beautiful architectural presentation and framing. Making a new choreographic work that will be suitable for 16 different spaces requires a very different approach from a one-off site-specific event; and while I wanted to retain the quality of a special event at each cathedral, it became clear that the choreography would have to use a generic and repeated form that adapted to the spatial demands and qualities of each cathedral.

73 *Standing Stones* (rehearsal at Guildford Cathedral)

As I discussed in Chapter 1, the craft of site-specific work can involve a checklist of questions: what are the site's social, cultural, historical, aesthetic, spatial, environmental or functional qualities? How can my work relate to or be inspired by these qualities? To what extent will the site/context become part of my choreographic 'score'? Approaching cathedrals with these questions was extremely interesting and, of course, very complex, as the environment in which one is investigating is usually between 700–1,000 years old – and usually with foundations that are much older. As some of the oldest buildings in the world they offer us unique historical information and a powerful sense of previous human communities, who prayed, walked, sat (and maybe danced) in the same spaces as we do now. The layered visual backdrops of Saxon, Norman, Early English, Gothic or Renaissance architecture became extraordinary to behold; a rich mix, particularly as there is also a significant amount of contemporary abstract sculpture, painting and stained glass in several of the cathedrals. My gaze wandered to much smaller examples of historical narrative or image in the carved misericords, windows and gargoyles which inspired the essentially abstract language of movement and gesture in the piece. The Chapter House at York Minster, for example, had embedded within its octagonal structure a vast collection of gargoyle heads. We studied these carefully and the third movement, particularly, drew on this grotesque and bizarre temple of human diversity, pain and comedy.

THE WORK

Mozart scored the quintet for clarinet, two violins, viola and cello in four movements – Allegro, Larghetto, Menuetto, Tema Con Variazioni – to develop a variety of moods and musical textures which

allows the clarinettist to display great virtuosity. Mozart was no stranger to making arrangements and reductions of his own works. Several piano transcriptions exist and in the light of this we used an arrangement of the quintet by Philip Catelinet for piano and clarinet performed by two exceptional musicians, Dave White (clarinet), with whom I had worked on *View from the Shore* (2007), and Jonathan Delbridge (piano). Mozart, like many eighteenth-century composers, was inspired by dance forms such as minuets, gavottes, courantes and sarabandes, and it was a joy to work with a kind of playfulness in the variations which always return to a core theme. The form of the quintet became a structural template for the choreography, which uses the four movements to create four different, although linking, episodes to the performance.

Using the metaphor of journey, I placed the quartet of dancers as far away from the audience as possible – this usually meant that they were positioned by the central altar at the back of the nave. At the beginning of the piece the dancers stood in a tight formation facing in different directions – north, south, east and west. Gradually breaking away from this human megalith, they emerged, walking forward, pausing at moments in relation to each other or to the cathedral architecture. Eventually the performers arrived centre 'stage' and looked at the audience, welcoming, acknowledging them.

> **The tall Katie Keeble, wearing a close-fitting bright yellow costume – balances on one leg, the other in a high attitude which rotates slowly from forward to back, her arms parallel to the floor – all then extending into a classical long arabesque in *plié*. The movement is about task, struggle and defiance of gravity as well as visual beauty. Katie is trying to stand on one leg with the other high in the clouds – we, the audience, want her to achieve this – but the effort is not concealed. She echoes the lines and Gothic heights of the cathedral and reminds us of the human labour of the stonemasons, carpenters and the communities who supported the building of these giant temples, sometimes over centuries.**[6]

Not all was about being new; this was somehow not at all relevant to the process, and traditional, classical and contemporary techniques and strategies were used – *pas de deux*, albeit women lifting women, women lifting men and simple contact techniques such as leaning and weight exchange on each other or on the pillars and walls. We worked with movement as both image and as impulse; I encouraged the dancers to be disciplined with the images they were exploring – to not demonstrate, but rather to emotionally and visually inhabit the imagery and control the flicks and kicks of technical mannerisms. Sometimes this micro-awareness seems to deny the dancer a kind of pleasure and comfort derived from age-old patterns, which are often embedded into the psyche of the dancer; but like the actor, who takes on other characters with all their patterns, the dancer is required to leave his or her own patterns at the door, or certainly to be aware of them. To support this process I gave the dancers notes to help them think about important moments and images within the work and maintain the qualities needed within the different movements while on tour:

- First movement – mapping the space/building, introducing you and the vocabulary to the audience.
- Second movement – emotional, hints of narrative, humanising.
- Third movement – historical, linking medieval with Pagan/Celtic cultures; psychological – dark/light, the gargoyles; function of humour to integrate and connect to the audience.

- Fourth movement – recapitulation of main themes, bringing together, community, memory and return.
- The 'gaps' – they too have different qualities.

Selected Images

- Ayano – 'the gift' (of life, of food, of beauty?) – the hand gesture in her final solo – symbolic, almost ritualistic.
- Building/architecture – the image of you as stonemasons, carpenters, symbolic and playful.
- Food and baking – the audience don't 'see' you baking, but they will 'feel' and enjoy it through the full commitment of that moment/movement.
- Honouring the body – looking at feet and hands (thinking about internal organs), taking care of yourselves and the musicians (watering place, giving the musicians water, etc., tidying up hats).
- Using the Gothic heights and transepts/arches/structures in the cathedrals – pay attention to detail and lines in the choreography and the spacing within the cathedrals.
- Gargoyles – recap your 'characters', remember that we found that it is essential that you have a motivation behind each expression – otherwise it looks coy and empty. You have to work like actors here.[7]

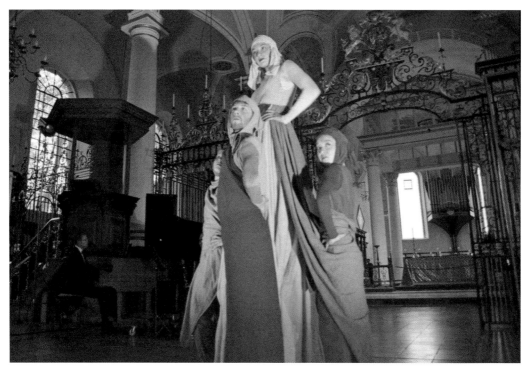

74 *Standing Stones* (Derby Cathedral)

Standing Stones was a work which, with the loving support of the dancers, did, I feel, fully arrive and which achieved a powerful dialogue with the Mozart Clarinet Quintet. The process of making the work was not without its struggles and the experience did confirm for me, once again, the benefits of self-produced work in which one is able to link all the production processes of marketing, press and venue liaison with the artistic work. Despite any questions about the process, making *Standing Stones* felt like a gift and it was a work appreciated by audiences:

> As a spectator, I felt, quite soon, the comforting feeling of being in safe hands: like Mozart's music, this choreography picked you up and carried you on a journey – a journey that was not in the least predictable, but you sensed that the vehicle was roadworthy. On the way you encountered joy, sorrow, comedy and sometimes something a little darker. Formally, the placing of the dark and comic medievalism in the 3rd movement was brilliant, inviting us to relate differently to the performers and to the choreographic material […] The tall figure of a woman on stilts, framed in the vastness of the nave, caused us to turn and look at her, marveling at the brilliant surprises she pulled – suddenly swinging the little red figure like a dog toying with a rabbit, or blossoming into a giant yellow flower while little peasant figures cavorted at her feet.[8]

A standing stone is both art and life – a natural stone that has the narrative and mark of the humans who have placed it. Still and certain it calls on our thoughts and feelings and determines space like sculpture. During the process of making the piece, I encouraged the dancers to visit Stonehenge and other sites where the great megaliths of the Neolithic and Bronze Age periods are arranged. I suggested that if possible they explore standing next to them or in a 'choreographed' relationship to them. How do the stones stand? How do we stand? Explore the warmth of a still-standing stone that was placed centuries before and made from material that has probably been on the planet forever. If as dancers we could evoke this, even for a second, it would be a profound achievement.

Notes

1. Ascendance Rep: community and education focused company based in Leeds. Founded in 1999 by Rachel Wesson, the company toured works created by a variety of choreographers throughout the UK, often working in non-traditional, site-specific spaces.

2. Katie Keeble: independent dancer, choreographer and teacher who trained at the London Contemporary Dance School. She has worked with companies including DV8, with Kim Brandstrup at the Royal Opera House, and was artist in residence with Les Reparage. Katie is a member of the Culture Collective, a group of artists working in music, dance, film and animation. She took part in *Critical Pathways* (2015) with mentor Rosemary Butcher and she is an Associate Artist at the Dance Research Studio.

3. Ayano Honda: Japanese dancer and teacher. After training in the USA and London, she performed with Ballet San Jose Silicon Valley, R-a.G Dance Company, Katie Thies Dance Theatre, C-12 Dance Theatre, Gelede Dance and Ascendance Rep. Ayano has worked with the English National Opera for several seasons performing *Madam Butterfly*, directed by Antony Minghella and Carlyn Choa. She is currently based in Japan where she works with contemporary dance and theatre companies and studies traditional Japanese theatre arts.

4. Paul Wilkinson: dancer and teacher; trained at the Northern School of Contemporary Dance and graduated in 2007. He has worked with Ffin Dance Company, The Cholmondeleys and The Featherstonehaughs, Pit Fleur Company, Gary Clarke and Simon Vincenzi for Duckie Decade. He has also worked with choreographers Ben Wright, Hofesh Shechter, Lisi Perry and Simon Birch.

5. Daniella Ferreira: dancer and teacher; born in South Africa and trained in the UK. She has worked with Phoenix Dance Theatre, Diversity Dance Company and with choreographers Slanjayvah Danza (Hybrid) and Cesar Moniz on tour in Portugal and Brazil. In 2011 both she and Paul Wilkinson became resident choreographers at The University of Cumbria until 2014; they now both live and work in Portugal.

6. 'Writing Choreography': as in Chapters 4 and 8, it is a form of writing from memory used by Lansley to bring the language closer to the live work and the choreographic process.

7. Jacky Lansley: extract from 'Notes for the Dancers/Standing Stones' (2008). Courtesy of the artist.

8. Extract from feedback by a member of the audience who attended a performance at York Minster in 2008.

7

RESEARCHING GUESTS

The theme of interdisciplinarity underlies all my choreographic work and for me this is ultimately about finding, or refinding, a sense of the whole. In our lives we do not separate movement from voice, gesture from feeling or the mind from the body. Our lives are messy, simple, beautiful and ugly and I am interested in exploring this in my choreography and teaching. In 2010 I once again collaborated with Tim Brinkman at the Hall for Cornwall, this time as co-directors, on a performance research project titled *Guests.* We brought together an experienced and diverse group of artists to share and exchange skills, techniques and forms and to 'guest' in each other's worlds. Tim and I were very aware of the different perspectives, histories and artistic experience from which we were both coming – differences which seemed to reflect the separation between dance and theatre practice in the UK – and in some ways we had to start at the beginning. What do we mean by a score? What do we mean by process? What do we mean by character and narrative? What do we mean by image? The extent to which we had to investigate these primary concerns was sometimes surprising, but we had created the precious collaborative time to unpick these questions and explore the gaps and differences between our varying perspectives.

Themes and images of displacement grew organically from our explorations – we realised that the idea of guests could not avoid the problem that the world now has more refugees or 'guests' in 'host' countries than at any other time. Somehow the artistic imperative to explore difference and strangeness enabled us to approach this difficult theme and early in the process I offered these reflections around the concept of guests:

- 'Guests' suggests invitation into something – a process, a house, a party. It combines a sense of being totally and utterly welcome with an idea of coming from somewhere else, from the outside; crossing over and entering into something.
- 'Guests' suggests the impermanent – a guest can come and go.
- 'Guests' suggests that there is some sort of body or institution doing the inviting – who is that?
- 'Guests' denotes pleasure, collaboration, harmony, a good time, courtesy.
- A guest is borrowed – something or somebody new, possibly unsettled, which could suggest a kind of dis-location and difference; a freeing of existing components – maybe within a group, a community, a family, an institution. As the outsider the guest can change things (Brecht[1] worked with these ideas – concerning alienation, difference and change. The everyday being made different by the unfamiliar).
- How does a guest feel? Welcome? Not welcome? A stranger? Are we all guests? What happens if we think of ourselves as all guests (on the planet) all the time – would we behave differently?
- Skills as guests: within an interdisciplinary landscape there are different, new and hybrid skill sets. Postmodernism liberated performance skills from traditional contexts – raiding, borrowing, parodying classical and popular art forms. Boundaries are blurred between classical actor, classical dancer, contemporary dancer, performance artist, visual artist, writer, choreographer, director, designer, composer, musician, clown, mime, etc. Artists with diverse training and professional backgrounds can guest in each other's worlds.

For the final performance event Tim, I and Jonathan Eato, who directed the sound and music research for the project, created an episodic structure that allowed us to share the company's research with an audience, without pushing the material into premature formal decisions. These episodes – **The Corridor, The Holding Space, Crossing the Border, People and Acts, Relationships and Questions, A Party, Confrontation and Negotiation, Discussion** – guided the audience around the landscape of our research, which explored the idea of stage, gallery and street. The Hall for Cornwall was completely transformed as the auditorium seating was removed to create a vast empty space in which Fiona Chivers,

76 *Guests*

who led the visual/design research, hung found objects and personal clutter such as books, shoes, bags, clothes, plants, food, photographs and toys that we had collected during the long research process.

The audience had to journey through a marketplace outside of the theatre in central Truro and enter by the stage door, the whole event merging with the fairground atmosphere of the market. The performer Tim Taylor, as 'Kevin', acted as a club bouncer ushering the public through the stage door and then along a corridor onto the stage 'The Holding Space' with the safety curtain lowered. On arrival, they were given chalk and invited to scribble graffiti on the back of the safety curtain. Following is a selection of fragments and words from the company's 'guest book' and the graffiti written on the safety curtain:

> *The burlesque refugee*
> *Doormat dog*
> *Welcome*
> *Unwelcome*
> *Displaced*
> *Arrived*
> *Found*
> *The predatory host*
> *The faceless host*
> *The compulsory host*

The absent host
The bureaucratic host
The reluctant guest
The mysterious guest
The unseen guest
The ignorant guest
The poetry reading as guest
The cellist as guest
Asylum seekers as guests

Journey
Jazz dance
Folk dance
Tribe
Suitcases
The showgirl driven to extremes
Alone in a crowd
Demonic following
Crazed devotion
Embracing menace
Metaphor of balance
Slapstick
Transformation
Adornment
Toasts
Gloves
Hearth
Entrances and exits
Invited, intruded, evicted, departed

Do Come In!
You are welcome!
Great to see everyone again!

The world now has 43.3m displaced people, or guests, in 71 host countries

If I'd observed all the rules, I'd never have got anywhere
I still arrive, in order to laugh and to cry, to fear and to hope

I'll not leave with another if I've arrived with you

To wish you beside
Me in my new hat and smile
But I don't know you…

77 Guests

GUESTS – 3RD DRAFT SCORE

	Action	**Location**	**Light**	**Sound**
1	An audience arrives. The event takes place as a series of episodes or chapters marked on placards held up by the ushers who guide the audience through the different spaces.	Hall for Cornwall foyer.	General note: pre-rigged generals and specials. Lighting will be simple but effective. It will be a support rather than a primary language of the R&D.	General note: the sound score will be developed during the week with palettes of sounds previously created by JE in consultation with JL and TB.
2	THE CORRIDOR The audience are invited by ushers (placement students) to enter the theatre via an unusual route. It is mildly intimidating.	Via stage door corridor.	Regular.	Big audience noise drifting through from front of house sound; the corridor sound may include a directorial voice which gives clues to some of the key research processes.

3	The audience are led single file through a black corridor on the stage, passing close by a displaced individual guarding his treasures. There may be some audience interaction here: (holding/picking up/eating/giving something – to be explored)	On stage between black cloths making the corridor. Safety curtain in.	Bright with shadows.	Heavy, unrelenting rain.
4	THE HOLDING SPACE The audience collect in a holding area. There are other displaced people who are guarding their belongings. They may exchange some words with members of the audience who get too close… (audience interaction?)	Stage between black cloth and safety curtain. Graffiti on safety curtain.	Shadows on safety curtain, deeply coloured light.	Sound begins transition from rain to airstream and pop saxophone (close, dry acoustic space). Quite busy soundscape.
	Research: metaphors of border and transition, slightly intimidating; site-specific exploration; deconstruction of stage.	Visual/event type experience at this point for the audience.		
5	The corridor cloths fly out to reveal an upstage gauze; the six performers are behind this gauze in the 'Allah position' (or similar-quality position).	Stage.	Cross fade to lighting behind gauze.	Continue pop and airstream, but MUCH more sparse (expansive, reverberant acoustic space).
6	They move from 'Allah position' to 'Metaphor of Balance'. They touch the gauze and make shapes against it. The gauze is lifted, the performers expand forward into the Holding Space to perform the Schubert sequence. Gestures of welcome and ritual. They are dancing with their suitcases; they are going on a journey.	Stage.	?	'Metaphor of Balance' sounds. Schubert?
7	Lydia drums up the group calling them to join together for survival's sake (Bogatania translated into something else; same comic/demonic leader quality).	Stage.	?	To be developed.

8	**CROSSING THE BORDER** The safety curtain goes up to reveal a large open space with some objects placed in it, suggestive of a camp made up of debris, found objects, paraphernalia of the theatre, etc. Lydia leads the six (and the audience) out into the auditorium with jeté movements; this moves into demonic running with laughter – as though mapping out the space – into the hide-and-seek movements finishing with the showgirl flourishes.	Full stage and full auditorium. Research focus: performers introduce the space and the movement language, etc.	?	Music/sound/recorded voices? International guest voices here. (Quite a lot of time.) Use spatial aspect to encourage audience to move forward?
9	Ushers take the audience out into the auditorium as the performers adapt to their environment – collecting objects and building 'homes/sets'; they each form a space – the audience are able to visit each space in promenade or watch the whole from a distance. They may have to help – carrying things, making decisions, etc. They are engaged in the setup.	Auditorium	?	Concealed radio mics pick up the sound of the performers adapting to the environment? (idea to explore?)
10	**PEOPLE AND ACTS** Kevin tells his story and reads a poem. He may permit a couple of questions from the audience (or from the other performers).		Special on Kevin within the light landscape agreed.	Relevant sound images? (Modified Schubert-inner parts?)
11	Lydia performs some of her various 'roles' – revealing glimpses of her 'real' story. She offers tea to the audience. She carries her own 'set' around with her.		Special on Lydia.	Recorded fragments of Lydia acting other roles. Quiet, whispered recorded 'internal voices' over PA (Lydia's live voice, acoustic).
12	Arabella, always the showgirl, protests about the homeless and nuclear weapons… She throws sweets at the audience, she is cross…		Special on Arabella.	Probably some 'showgirl' material and other protesting/rally voices – modified from bits of T. Rex and Schubert tracks.

13	Jay cracks his whip and makes a space through the audience to share his story – through tricks, grotesque gestures and food…	Special on Jay.	Other relevant sound images? Possibly one of the other performers becomes his voice (live).
14	Someone asks Mary about her story. She tells it as a 'storyteller' as though to a group of children. There are some questions and she becomes defensive… is the story about her?	Special on Mary.	Relevant sound images?
15	Petra – cynical dancer, has been quietly watching the others – begins to dance (a structured improvisation that is her own unique language of movement). RELATIONSHIP AND QUESTIONS Research focus: exploration of relationship, between the characters; narrative within movement/gesture; space.	Special on Petra.	Need to find music for dance? Also maybe whispered/spoken recording of Petra talking about her 'lost' child (and maybe her ballet background?)
16	Arabella and Kevin start to perform a cabaret duet over and around Mary – quite sinister… (to be developed).		Wonky cabaret music; Marc Bolan talking to Schubert.
17	Petra, Lydia and Jay perform a strange burlesque act (to be developed). There are howls from Jay – his dog pelt is missing. A mad search ensues…		Music/voices about displacement: Mulholland Drive, cabaret technique, distant saxophone 'screams' – very quiet.
18	It is revealed that Mary has stolen the dog pelt. The group deal with this situation… how? (all to be developed during the week).	Bleak lighting?	Dark serious, rain and screaming sax.
19	A PARTY		

20	Kevin, who is always trying to patch things up, is revealed onstage framed by a sparkly proscenium; he starts to perform a boogie dance, the others join him to perform for their guests – the audience. This transforms into a hybrid folk dance that gets overly intense and wild; it spills back into the auditorium and involves the audience… (these two dance moments could be reversed).	Auditorium looking through to stage; party atmosphere.		Crazed out, LOUD, version of Marc Bolan's 'Jitterbug Boogie'. HOW LONG? Balkan folk dance with voices – no music?
21	**CONFRONTATION AND NEGOTIATION** A large voice (recorded or megaphone) stops the show and tells the six characters they have to leave (or tidy up their camp). The performers are scared, they put boxes on their heads and pose anonymously for the camera with their cardboard manifestos – as though prisoners (this image would be strongest framed onstage).	Auditorium and stage.	Lighting onstage swelling to take in the auditorium, threatening, perhaps searching spots.	Brooding, threatening sounds/voices. Megaphone voice can come through all speakers but with constructed crap PA delay. (Also add saxophone screams in far distance – but more coherent?)
22	The performers return to their camp and attempt to cooperate, packing up the camp and their suitcases – some are selfish, some are cooperative… they ask the audience what they should do; they ask members of the audience to help.	Stage and auditorium.	?	Continue…

23 Eventually they resolve to follow Lydia again and all wrap headscarves around their heads. They perform a group dance (maybe each carrying a chair and possibly returning to Schubert movements/music).

24 They pick up their suitcases (and chairs?) and continue on their journey – leaving the space (or return to their loitering positions around the space; different end options to explore).

DISCUSSION
The directors invite the audience to stay and talk about the sharing (which they will chair) – those who want to stay or leave can. There is a sense of continuity from the performance. (Tea may be provided for the guests.)

Auditorium.

Music and international 'Guest' voices? (TBC) with Schubert?

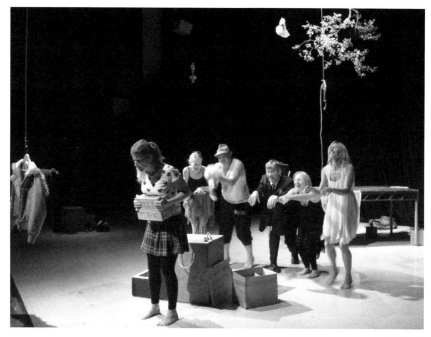

78 Guests

COMMENTS AND QUOTES

Audience member:

> I liked the idea that there was no ideological hiding place for the audience. There were some very uncomfortable things confronting me, which had been so far from my mind when I was walking in the sunshine through Truro and then stepping into the theatre, which was really quite industrial – I had no expectations.

Tim Taylor/Performer:

> Having the gestation over a period of months, with time elapsing in between and many different things happening in between, has informed the development in quite a key way – it's quite different from the intense three-week rehearsal experience. There is an ease that develops when getting to know a group of people over a long period of time; we go through several processes. In this project it was always good – but it's like that norming, reforming, storming thing that happens – you know the day you leave rehearsal and everyone is in cloud nine and the day you leave rehearsal and everyone is a bit the worse for wear; having been through the ups and downs – we now know it's ok, these people are good, you can rely on them.

Dagnija Innus/Administrator HFC:

> When they started to boogey and jitter bug – that struck me as completely true. I come from a displaced background so I felt this afternoon very viscerally […] because I remember when my family and their friends got together – displaced people party hard. They take every grain of happiness that they can and they let it go – it was really moving to see that and then to be told you have to move on because that was their, my family's, history.

Brett Jackson/Performer:[2]

> I have lived and worked on the road with the circus for 20 years of my life and so a lot of my performance influences come from the street – not necessarily any pure forms – but just the awareness of the street and people. How the interface operates between a street artist doing dance, performance art, clowning or circus – and people going about their normal lives.

Audience member:

> The whole concept was illuminating. I loved the separateness of what that man called 'the fairground aspect', it made us audience become individual performers too, as we wandered from act to act but led always by the directorial and lighting guiding hand.

Ursula Early/Performer:[3]

> I am a classically trained actress and the majority of roles I have done have been within the realms of some sort of naturalism. I would go away with the character from a play and

come up with a back story – where they come from, what they were doing, what other characters say about them – to try and create an internalised life for the character. This project took me in a different direction; we did huge quantities of work from different sources – postcards, poems, movement, improvisations in duologues, trios and quartets – and from that process I had snippets of four or five characters and I didn't want to bin any of them! I felt like I had developed something in all of them and it became about trying to find a link so that I could be all these different characters in this piece – this 'show' whatever it might be.

Audience member:

I was touched and moved by it and I felt I was being asked to take a look at some issues and things taking place in the world that I need to wake up to. I know the project used the references of refugees and displacement – but then I realised… hang on a minute, this is me that you are talking about… this is me that you are acting out… and how am I relating to some of the issues you are raising?

Prior to working on *Guests* at HFC, I had begun a creative dialogue with the Bach Cello Suites and somehow the suites had influenced the *Guests* research process in a vital, although mysterious way. On the surface the *Guests* research project seemed entirely different from my next project, which I titled *Guest Suites* (2012), although I know that the ensemble research in Cornwall was crucial to the development of *Guest Suites*. The transition from one project to the other seemed very smooth as many of the underlying themes and questions were the same, despite formal differences. As a research project *Guests* gave us time and permission to explore a rich mix of media, techniques and themes which seemed to provide a canvas for *Guest Suites*.

Notes

1. Bertolt Brecht (1898–1956): German poet, playwright and theatre director. He made groundbreaking contributions to theatre production and theory, mainly through his work with the Berliner Ensemble, the post-war theatre company he operated with his wife and long-time collaborator, the actress Helene Weigel. They forged a distinctive visual style known as 'Epic Theatre' and developed techniques of 'Alienation', and use of 'geste' to explore difficult topics about war and poverty through visual, physical and music languages. He collaborated with the composer Kurt Weill on many productions of his iconic plays, such as *The Mother* (1946), *The Threepenny Opera* (1928) and *Baal* (1923).

2. Brett Jackson: mime, clown and acrobat who trained at Lecoq Ecole du Théâtre Corporeal in the 1990s. Based in Cornwall he is the artistic director of Swamp Circus which he founded in 2000. Swamp works extensively in Cornwall and tours throughout Europe working with street and physical theatre and making shows for Big Tops. In 2002 Brett became the development officer for Circo Kernow, Cornwall's circus school, which runs accredited training courses.

3. Ursula Early: actress, producer, Artistic Director of Big Bear Theatre Company. Currently an associate producer at Glynis Henderson Productions. She trained at the Guildhall School of Music and Drama and has performed extensively in theatre, TV and film (including Lansley's film *The Life Class*, 2005). Ursula is a member of the Production Exchange and has been a producer for Old Vic, New Voices. She is an Associate Artist at the Dance Research Studio and will perform in Lansley's new interdisciplinary project *About Us* (2017/18).

8
GUEST SUITES

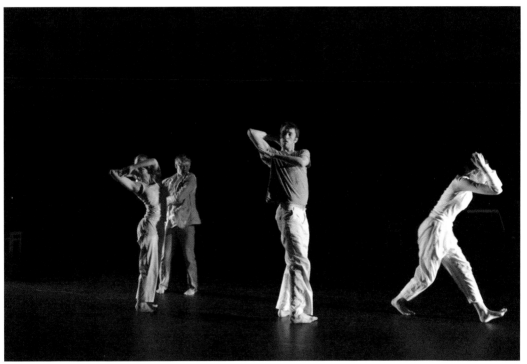

> The dancers were not occupying the space by moving in it, they were people living in the space […] I felt a welcomed guest: I was there, waving to a friend, walking in the street, rushing for a bus.[1]

Many people do not allow dance the distinction of being an art form. What therefore is it? More complicated is the role of the dancer and choreographer – what are they, if not artists? What are we looking at when we watch dance rather than do dance? For some people, when the process moves into composition – making a choreographic object which exploits strategies and disciplines similar to that of painters, writers or composers – it actually, in some way, ceases to be dance; for me, this conclusion has to return to the question – what is dance? The modernist shift towards everyday movement as dance and the eligibility of improvised performance to be choreographic has created a lively and extensive discussion within the dance community. The philosopher Suzanne K. Langer states, '[n]othing has an aesthetic existence without form. No dance can be called a work of art unless it has been deliberately planned and can be repeated'.[2] This supposes that as a performance aspires to the condition of art it attempts to acquire the status of an object. However, can any live performance with its contingent mistakes and vulnerability achieve this status? Live performance is always ephemeral, a condition which can empower the performers, who are creating the performance in the moment, to explore and negotiate with these contingencies; a process which seems to constantly build and dismantle the idea of object.

THE EXCEPTIONAL AND THE MUNDANE BODY

Despite these important conceptual discussions, the fascination with technical prowess and the exceptional body continues to dominate the landscape of 'contemporary' dance over and above other considerations. Alongside many other practitioners, I have for a long time been interested in working with the everyday, the ordinary and the mundane body, the body as a living process rather than a stunning product. These categories of the body are strange and absurd, and yet they hold some reality for us. Our bodies are not immune from the trends and grooming of fashion and food industry advertising, or the pressures to conform to and fit into furniture, vehicles and buildings within distorting urban environments. This manipulation of the body serves world economies and the dance 'industry' is required to be part of all this; yet there is a paradox, as dance and dancers are somehow also required to stand outside of these trends as the 'free' body, the 'pure' body – a tricky balancing act!

Guest Suites (2012) was developed in phases over three years with a group of six exceptional dancers. We were interested in drawing attention to the conceptual and aesthetic languages in the work and to the dancers' presence as part of something bigger, where their skill of inhabiting and embodying the material is fundamental to the whole. Following are quotes from some of the performers who participated in *Guest Suites*; they reveal a little of the extent to which the performers immersed themselves in the conceptual processes of the work, and how they took responsibility for its realisation within the varied sites as empowered performers:

> A particularly pleasurable process was developing the Allemande of the 3rd Suite, which is based on fifteen random images taken from magazines and newspapers. Again, Jacky invited me to embody the images, which is a fascinating process of really becoming the 'thing', not simply appearing like it. At no point did I feel we aimed for a performance of perfection, rather we sought to respond to our environment and venue. This meant being spontaneous in performance and left no opportunity to get too comfortable or familiar with the piece.

Again, I believe it was this spontaneity that enabled a performance of six human beings that performed together, as opposed to a company perfecting their repertoire.[3]

Yet another challenge and/or aspect to *Guest Suites*, were the very different venues we performed at. First was the Clore Studio at the Royal Opera House, where the stage was a conventional rectangle with the audience as a 'front'. The space was opened up by us dancers always being 'onstage', and at the same time watching our co-dancers and Audrey the cellist. This meant that for 70 minutes you performed in some of the pieces physically, but mentally in all of them, as your energy was a part of *Guest Suites* at all times, not only when dancing. In York Minster the audience surrounded the space. For me, this brought yet another layer into the pieces as the audience members seemed to direct all their energy towards us, to those sat opposite them and to the room.[4]

80 *Guest Suites* (Chapter House, York Minster; drawing by Jacky Lansley)

WHY BACH?

Working with Bach was an experiment and an investigation of a relationship between music and dance. Over the last decade I have worked with Schubert's late piano sonatas (*Holding Space* [2004]) and Mozart's Clarinet Concerto (*Standing Stones* [2008]) as well as contemporary composers such as Lindsay Cooper (*View from the Shore* [2007]) and Jonathan Eato (*Anamule Dance* [2007], *Guests* [2010] and *Guest Suites*). How do I work with music? How did Jonathan Eato intervene as a composer into the world of the Bach Cello Suites – and how did we work together on this experiment? These are important questions, yet they don't often get asked in dance practice. Following is some writing by Jonathan which helps to contextualise our thinking and process:

The contemporary condition is a complicated one. It is not simply about privileging the here and now, the latest and most fashionable, but about situating this alongside our understanding

of the past and our hopes for the future. Since Pablo Casals' twentieth century 'rediscovery' and subsequent championing of the Bach Cello Suites, these works have remained a touchstone for artists across a wide range of disciplines and practices. Examples include Maria McManus' poetry collection 'The Cello Suites' which adopts Bach's structure, and Yo-Yo Ma's 1997 film project that pairs the Suites with choreographers, ice dancers, architects, film-makers and Kabuki artists. However, having first discussed this project with Jacky, my principal point of concern has been how the Suites can be opened up to allow contemporary practitioners space for creative engagement and dialogue with the original. To put it bluntly, what room is there here for me as a composer?

Quite early on in the collaborative process Jacky and I decided that I would compose a number of responses – we're calling them Suite Inserts – to the Bach. These would then be interpolated into the performance of the first three Bach Cello Suites that underpin *Guest Suites*. Just as Bach drew his inspiration from dance forms developed in an earlier period, I have written two allemandes, a courante and a minuet, albeit in a highly abstracted form. We also wanted to acknowledge the role that Pablo Casals played in rehabilitating the Suites and so in addition to my interpolations, some movements of the Bach are heard played on historic recording by Casals.

Scholarly research has shown that some of Bach's solo string music is based on inaudible cantus firmi (pre-existing melodies forming the basis for new compositions). My point of entry was to imagine how contemporary dance, choreographed to the original Bach, could reach back to the eighteenth century and embody a physical cantus that in turn supports the construction of new musical architectures that are both removed from, and connected to, the original Bach. From my perspective the exciting thing about working on the Bach Suites in an interdisciplinary context – where performance, composition, sound design, choreography and lighting all offer a creative perspective on Bach – is that different viewpoints are brought into relief, cross-fading the historic with the contemporary.[5]

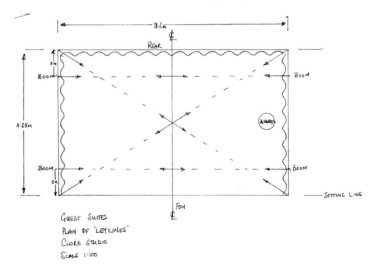

81 Ley Lines (lighting design)

The idea of an underlying cantus firmus from which Bach constructed the existing movements was intriguing and I explored choreography that attempted to provide, at times, a visualisation of this invisible infrastructure; a process echoed in the beautiful and subtle lighting by Jack Robson,[6] who worked with the idea of invisible ley lines.

The cello suites are built from old dance forms – courante, allemande, sarabande, minuet. It is not at all surprising that choreographers should be drawn to them; and there have been many of us. As a very young dancer I had the opportunity to work with the great Mary Skeaping who researched and refound precious historical dance forms. As I mentioned in Holding Space, I was involved in her first re-creation of John Weaver's ballet *Mars and Venus* in 1969, playing the role of Venus as part of a 'Ballet for All' tour. The material was made up of sarabandes and courantes and from this experience I have access to the original eighteenth-century dance forms – which I have quoted and translated in several movements in *Guest Suites*. Bach's music also involves something of the folk origins of dance prior to its refinement in the French court; for example, the courante at court was performed as an extremely slow dance, whereas Bach keeps to the lively running tempo of the country dance that the name suggests. When Hannah Mi[7] and I began to work on the gigue from Suite 3, taking our first steps to place ancient belly dance alongside Bach's cello voice, we were struck by how easy it seemed. Hannah is an outstanding performer and I felt confident she would find the key, but the quality of a gypsy dance was already there in Bach's gigue.

In *Guest Suites* I chose to place the cellist almost centre stage. This single decision was incredibly important for the whole work. It conveyed the centrality of the relationship between the music and the dance and allowed us to engage with the gestural language of the musician. It created an almost constant visual juxtaposition between stillness and movement; between sitting and other embodied

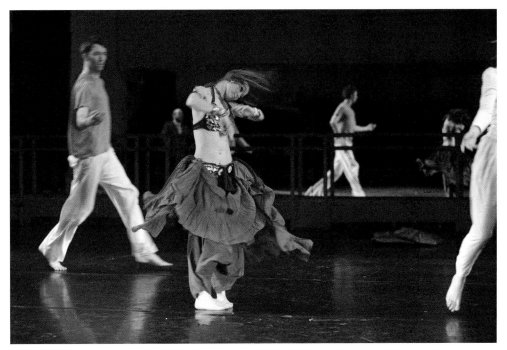

82 Guest Suites

planes – standing, rolling, jumping, running, etc. It provided focus in the space, creating a spatial coherence for the viewer and a place from which to move away from, come towards or ignore. It gave the viewer a sense of where they were. The cellist's position, then, became a dialogue rather than a hierarchical relationship with the performers, in a work where all the languages had equal status.

Audrey Riley[8] is a wonderful cellist who has an ongoing working relationship with the Bach Cello Suites. She also brought to the project her own interdisciplinary background and experience of working with dance (she has toured extensively with the Merce Cunningham Dance Company, performing works by composers including John Cage and Gavin Bryars). In the minuet, Suite 2, she was required to cross the boundary between music and dance as she moved across the space, holding her cello escorted by one of the performers (Tim Taylor). They performed a quiet, minimal, circling duet, accompanied by an historic recording of Pablo Casals playing the minuet.

Jonathan, Audrey and I were very concerned not to be over-reverential and to constantly remind ourselves that Bach in his own life was a working artist, probably struggling with economic concerns and desiring to make contemporary work away from his day jobs as a choir master and court organist. I have said that we were having a 'dialogue' with Bach and that the music was providing a 'text' for the choreography. As collaborators, however, we gave up on the idea of trying to make something complete – that already existed in the music; *Guest Suites* became more a series of questions which we attempted to embed in its form. Jonathan's inserts provided a kind of landing place – a contemporary 'in-between' where we could take a breath – and throughout there was a constant interplay between the contemporary and the historical; it was a multi-layered, unfathomable process.

Suite No.1: Prelude[9]

[The cellist Audrey Riley had mentioned that this first prelude felt like warming up; this was also true of the choreographic experience.]

A solo dancer: a woman.

The dancer is on a diagonal [that is if the piece is performed within a theatrical frame]. There is definitely no focus on the audience – no looking at them – the angle is oblique.

There is a very carefully considered and special relationship between the dancer and the cellist – although they are in their own worlds. They make eye contact, agreeing readiness.

The dancer has soft eyes; they are looking inwards – although the gaze is beyond the fourth wall towards an invisible horizon.

The dancer tests the floor with her foot. She draws a circle with her right foot very smoothly. As though she is feeling sand on a beach.

She repeats movements facing different directions, as though practising but also exploring perspective. The dancer can be watched from any perspective.

The dancer literally holds parts of her body and the spaces left behind where the body shifts and changes position. She lifts her knee in parallel – her foot points down – she holds the lower part of the leg from toe to knee – she removes her leg from her hands and continues to hold the empty space.

The audience is drawn in, invited to fully engage with what they are watching.

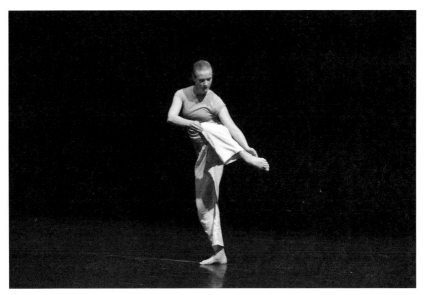

83 *Guest Suites*

Suite No.1: Allemande [Insert by Jonathan Eato]

A trio – three women in white. They walk quickly, aware of each other but separate. They stop three times – arriving in found shapes, almost gesturing. The body shapes, gestures are sculpturally deliberate and vital.

The dancers can be looked at from any perspective. They seem to be mapping out and exploring the space. They find each other and form a diagonal line, dropping into a lilting walk while circling their arms above their heads. The dominant image is relaxed, synchronised circles, echoing a chorus line. They switch focus lifting knees – high stepping – preparing for one of the women, Esther, to be lifted horizontally while turning. They emerge from this gentle lift to spin – each dancer spinning while the others escort them across the front of the space. They settle in a still cluster touching, leaning, resting on each other. They shift into three different still sculptures.

Esther breaks away running – enjoying the space while the others walk on a diagonal slowly; they are in their own world with Bach – playing, breathing, soaring. The running dancer gathers another. They run together as though playing; the energy takes them into a synchronised jump – a jeté followed with high knee lifts again – a spin – a cabriole – the ballet quotes; playful, almost circus like. They are enjoying themselves; they have picked up the exuberance in Bach's allemande. This heightened moment softens; all three come together in the centre of the space. There is an intimacy, friendship, even love. One dancer lies on the floor – the contemporary music hums a drone, not shaped and rhythmic – it is otherworldly.

She lifts her hips off the ground, her legs rising straight above her – another dancer pulls and supports her leg upwards as the music soars. They shift into another tangled lift. This intense trio moment then disperses as they again walk, mapping the space… the

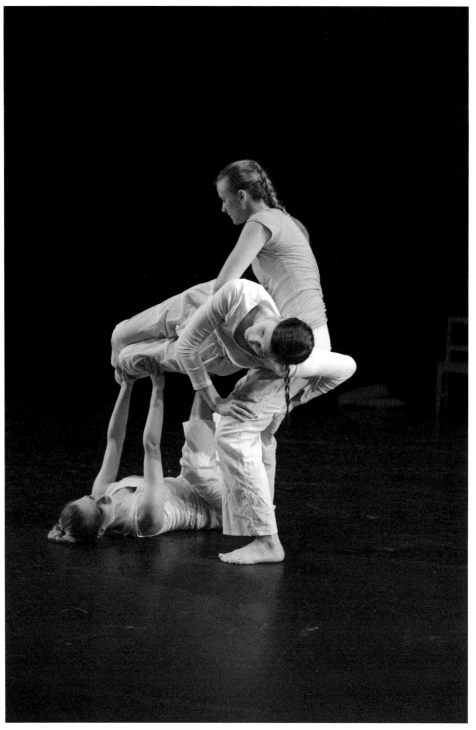

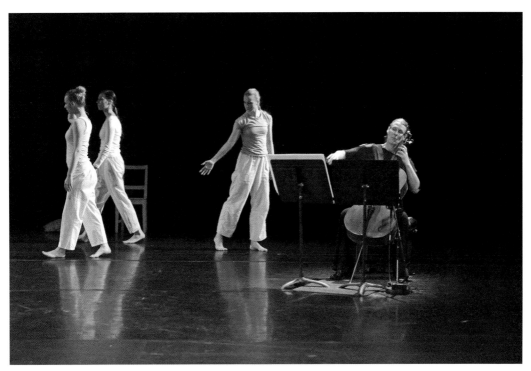

music repeats, they repeat the chorus line – the horizontal lift with Esther – the spins, the escorting, the arrival together, the exhale and the stillness as a living sculpture. This moment demonstrates harmony between the women and between the music and the dance.

Eato's music provides a difference – a contemporary flexibility that opens and reveals the beauty of Bach. Choreographically it provides a space – a stepping stone as though to gather strength to engage with the Bach again.

Suite No.1: Courante

[The process of making this dance began in 2009 with a simple idea of tone and release; propping and holding; ordinary and special.]

The three women spread through the space.

The movements work with the pulse of the courante. Perky, angular, quirky, awkward movements that are grasping and giving.

A whisper, a flavour of a courante – down up up, down up up…

Challenging, busy women isolated from one another. Coming together at the end and flicking off the stress… the debris.

Suite No.1: Sarabande

The watchers appear.

Two tall women balance two large cushions on their heads.

The cushions have a slight period pattern in beige and gold – a suggestion of the eighteenth-century drawing room. The same cushions provide 'salon' floor seating for the watchers.

This piece hints at a narrative; young women practising deportment; walking backwards in perfect symmetry on opposite sides of the 'room'. Halfway around the space they carefully remove the top cushion and stuff it under their T-shirts – as though pregnant. They continue to walk backwards practising their deportment while pregnant.

Two other people, a man and a woman, watch this exercise; one sits on a stool, the other a chair – which are also part of the salon furniture. When the two young women have completed their square journey the watchers pick up their furniture and walk to the centre of the room facing in opposite directions towards the 'front' and the 'back', each observing one of the walking women. At the start of the second leg of the women's journey, the watchers stand and carefully replace their furniture so that they are facing each other. Only when the deportment dance has finished and the women are no longer pregnant [having removed the cushion from their T-shirts] do the watchers look at each other.

This sarabande explores the perspective of both the performers and the audience. The presence of the watchers makes clear that the 'dance' can be viewed from any perspective –

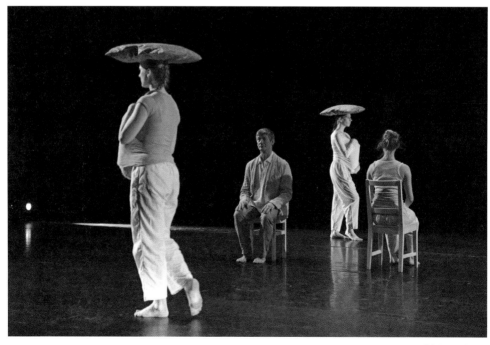

both physically and conceptually. This idea is underpinned as the women walk backwards – reinforcing the idea that the back view is as important as the front. The body is three-dimensional, not just a theatrical front. The watchers seem to invite the audience to join them as they explore watching from different positions. [We did discuss the possibility of inviting the audience into the 'room' and later in the piece this happens.] The watchers also denote the visual, the gaze, the scrutiny. There is an Edward Hopper-like[10] certainty to the piece; the watchers in contemporary 'neutral' clothes observe the eighteenth-century characters moving across the space; they are the still viewers watching the moving picture. The whole distils a contemporary/historical narrative.

Suite No.1: Minuet I & II

The dance works closely with the music – on the phrasing – and is highly structured. Hand movements that suggest opening and closing doors as Tim steps forward and back with sharp but lilting steps. The hands carve out the space, a gestural action that hints at an eighteenth-century minuet. He is a distinctive character – we don't know who he is – but his presence introduces a different, more theatrical and narrative form. He is a guest.

A young woman [Huri Murphy][11] stands opposite him; she is one of the young women who were playing at being pregnant. There is an idea that they are meeting in the same room – they may have a relationship of some kind – Father and Daughter? Lovers? Dancing master and student? Together they repeat the same neat symmetrical movements facing each other as though minueting – they could be having a conversation.

They break apart and promenade around the room in opposite directions passing at the apex – thoracic spine held high, heads in épaulement – they walk high on the balls of their feet – up up down – like a sedate Martha Graham triplet.

They meet again in the centre and repeat the ritual dance structure – a new gesture emerges – anguish, desperation, they both hold their heads in their hands as though having a small nervous breakdown. The 'drama' of the gesture is surprising, an unexpected emotional image. It is the gesture that conveys this story – they don't 'act' it out. They separate and come back together.

Unexpectedly the gentleman draws out a letter. We the audience understand that a gesture he has repeated – drawing his hand towards his pocket and twirling his wrist and hand outward towards someone as though presenting something – has prepared us for this moment. The young woman does not take the letter! They triplet sedately around the room again – the gentleman puts the letter away.

They come together in a kind of embrace – a very different released movement language – they hold each other's heads – it is almost passionate. The gentleman draws out the letter one more time; the young woman does not take it and leaves.

Suite No.1: Gigue

This movement begins in silence. Two women meet and hold hands using the contact to loop and duck and lift each other. After the richness of the Bach we listen to the silence. We the

watchers are intrigued – the space has become like a classroom. As the women explore, a very tall young man walks past them; he glances at them in a relaxed manner and joins another woman in white who is 'waiting' at the side of the space.

The first couple finish their opening episode and walk to a starting point to begin a definite synchronised buoyant dance with the music – a bounce with light skipping steps. It seems now that the first sequence was a 'warm up' in silence. As they begin this sequence the waiting young man and woman walk to a starting position and repeat, exactly, the linked dance of the other couple. The silent episode encourages us, the audience, to think about what the choreography is doing with the music. Humour is also there.

Silence returns and we listen to footfall and breath and watch the still cellist who is clearly intrigued. The dancers are all incredibly different – like all human beings – and yet the choreography requires that they perform the same tasks and movements. But there is space for difference. Some conventional dance gazers may find this vulnerable. Most find it fascinating and it is this difference that creates emotional empathy.

Suite No.2: Prelude – with Ayano

[I first developed the prelude from Suite 2 with Ayano Honda who was not able to participate in the final performances; her contribution, nevertheless, was very important.]

Ayano seems to become the cello; most people would create cliché with that task.

She first improvises to/with the music to explore a relationship. She is an exquisite dancer – she has a great sense of stillness and quiet which she is able to combine with a breath-taking technique when required. She has absorbed some of the qualities of traditional Japanese performance disciplines and is able to distil movement, image, beauty and passion.

We reflect on her improvised response and discover there are particular pathways and a distinctive use of planes, e.g. a long episode on the floor. We keep these structures and focus on one or two movement motifs.

The solo begins with a very slow diagonal walk which has the still, gliding quality of a Noh actor. She then progresses along 'the front' very close to the audience, gently changing direction as she travels. She then stands and drops very slowly to the floor, as though dropping forever; she is then on the floor writhing, rolling, feeling, pushing against it. There is pain and pleasure in this episode.

She stands slowly – pushing up through the atmosphere, eyes deep within her, yet outward to the horizon spiralling, turning, dropping, rising – and then a huge leap – Bach and the dancer leaping together – back to a starting point next to the cellist and yet everything different.

Suite No.2: Prelude – with David[12]

David also improvises with the prelude. It is free yet contained within a familiar vocabulary of Cunningham, Aikido, Release and Street Dance. He has strength and a compact quality for such a tall person – it is magnificent to see him gliding, falling, lifting, running. The lines go on forever.

He really enjoys improvising with the music – and he is an extremely musical dancer – he understands and feels the Bach. Having done a big free improvised dance, he explores a very minimal and contained version. This too is very powerful – all is expressed internally, supported by a few small gestures going outward and inward. It hints at narrative – at loss.

[We talked about this and we both cried a little. Somehow we agreed we would create a solo that combined both experiments, both journeys, the large and the small.]

Like the prelude from Suite No.1, this prelude also suggests 'warm up', an idea of exercises. David performs sequences of tendus, glissades, chassés – creating horizontal, vertical lines with his long arms and legs. Perspective is deliberately explored, as he repeats sequences 'facing' different directions.

[This idea was explored beautifully and much more fully at York Minster in the thirteenth-century Octagonal Chapter House.]

David has a gentle way of placing gestures in space – we, the audience, watch a kind of moving sculpture which demands our attention. He watches Audrey the cellist – there is an understanding between them. As he returns to the repetition of the classroom movements – we are moved. There is a sense of the dancer's struggle, the task, the effort of repetitive work. Bach too reminds us of the ongoing repetitions and struggle. At one moment David jumps from a crouched position throwing up his legs in a split jeté position – it is breath-taking. At another moment he performs the moon walk and becomes Michael Jackson – he is versatile and charismatic – he leaps out of the frame at the end of the dance – leaping away he runs, he walks, he looks back to the cellist…

I did not complete the process of 'Writing Choreography' for all the movements in *Guest Suites* – it is a process I would like to return to, although the time lapse will produce something very different. I feel privileged to have been able to make *Guest Suites* and like my other works it came from a deep feeling of necessity. Given the lack of financial resources for work at this scale one would *have* to be supported and propelled by some wiser logic, otherwise it would all be too hard. A positive outcome from the *Guest Suites* project is that I want to experiment more with context and find fresh spaces to take my work; spaces which do not feel arbitrary or compromising, but are supportive and right for the work. In 2012 *Guest Suites* was performed six times and it was only due to the strategy of performing it in highly visible venues, such as the Royal Opera House and York Minister, with all the attendant marketing support, that it was, to some extent, seen and reviewed. For a project that took three years to make, albeit slowly in phases, six performances is not nearly enough exposure and I would like to remount the work for round spaces, with the necessary creative and financial resources.

As an experienced independent practitioner, I feel I have a kind of responsibility to be seen making and holding the choreographic space. If artists of my generation are unable to do this, it will be much harder for those who follow. In the next chapter I talk to some of my peers who are, in different ways, holding their space and creating vibrant and interesting work in diverse contexts.

Notes

1. Antonia Consonni: teacher of English, Italian and French languages and literatures. She has a Ph.D. in Media Studies and her work on the British periodical press in Victorian India has met with much interest in the academic world. Lover of the arts, she has worked for several Italian and Turkish periodicals as a freelance journalist.

2. S. K. Langer: *Feeling and Form: A Theory of Art* (New York: Charles Scribner's Sons, 1953), 175. Also used in *Postmodernism and Performance (New Directions in Theatre)* by Nick Kaye (London: Macmillan Press, 1994), 71–89 (89).

3. Esther Huss: German-born dance artist who has been living and practising in the UK for over a decade. She has worked with choreographers including Aletta Collins, Jacky Lansley, Michael Keagan-Dolan, Ron Howell, Bernadette Iglich and Kate Flatt. In 2013 she co-founded the Dandelion Collective, a platform for inclusive activities open to anyone with or without a learning difficulty or disability. She is an Associate Artist of the Dance Research Studio and will perform in Lansley's new work *About Us* (2016/17).

4. Sanna Eriksson Ryg: Norwegian dancer and choreographer who trained at Laban. After graduating she joined Chrysalis Dance and later Ampersandance, a Nottingham-based company, before working in opera and with Jacky Lansley. She is currently dancing with Domogalla Dance and working with the youth company Happy Feet in Bærum as a dance teacher and choreographer. She is founder of the Inamorata Dance Company (2014).

5. Jonathan Eato: extract from programme notes for *Guest Suites* (London, Dance Research Studio, 2012). Courtesy of the artist.

6. Jack Robson: lighting designer and company manager for more than 30 years, working with companies including the National Theatre, Sadler's Wells, the Royal Ballet, the Arnolfini and Bristol Old Vic. He has also worked with many small-scale touring companies such as Green Candle Dance Company and New Perspectives; he is based in Devon and teaches at the University of Exeter.

7. Hannah Mi: began dancing as part of the ambient oriental dance ensemble Samanyolu in Tokyo in 2000. She has toured extensively around Europe and the Middle East with musicians Oojami and Dajjah. Based in London she taught at the Dance Research Studio for several years; she co-runs tribal fusion belly dance night 'Firewater' and directs the dance troupe La Zingara. Her style is a representation of archetypes – the wild woman and the sacred knowing dancer.

8. Audrey Riley: cellist who has been a member of the contemporary music group Icebreaker since 1989. She has performed with dance companies including the Royal Ballet, Scottish Ballet, Random Dance and has toured with the Merce Cunningham Dance Company. In 2003 she began her own project, *A Change of Light*, producing new works for cello in collaboration with composers and visual artists. She tutors in composition and arrangement for the Institute for Contemporary Music Performance and teaches the cello at Goldsmiths College.

9. 'Writing Choreography': as in Chapters 4 and 6 the bold text is a form of writing from memory used by Lansley to bring the language closer to the live work and the choreographic process.

10. Edward Hopper (1882–1967): prominent American 'realist' painter. Most popularly known for his oil paintings, he was equally proficient as a watercolourist and printmaker in etching. Both in his urban and rural scenes, his spare and finely calculated renderings reflected his personal vision of modern life in the USA.

11. Huri Murphy: dancer and choreographer. She trained at the Yildiz Tenik University, Istanbul with the choreographer Geyvan McMillen at the Rotterdam Dance Academy and the Northern School

of Contemporary Dance. She works with the Turkish choreographer Beyhan Murphy for whom she performed a solo work *Variations on the Breath* (2012).

12. David Ogle: dancer and choreographer who began his career with Transitions Dance Company and has since worked in a diverse range of theatre, film and festivals. He is the co-founder of MOHOdance and was the movement director for the National Youth Orchestra for which he choreographed a work with the composer Ana Meredith as part of the 2012 Cultural Olympiad. David currently teaches at Stagecoach Theatre Arts, London and works at Maiden Voyage Dance.

9

OTHER VOICES

Throughout 2015–16 I interviewed several experienced UK-based dance artists about their work, specifically focusing on the question 'What is Choreography?' Following are extracts from my interviews with Rosemary Lee, Tony Thatcher, Matthew Hawkins and Miranda Tufnell.

ROSEMARY LEE

> I'm good at making people – audiences, participants – feel like they are the same as the dancer and they rediscover their dancing self whether they can move easily or not. A kind of dancing state which allows us to be more aware of the world.
>
> Rosemary Lee

Jacky: Rosie [Rosemary] what does choreography mean to you?

Rosie: The word choreography should mean a whole vision: of people in space and where they are placed, as well as what they are doing, how they relate to each other and their effect on the environment and its effect on them. The architecture of it – this should be part of the meaning of the word choreography – but I don't think it's always seen as that. So I started to try to call myself an artist, or better still a maker, to try to show that I saw myself as part of the wider artistic community rather than the sort of specialist in one thing who 'makes steps'.

Jacky: As you say, it's about *how* you work with people; that is part of choreography.

Rosie: All of that is choreography, exactly. I'm thinking about my site-specific work now because that's what I've been doing for the last few years: how you engage with the space, the placement of the people in that space, how they move through it, how they engage with it, how they seem to sense it, is central to the process. Through the marriage of use of space, ways that people engage with the movement they are doing and how they portray and radiate that to their audience; how time might be manipulated and shaped, so the audience comes out feeling that they inhabit a different pace and space. For instance, in the last piece *Under the Vaulted Sky* (2014) in the Milton Keynes International Festival, I noticed that people came in chatting and went out whispering, or silent. Well, something has happened kinaesthetically to their mood. It was a daytime performance too, so harder to create this effect.

How is that done? I think it is by changing their relationship to time and making them listen, making them all aware. The big thing for me, I think, is that I love dancers; I love being with people in the dance profession, they seem to be amazingly thoughtful individuals and very disciplined and hardworking. I love how they see the world, it's often quite left field, quite lateral. I think it is the reason why I stayed with dance, because it makes me feel a bit more sane in a mad mad world. I want to give that to my audience; to give them the taste of what it feels like to be in that world, to be able to observe things and to look at detail and to listen and to hear the birds you may not have noticed before, and engage with your shared environment, with the present moment.

As a young dancer I loved discovering new worlds and ways of presenting them; when I was coming to see your early piece *I, Giselle* (1980), and other works, I was there in the audience thinking – 'oh what's this?'; it helped broaden my horizons.

Jacky: How do you start to make work?

Rosie: I start with the dancers and their somatic sensation when they're working with movement. I try to get beginners, people that have never moved in this way before, to sense movement from the inside

and to work with the quality, whether it's slowness or delicacy or floatiness; to engage with how it feels – which is very transformative.

Jacky: Feelings?

Rosie: Yes, kind of sensation, as Nancy Stark Smith[1] would say, 'sensation is the language of dance' – that always stuck with me – and so I really try to get them to feel it, to taste it. To taste it I think is a better word. If it's sensory then one listens more and touches more – and I know it also has a therapeutic value. I am trying to stay with the art and make work that will be seen by an audience, but I am very aware of the effect sensory work has on people actually dancing and on the people watching it. I'm really physically specific and then I worry and I say to the dancers, 'do you think this is too like army manoeuvres – are you getting something as you're dancing this?' And they usually (and hopefully) say 'no it feels like mine', and that's what I need it to feel like.

Jacky: So they have a sense of owning the material too?

Rosie: Yes that's really important because it isn't mine, it's theirs; they are making it for me aren't they? And that is incredible. They are dependent on me and I am dependent on them and I try to really make that clear. If I'm working with 81 people, really every one of them is important to me. They aren't dispensable. I don't ever want them to feel that they are.

Jacky: Talk to me about working with 81 people a bit more. Because that's a very particular skill and experience that you have. There is an artistic rigour in what you are doing, but it is also about community, isn't it? And you've managed to bring those things together…

Rosie: Again that term: Is it community work? Is it community art? When I first started to make work and do less of being a dancer for other people I didn't like being labelled as one thing, so I would go from doing a solo to working with a child to working with a community, to site specific, back into theatre; then I started working with film, then into installation and I tried to change the context all the time. That was partly to keep me from feeling stale as a maker, but I think it was also partly strategic because I thought if they can't put me in a box, I've got more opportunities… going from small scale to large scale with pieces such as *Common Dance* (2009).

Jacky: Returning to your strategy to shift your contextual position. It always feels to me that I am having to create context around my work – which can sometimes be exhausting. I say to young artists that they have to take this on – to keep working, to keep going – but they also have to create the context for their work, because there really isn't one out there for innovative dance practice. It seems to me that you have been very successful at this.

Rosie: My *raison d'être* is about working with people and I can do that working with film and I can do that in an installation and I can do it with live work and I can do it with 81 people or with one person and it's still the same.

Jacky: And that's all choreography?

Rosie: It is all choreography and it's about drawing something out about the humanity and potential of someone, so you can see it and also realise something about your own self in the process. If one really got down to what that might be – it is non-verbal. One can tell people lots of stuff, but then there is

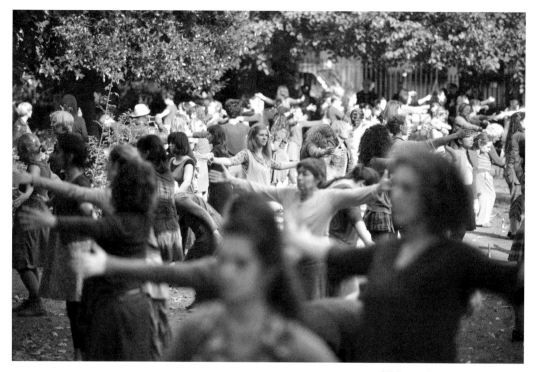

87 *Square Dances* by Rosemary Lee

something else you can do which is non-verbal and that's the bit that is hard to talk about. One can touch people in a certain way with dance, but I think it's quite delicate. It could become spectacle, it could be spectacular, it could be athletic and be wonderful to watch, it's very stimulating to watch people move, but that's not what I'm good at. I'm good at making people – audiences, participants – feel like they are the same as the dancer and they rediscover their dancing self whether they can move easily or not. A kind of dancing state which allows us to be more aware of the world.

Western versus other formative ways of being in the world, I find it all so fascinating. Western dance and contemporary dance are what we've grown up with and they seem to be so much about the distinctive voice, the individual and less about the collective. Our training was all about reinventing, reinventing… to a point where in the first 20 years of my career I worried if I repeated the same move. I thought I'd be found out. Now I don't care. I thought about visual artists such as Mark Rothko[2] who refine their art in gradual shifts and through repetition.

So in the large-scale works that I make, there is a lot of unison, but with a lot of individuality within that. I'm not making folk dances at all, but there is something about being part of the collective *and* staying as a distinctive individual, that I seem rather drawn to creating. So I am very interested in the ensemble and the individual which of course is choreography, but it's the choreography of the world and society.

Jacky: Choreography of the world. That's a very nice thought. That opens up the word.

Rosie: Yes it does, society is a kind of choreography. Town planning and architecture is a choreography, all of that is fascinating. I've always been fascinated by the movement of people, the way they collect

and how they gather and whether they get near each other and whether they don't. The choreography in Japanese cities is so different to here. I love that. It's so choreographed.

Jacky: It's also about a discussion between theatre and art, which I feel gets neglected. If one looks at a Marc Chagall[3] painting, there is a lot of theatrical imagery within it. It's not that theatre can't have a place in art; yet somehow in dance it all gets very polarised with theatre and 'entertainment' on one side of the boundary and the gallery, minimalism, abstraction, concept and form on the other.

Rosie: Definitely. When I was trying to get my film work or my installation work into a gallery, especially with *Remote Dancing* (2004), I actually got a visual art curator to look at the work and talk to me. I said, 'what language would you use to define my work?' 'Oh it's a new lyricism', she said, which I found fascinating. She could see its place and I had some success with this, but on the whole if you say the word dance within visual art contexts, it puts people off.

So to return to the word choreography, for me it slightly mechanicalises the process and I start worrying about choreography looking a bit like notes on the page rather than it being more organic, or more felt.

Jacky: In the end it's about the practice, it's about what you are doing. I was thinking about what you were saying earlier about calling yourself an artist and people thought you meant that you were a visual artist; well in a way you are don't you think? There is an assumption about choreography that because it is often collaborative, ensemble or community-based, that it isn't, therefore, art. Working together, with others, is what we are good at and many visual artists don't have that experience – traditionally they work in isolation and don't necessarily understand our more collective practices; but nevertheless you work with a sense of composition, a personal voice, with space, image and duration – there are many overlaps with visual art practice.

Rosie: I remember the performance artist Gary Stevens[4] once said to me with a slightly puzzled look: 'I would say what you do is not so much a dance but behaviour', and that helped me so much. I never thought of trying to choreograph behaviour but I think he is right. I'm really interested in how we behave with each other and how we touch and how we support and I hadn't thought of that before. It's always stayed with me. I felt it was actually a compliment because sometimes I find artists from other fields don't like dance because it feels too 'dancy' they say... 'Oh contemporary dance here we go, I don't get that'... so if someone from a visual performance world is saying it was like behaviour, I thought OK I've achieved something here. It is choreography but it's more metamorphic and more anthropological – which is something I am interested in.

TONY THATCHER

Most industry post performance talks are about the labour of making choreography [...] It is limiting to talk about an idea in terms of the labour that went into it. No painter talks about the number of painting hours that it took them to make a canvas.

Tony Thatcher

Jacky: I am very interested in your response to the question 'What is choreography?' Maybe you can answer it by talking about your own work and experience of making and teaching choreography.

Tony: When I first came to Laban[5] there was a great concern about how you teach choreography and how it worked in relationship to ideas of composition, time, space and movement language vocabulary.

I didn't want to only focus on training and performance, because it is very easy for an engaging, creative idea to become lost or becalmed amongst the sea of exercises and studio procedures. It's my view that those things can cause one to lose the clarity of what it really is that you want to make. So for me making a site-specific work created a great set of problems in so far as we couldn't studiotise the experience. We really had to be out there in the space, we had to recognise what it was and see what we could do, what the actual space was offering us.

For example, in my work *Scape* (2010) we were ten miles out at sea, in a little boat, checking the winds and staying in touch with the coast guard. The boatman needed to know the gullies that we could move through, which was very exciting. There are only certain times of the year you can go on Goodwin Sands, which are littered with wrecks, so we had to be very careful. It was also a place where one could explore not standing up; the space itself created a vocabulary that moved between almost standing and lying down, or falling and then discovering how to come up from the horizontal and move away from the vertical. We also explored how the body can be changed by the mouldings in the sand, which are very beautiful and gave us new ideas and sensations.

I think my experience of living and working in Holland – being around improviser-composers like Eva Karczag,[6] Steve Paxton,[7] Ria Higler,[8] Pauline de Groot,[9] Jaap Flier,[10] Remy Charlip[11] and Trude Cone[12] – gave me a sense that you can try to find a new ground for the way you might move and think, and so the site-specific spaces were one of the first things that I started to explore when I returned to the UK. All of these experiences informed the way that I *didn't* want to do things, and I said to the teaching community here at Laban that we don't want to swamp students with choreology and rather mechanical ways of encountering movement ideas. What is important is that we understand *how* we might research and interrogate an idea. That it is possible to have *any* idea and find a choreographic and theoretical perspective in relationship to it.

Jacky: Your journey began with a fine art training, so you had a cross-disciplinary reference point right from the start.

Tony: Yes, I came to London having made films at Falmouth School of Art and I wanted to understand what film meant choreographically, what it meant in time, which is how I became immersed in dance and choreographic practice. This experience informed the reason why the Master's programme here at Laban has a film module. We don't tell students that they are learning film-making; we are saying 'you are learning what it means to work with a time-based art that in some respect you can control quite easily and get quick results from'. Asking questions such as 'how long can a long shot be?' and 'what is framing?' These are essentially all choreographic ideas. The idea of multi-screen work is very choreographic in so far as you can set one event off in time against another event in time, and look at the space in between, and you can start doing that with your dancers; I use the term 'dancers' to describe collaborative makers. It's not a good thing to try to limit what could be a choreographic idea by saying to a student, or even talking to a fellow artist, 'oh that doesn't seem to be a choreographic idea!'

Jacky: I'm interested in choreography as art, so what is that?

Tony: Yes, the thing about film is that you are able to look at the way somebody else watches and sees, you become more reflective. You are not caught up in the heat of 'what am I going to do with this dancer, is the idea interesting for them?' One can film anything and already have a distance from what it is. You start to see how something is composed; you start to see how long something should be. We

88 Tony Thatcher

have all had 200 years of visual culture and are sophisticated experiencers of how long something should last, or knowing what is visually interesting. I think what is tremendously interesting about it, is that you really do look in another way because this medium helps you to see what it is that you've done, and that can be *anything*. It doesn't just have to be dance or movement. At the very start of the programme we ask students to shoot about 47 images to last one minute. Then we ask them to change the order which encourages a much greater awareness of how they relate to the positioning of the spectator. It becomes a more personalised, impressionistic, less linear sense of having a dialogue with the spectator.

When we gather to watch a dancer moving by themselves onstage, it can't be helped that people see this in the context of a more conservative frame, in which you're called back to the traditional presentation processes of seeing dancers 'perform well', and all those values seep back into that kind of context. I think you can't help but feel 'I should be looking for a really good attitude now, or I should be looking for a great line'. If you take a piece of choreography that you created and put it in a completely new space, perhaps a utilitarian space – such as the men's changing room here – and then go: OK, what are you going to do with that by relocating it? So we talk about the poetic space, the poetic of the space, by actually looking at a space.

Jacky: Can we talk about movement language, gesture and the sort of emotional inhabiting of the body that is tied into the reflexes and the integrity of one's whole physical anatomy. It is never only about external virtuosity, it is about a quality of presence isn't it?

Tony: Yes absolutely. I'm interested in movement, but I'm more interested in the immediacy of an experience rather than a task that you have to do. That is why I give performers I am working with Alexander Technique workshops. I find movement through touch, their responses to different sorts of touches and different sorts of scorings. Working with gesture is part of the process, but it comes from the idea and a tangible sense of the body in a location – a kind of drawing in the body.

I just recently made a piece where we were looking at a rhythm and we realised that the rhythm was exactly ten seconds, so all the materials came from an appreciation of what could happen in ten seconds. And it meant that it was through this rhythmic understanding of how long something lasted rather

than counting ten seconds. So people learnt this rhythm, it was a very dynamic off-beat rhythm (Tony demonstrates the rhythm by knocking on the floor). So that's ten seconds. But we didn't realise it was ten seconds. People found that rhythm and started making stuff with it in their mind. They could feel it; they could do lots of different things with it. So people already had a sense of a unit of time that wasn't imprisoned by counting it. I've been doing some external examining in Singapore and we looked at some of the folk dances there which have a very similar structure in the sense that people learn and absorb percussive rhythms without counting them as a 4/4 or a 7/8, etc. So what was exciting about this is a physicality of time, which meant people could be engaged with body; dancers are never dancing if they are counting.

Jacky: The role of the choreographer can become problematic; can become seemingly authoritarian or something undemocratic – telling dancers what to do. This may be a very simplistic view of the process and one that ignores the rich variety of methodologies that contemporary choreographers around the world are exploring; however, it is a perspective that seems to continue – this reluctance to allow choreographers the space and dignity, if you like, of artistic authorship.

Tony: I think one of the pressures on choreographers that is different from other artists is that we are called upon to show that we are good through labour. Most industry post-performance talks are about the labour of making choreography; showing the audience that it is hard work that takes a lot of time in the studio. It is limiting to talk about an idea in terms of the labour that went into it. No painter talks about the number of painting hours that it took them to make a canvas.

Jacky: It seems like choreographers have to justify the work through everything but the art.

Tony: I think a similar problem exists in training, where students naturally think 'I'm in class and this will help my choreography, or my choreographic idea' – and I keep saying that training in a dance class is not necessarily going to help you examine or interrogate an idea you have for choreography. You and I talked earlier about performers – those who really understand the different sort of strands that make up the work and those who offer a very polished technical process, which gives a sophistication that is not necessarily appropriate to the nexus and intentions of the work.

Jacky: Yes, I think the relationship between choreographers and performers is central and one that is very complex. So Tony, what is choreography?

Tony: It is something that we shouldn't define.

MATTHEW HAWKINS

> Maybe ideas have fragility; certain pigments fade in the light […] It's quite possible that some really meaningful and innovative piece of artwork has a similar quality. It actually gets used up under scrutiny.
>
> Matthew Hawkins

Jacky: Matthew, I have been asking a number of people – what is choreography?

Matthew: Sounds like choreography could be centrally about the body (core/corps) and an act of visualising this graphically. But grab the dictionary and you are faced with a connection to the Greek word CHOREA which is more to do with uncontrollable impulses or twitches (Huntington's Chorea)

and historically associated with the St Vitus Dance, where contaminated unfortunates lurched uncontrollably. I think it is questionable whether you can designate meaning in a word by only looking at its derivation, because a word means what its usage is, as much as its derivation; if you sidestep what the word choreography is tied to in the lexicon – impulses and energies that come unbidden – you can think about it differently. In China, there doesn't seem to be a direct translation for the word choreography; the formula used there comes out in English as 'dance-editing'. So a choreographer in China is a dance editor. I thought it was interesting to find that out, because to me that implies that somehow the dance could be already extant in some larger way. The rightness of the dance is a pre-existing thing and the editor tries to draw that down with skilful cut. And what is that raw footage? It is fascinating that there is no one word for choreography in China, whereas we apply the one word to the several thing.

Jacky: I have also been asking the question – what is Independent Dance?

Matthew: You and I were both in a big ballet company; that's not independent practice, that's institutional. In that context, one surfaces within a developed repertory which is part of a big popular reach. What is independent dance? Independent of what? I think it's a question. Is it something you are doing that nobody's asked you to do? Is it a sort of unasked for creativity, which if you think about it, could be the only kind with real credibility? On the other hand, a professional practice of any kind seems to need partners, cohorts, collaborators and maybe programmers. So what is the independent practice? Is there a way that independent practice looks? Is there an attitude? I have been really pondering these questions. We mentioned Frederick Ashton because we can. At a certain point Ninette de Valois and he had created an institution (that big ballet company we were in at different times) which became a great public utility; then it was not so much that Ashton himself was making the entire statement with his choreography, but that the institution itself started to be the statement. For example, any of his works that were more inspired or better judged, would start to look great anyway because of their setting. I believe he had an astute knowledge of all this. And clearly his energetic work had earned its right to be there, where it starts to be a statement that is naturally amplified by status. Some artists long for and even deserve this of course. It's a trajectory, isn't it? But maybe independent practice rather shies away from that idea – it wouldn't be *you* making the statement it would be the institution that you were couched inside. This is moot for contemporary dance makers who now get picked up and supported by large venues and organisations. Their surroundings speak volumes.

Jacky: You seem to traverse different worlds quite happily. Painters and sculptors with long careers are allowed to be eclectic and that's perfectly legitimate. They are not regarded as dilettante and unserious, but somehow it seems very difficult for choreographers to change and do different things.

Matthew: To turn the corner… I worked a little bit with David Gordon[13] recently who came to teach a course in Scotland. He has a very good way of seeing people's work and making some crucial points. He said he thought there was that something about my work which was always about *what's around the next corner*, and in a way that is great – or just absolutely exasperating, because you think you are seeing something from me – but maybe there's something else pending? In my work I never quite stop and tell you – and he suggested that was potentially a flaw – that it never quite integrates into a particular statement. So there is an evasion about this continuing 'to turn the corner'.

89 Matthew Hawkins

Jacky: Is there possibly a deliberate artistic choice in there? That you are almost concealing things within the work because you are actually trying to avoid the stereotypes of the industry?

Matthew: Maybe a commitment to making some sort of statement that could be seen and that could be acknowledged, whether it's a very gripping, fascinating statement or not, would enable confidence in one's own process and choices.

Jacky: For better or worse, and actually even with the flaws…

Matthew: Exactly. The times when I have had a few seasons where things have really come together and I was able to really make a particular statement, I usually found that there was a delight in that. There again, there is always the possibility that one would also expose the flaws and limitations of the thing itself, which could cause a cooling of interest. Maybe ideas have fragility; certain pigments fade in the light. Some beautiful things do fade in the light. It's quite possible that some really meaningful and innovative piece of artwork has a similar quality. It actually gets used up under scrutiny.

A practice like mine involves personifying a learnt form and expressing that to others through teaching and performing. I'm always there in dance class, in a way, personifying the thing which makes the class happen, and makes it continue for weeks and months because, as an experienced 'older' person, I'm pegging things down and personifying learnt things. Now there is only a tiny little iceberg tip of that practice that surfaces in the public gaze in conventional performance and those things are rare. I found that maybe that's how it's supposed to be for me.

Going back to this idea of independent practice and how I am maybe a single physical link between the different modes of my practice; I work with a special needs class, they won't necessarily come and see me in a show, but then they know me as the person in a room with them at that time. Then there are people who go to the ballet classes I teach and see me dance there and those people won't necessarily realise that I teach people with special needs, or perform, so, you know, I am enjoying being a single agent. I feel licensed to rate the full potential of each thing I am doing, whether

it involves drawing on teaching skills, using an ability to personify a system, moving to elevate a single class, or just being invited to talk about this with conviction. It becomes an independent practice in the sense that each of those disparate events is freestanding. That is a freelance practice and eclectic practice. You're not simply doing one thing to serve the other thing. It used to be that I had a hierarchy of what I thought was more important than another thing and that's where it all can get kind of curdled, actually. It took me some time to realise that was all complete nonsense and that it's more interesting to put that fullness into the thing that you are actually tasked to doing at any particular moment.

Jacky: Are you working with any new choreographic impulses?

Matthew: I'm looking at the methodology from a solo made exactly 20 years ago. This was *Alone in Your Company* (1996) where I moved around in the atrium of a new hospital building for days at a time, grazing somewhat on the public motion and setting, to form choreography. Except for the call of anniversary and what this might mean, this current look at the archive has been un-asked for. But meanwhile I have been approached by a contemporary music group to tackle an iconic work for chamber ensemble and solo dancer. This all feels connected.

MIRANDA TUFNELL

> I think that if one person begins to feel, they begin to question and look with more depth –
> and this cascades through their family, friends and colleagues.
>
> Miranda Tufnell

Jacky: I want to ask you what you think about choreography…

Miranda: Do you mean how do you make a piece?

Jacky: Yes, making comes into it, absolutely. I know that you are involved in constructing – in making, aren't you?

Miranda: I am still making. It's been an incredible journey, coming from a traditional dance training at The Place (London School of Contemporary Dance) and delving to find what one's work is really about. The questions that drive one through a lifetime – what is it one is seeking to make visible in and out of all the pieces one makes in a lifetime? For me it has been about perception of space, of the ways things move and are changed through space, through time. What becomes visible through a body in space? I think that is at the heart of it.

Jacky: What is so central to the work we do is the negotiation and relationship with other people – performers, other artists. If you are an artist and have particular processes and ideas that you want to explore and you're inviting other people to go on that journey with you – but nevertheless you're holding some kind of authorial voice – creative negotiation becomes vital. How have you negotiated those questions when working with other people and doing your work?

Miranda: Well every phase of work has been different. Each of them has called up work created through different kinds of relationship. When I was working with Dennis (Greenwood), which was a nine-year working relationship, everything was so co-created. In some ways I took final shaping decisions, but actually whatever we made was a dialogue in process. All our work was about the nature of dialogue

and conversation and the way we are always in this place of exchange and interchange. It was a process utterly dependent on the nature of our dialogues through movement; *Silver* (1982), *Night Pieces* (1984), *Chair Piece* (1979) were all co-created journeys in particular landscapes. When you're working just with one other person, the closeness and the sensitivity to moment-by-moment invisibles is profound.

Most recently I've made a piece, which involved five people – two musicians and three dancers. I'm not in it, partly because we had to work extremely fast. It needed somebody taking very fast outside decisions to shape it. I would come up with a movement seed or territory – and then share it with a dancer who would develop it further – and then we'd gradually shape it in time and in relation to the others. Nothing is set – the challenge is to find some essence of form that allows continual re-creation. I am no longer interested when work becomes too set, I'm interested in a person at the edge – and the kind of decisions they are making in the moment – finding structures to elicit, to enable that.

Jacky: You said that the work very much depends on the relationship, and so feelings and life experience comes into it…

Miranda: Absolutely. We're sifting up a territory through movement. Through responding to each other in movement, until these invisibles become a conscious rather than a subliminal territory. I think of the material being immanent within somebody, but not explicit. So there's this phase of sifting up to the surface. I always use writing quite a lot.

Jacky: Your very early book, *Body Space Image*,[14] held the qualities you talk about; you were writing the physical language. It seemed very close to the experience. It's interesting because it is as though you have had another form to externalise the practice: the book, the writing, the words are not separate from the embodied process.

Miranda: The second book, *A Widening Field*,[15] took nine years to write; it was a long seeking, trying to find a way to give language and words space to be experienced in a bodily way. So in that sense the book is like choreography, a choreography of space, image and words. Only in poetry does one get more of multidimensionality. Mostly language condemns us to a linear sense – which is not at all like the bodily experience; it's very difficult to convey the multi-layered nature of any one moment – and that is what really interests me. So I work with metaphor and imagistic language. The spaces, the gaps and the silences are just as important as the actual words, or the actual movements.

I think it is a challenge to really stay with an open improvisatory mind – not to play safe with the known or predictable. When Sylvia (Hallett) and I were making work together – we gave ourselves the challenge of always entering the piece as if it had never happened. That was our first instruction to ourselves. In that way we avoided habit and the rut of doing what is familiar and predictable. We both stayed on the edge within a territory, or series of rhythms, images, movements that we gradually sourced and which became a particular piece; it could be deeply unnerving, especially in performance. I can think of one time when my body and mind went blank and I could not feel – I was dry – and could not drop through to the perceptual openness, that inner space or state of mind, where one is completely present and imaginatively alert. I was onstage frozen in a strange vacuum. I felt as if all the air had been sucked out of me – and was unable to move. After that I thought I would never dance again; I was so internally shocked, shamed.

Sylvia and I would work on something over a year developing a landscape of imagery and sound – and in performance that particular landscape was created anew each time: both musically and

movement-wise. We were seeking an emergent form and a trajectory in which we travelled on each other's minds and imagination. This may seem as if we could just turn up and perform, but it takes body time to get in tune with a space and to see it for what it is – what is visible in it. I need to hear a space with my body – the walls, the floor – and to feel it. It is a slow process – getting in tune at many levels.

Jacky: Slow is good.

Miranda: *(Laughs)* Thank you!

Jacky: I also wanted to ask you about the artistic strategies that you use – and the word 'minimalism' comes to mind. Although you're working very much with your own voice and within your own sphere, your aesthetics could be described as drawing on modern and postmodern artistic movements. To what extent do you relate to that?

Miranda: I don't feel minimalism is so relevant now. Initially I had to clear my eye and my body from certain predictable patternings of movement imprinted from traditional dance. I worked with everyday movement and took simple actions like walking and played with all the permutations of step, rhythm, etc. just to make visible the extraordinary richness and complexity within the pedestrian and everyday. I had to wipe my mind clear. Everything since then has layered up on attention to detail – now, I'm really interested in a metamorphic, mercurial nature of each person. If you saw our latest piece, *Pneuma* (2015), I don't think you could call it minimalistic. I am seeking the wild!

Jacky: It seems also that you are bringing other, emotional, 'therapeutic' processes into the work; is that part of it?

Miranda: I don't see any separation between my therapeutic work and my performance work, because I think they are both about listening and perceiving undercurrents, the invisibles in a person or between people, or between people and a place. Therapeutically, when working with injury, pain tends to cause a part of the body to isolate itself – a listening touch helps restore flow in injured tissue, which helps it to heal. When I say the body, I do mean the whole of what it is to be a human being – I don't think you can separate body and 'the soul'. I've always found the word 'therapeutic' a very awkward word. I think the arts are healing just by their very nature in making us more whole. There isn't any separation between artistic and therapeutic, they are both arts. I often think of that Rumi line: 'This being human…' in this crazy time dominated by a language of consumerism, targets and quality assurance, to come back to what feels REAL, what feels human and humane, feels essential.

Jacky: I think that's right and if you look at the big issues that affect us all: climate change and the environment, poverty, gender inequality, wars – issues that seem to be getting worse (they're certainly not getting better) – it seems that the arts is the only place to be. One of my concerns, which links to the importance of the arts in society, is the invisibleness of this rather ephemeral form, 'dance', that we're all working in, which isn't product-like or object-like; it's to do with the live event and the *now*. As a result, it's quite vulnerable and often remains invisible – but not in the way that we want it to. That's why I think your books have been so important. Do you think about that?

Miranda: I think that if one person begins to feel, they begin to question and look with more depth – and this cascades through their family, friends and colleagues. I think there are some artists who have a

huge global voice and I don't have that kind of energy or charisma, but each of us can put our shoulder to the great wheel where we try to create change. I would not be alive but for the arts, my heart would have broken with the state of the world. Yet over and over an artist's voice rings out and I feel the potency of their care and know that it matters and that we have to make our care matter – and that mattering comes through feeling which is what I think we dancers can bring to the situation. It feels like the present crisis, as much as anything, is a crisis of aesthetics, of a lack of feeling: feeling for, feeling with. That's where I think the whole realm of the arts is so important; so we have to all carry on.

Jacky: I think the carrying on is very important – many have not. We are people who have continued and we take our practice very seriously and I think that's important for younger people to see that we're doing that. So what is next Miranda? What are you making now?

Miranda: I'm working on another book called *When I Open My Eyes*. It's a book for dancers working in health, about the absence of the body in health; it is a book with voices of many practitioners, so it's different to the other books. It's trying to give a window into practice. I've worked fourteen years in the NHS (National Health Service), and know how much an arts practice can bring to how people manage illness. It's not an academic book – I hope it inspires and speaks to this territory of listening to the body.

Jacky: It sounds like it will be a very important book. Returning to my question about choreography, it is interesting that the word triggers such different responses amongst the practitioners I have been talking to…

Miranda: Choreography. I haven't looked at its etymology; the term implies hierarchy and control. In some way it's like the word 'dance'. Each has so many associations, it does not feel like a word for our times.

90 *Pneuma* by Miranda Tufnell

Jacky: There are frustrations there, because we have now had in the UK 60-odd years of contemporary and radical dance activity, but you have probably noticed yourself, if you travel and talk to people in Europe or the USA, the perception of the work going on here in the UK is not particularly good. It seems that artists like you and I have to work in the interstices, the in-between, don't we? But I think that can be a very good place to be.

Miranda: Yes I think we are people at the edge. And I think we also draw a lot from other art forms and disciplines, but we are not *of* those disciplines – so we are also between people, not quite this or that and I feel that gives us a certain freedom. Our work cannot be pigeonholed – it is a good place to be, in the in-between. I absolutely love our work. It's always drawing me on. Sometimes I lose heart and decide to be a gardener but something catches my interest again and I am back to dancing again. Like you I sometimes feel I'm not moving enough, yet the moment I am back in the studio and moving I feel an exhilaration – this is my language, this is the way I am able to see.

ARTISTS' BIOGRAPHIES

Rosemary Lee

Rosemary Lee has been choreographing, performing and directing for over 30 years. Known for working in a variety of contexts and media, she has created large-scale site-specific works with cross-generational casts, solos for herself and other performers, installations and films. Recent projects include *Without* (2013), a seven-screen video installation capturing a panoramic view of the city of Derry/Londonderry with over 400 participants gliding and moving through the streets; *Liquid Gold Is the Air* (2015), a triptych video installation shot in a cathedral of trees with 80 dancers and touring galleries and cathedrals; and *Calling Tree* (2016), co-directed with Simon Whitehead involving three to four singing, talking, climbing performers in a mature tree. Lee also writes, guest teaches and lectures internationally. She is an Associate Artist at ResCen Middlesex University; Senior Researcher at C-DaRe-Coventry University; Associate Artist at DanceEast and Artist with Artsadmin and Work Place, London. She was awarded an honourary doctorate from Roehampton University.

Tony Thatcher

From large ensembles (De Ereprijs – Holland; Muziek Lod – Belgium) to percussion quartets (Studs – with Jim Fulkerson, USA), Tony Thatcher is known for his choreography with live music. Thatcher was educated as a dancer/choreographer at Falmouth School of Art and Goldsmiths, University of London, England. He gained his MFA from Bard College, New York in 2001. He was also educated as an Alexander Technique teacher at ATON Amsterdam under Arie Jan Hoorweg. His company, Dancework, based in London (with Christine Juffs), allowed him to introduce new American choreographers and teachers into London's developing dance scene. As a founder faculty member of the Center for New Dance Development (CNDD) and the European Dance Development Center (EDDC) in the Netherlands, he contributed greatly in helping to establish a major centre for experimental teaching and performing in Europe (1989–2002). He is currently head of the MA programme in Choreography at Trinity Laban Conservatoire of Music and Dance.

Matthew Hawkins

Londoner Matthew Hawkins joined the Royal Ballet in 1977, where he danced in works by Petipa, Fokine, Nijinsky, Massine, Ashton, Macmillan and Tetley. Meanwhile he began to make and show his

own work, supported by studies with Merce Cunningham and John Cage. Independent practice began for Hawkins in 1982: immediately he danced in new work by Ian Spink, Siobhan Davies and Richard Alston (Second Stride) and for Michael Clark and Company (1984–91). He has also danced in new work by Ann Dickie, Claire Russ, Rose English and Blanca Li. A Bonnie Bird Choreography Award, the Chris de Marigny Dance Writers Award, a Digital Dance Award and the Jerwood Choreography Prize each came to Matthew Hawkins in the period 1993–2002: these fuelled the making and showing of his choreographic works; a process that continues in Scotland where he currently resides. Matthew now teaches a wide ability/age-range whilst researching new works, assisted by Dancebase Edinburgh, Dance House Glasgow and Citymoves Aberdeen: supported by professional development and Choreographic Futures awards from Creative Scotland.

Miranda Tufnell
Read English at University College London, before training at the London School of Contemporary Dance and in New York. Since 1976 she has been showing her work in galleries and theatres throughout the UK and abroad, often making site-specific events and in collaboration with visual artists (Tim Head, Stuart Brisley and David Ward). With long-term collaborators, Dennis Greenwood and musician Sylvia Hallett, she created dance pieces where light, sound and movement formed rich and mysterious performance landscapes. In recent years she has worked both in the NHS and independently in the field of arts and health. With Chris Crickmay she co-authored two handbooks on sourcing creative work: *Body Space Image* (London, Dance Books, 1990) and *A Widening Field: Journeys in Body and Imagination* (London, Dance Books, 2004). Recently she made a piece for twelve older people at the Victoria and Albert Museum in response to Julia Cameron's photographs. Her most recent collaboration is *Pneuma* (meaning breath, wind, that which is blown or breathed) with David Ward, Sylvia Hallett, Tim Rubidge, Eeva Maria Mutka and Cai Tomos.

Notes
1. Nancy Stark Smith: American dance practitioner who in the 1970s danced in the first performances of Contact Improvisation in New York City and has since been central to its development as a dancer, teacher, performer and organiser, working extensively with Steve Paxton and others, including Ray Chung, Karen Nelson, Andrew Harwood and Julyen Hamilton. In 1975 she co-founded *Contact Quarterly* – an international dance and improvisation journal – with the artist Lisa Nelson; they continue to co-edit and produce the journal.

2. Mark Rothko (1903–1970): American painter of Russian-Jewish descent. Rothko himself refused to adhere to any art movement, although is generally identified as an abstract expressionist. With Jackson Pollock and Willem de Kooning, he is one of the most famous post-war American artists.

3. Marc Chagall (1887–1985): Russian-French artist. An early modernist, he was associated with several major artistic styles (cubism, fauvism, surrealism) and created works in virtually every artistic medium, including painting, book illustrations, stained glass, stage sets, ceramic, tapestries and fine art prints.

4. Gary Stevens: UK-based performance artist. He creates live performances which bring together artists/performers from different specialisms, as well as video installations. He lectures in fine art at the Slade School of Fine Art, University College London, and runs many international performance workshops including a regular Performance Lab at Artsadmin, London.

5. Rudolf Laban (1879–1958): Hungarian dancer, choreographer and dance/movement theoretician. One of the founders of European modern dance, his work was extended through his collaborators Mary Wigman, Kurt Jooss and Sigurd Leeder. He established choreology, the discipline of dance analysis, and invented a system of dance notation, now known as Labanotation. Laban was one of the first people to develop community dance and reform the role of dance education, emphasising his belief that dance should be made available to everyone. The school began life in 1948 as the Art of Movement Studio in Manchester; it is now part of Trinity Laban Conservatoire of Music and Dance which in 2002 moved to a RIBA (Royal Institute of British Architects) award building in South London.

6. Eva Karczag: dance artist who worked with Strider in the 1970s and the Trisha Brown Dance Company from 1979 to 1985. She has performed her own work in diverse locations, including with visual artist Chris Crickmay, composer Sylvia Hallett and dance artist Gaby Agis. Her performance work and teaching are informed by mindful body practices including the Alexander Technique (certified teacher) and Ideokinesis. She has taught dance at major colleges and studios throughout the USA, Australia and Europe and has been on the faculty of the European Dance Development Center (EDDC), Arnhem, the Netherlands (1990–2002) and at Princeton University, USA.

7. Steve Paxton: American dance artist who performed with the Merce Cunningham Dance Company from 1961 to 1965 and was one of the founders of the Judson Dance Theatre, whose members are often considered the founders of postmodern dance. He was also one of the originators of the improvisation group Grand Union in the 1970s. In 1972 he named and began to develop the dance form known as Contact Improvisation. With Anne Kilcoyne he founded Touchdown Dance in the UK for visually disabled people. He is a contributing editor to *Contact Quarterly* dance journal and performs, choreographs and teaches primarily in the USA and Europe.

8. Ria Higler: Dutch choreographer and performer, co-director of the School for New Dance Development (SNDD) at the Theaterschool in Amsterdam from 1989 to 1998 and now a staff teacher and mentor. She has shown her work worldwide, both as a solo artist and in collaborations. The main subject of her teaching is movement research, based on her knowledge of modern dance, release/alignment work, voice work, studies with the Indonesian movement meditation master Suprapto Suryodarma and chakra work in motion.

9. Pauline de Groot: choreographer, dancer and teacher who was one of the early pioneers of contemporary dance practice in the Netherlands. In 1968 she founded a school in her studio, which later formed the foundation of the School for New Dance Development in Amsterdam (SNDD). Her work has integrated the movement disciplines of t'ai chi, chi kung, Alexander Technique, Release Technique and Contact Improvisation. As one of the main teachers at SNDD for many years, she has been a major influence on several generations of dance makers.

10. Jaap Flier: choreographer, dancer and teacher; he was a founding member of the Netherlands Dance Theatre in 1959 and worked as one of its principal dancers. He served as director of the Australian Dance Theatre (1973–75) and the Sydney Dance Company (1975–76). He then returned to the Netherlands where he has continued to work as a choreographer and teacher. In 2016 he made a documentary film of his life and work *Solo*, with film-maker Jellie Dekker.

11. Remy Charlip (1929 2012): American artist, writer, choreographer, theatre director, designer, teacher and author/illustrator of 29 children's books. He was a founder member of the Merce Cunningham Dance Company, for which he also designed sets and costumes. In the 1960s he created a form of choreography, which he called 'air mail dances'. He would send a set of drawings to a dance company, and the dancers would order the positions and create transitions and context, without Charlip's further participation. He directed plays for the Judson Poets Theatre, co-founded the Paper Bag Players children's theatre company, and was the director of a 1962 production of Bertolt Brecht's *Man Is Man* for Julian Beck's Living Theatre. In the 1980s he moved to San Francisco where he continued to be involved in arts and community work.

12. Trude Cone: dancer, choreographer, teacher; she was co-artistic leader and study director for the School for New Dance Development (1989–2000) and Director of Dance Departments at the Amsterdam School for the Arts (2000–05). She has continued to teach in a variety of contexts and has developed a coaching method called 'Moving Thought' for professionals who are interested in working with early movement patterns and development as a filter in their own practices. She also works with adults who have come to an emotional standstill, supporting transformation through movement.

13. David Gordon: American dancer, choreographer, writer and theatre director prominent in the world of postmodern dance and performance. Based in New York City, Gordon's work has been seen on TV and in major venues across the USA, Europe, South America and Japan. Twice a Guggenheim Fellow (1981 and 1987), Gordon has been a panellist of the dance programme of the National Endowment for the Arts and the New York State Council on the Arts. He is a member of the Actors Studio, and a founder of the Centre for Creative Research. He is married to the actress and dancer Valda Setterfield.

14. Miranda Tufnell and Chris Crickmay: *Body Space Image* (London: Dance Books Ltd, 1990).

15. Miranda Tufnell and Chris Crickmay: *A Widening Field: Journeys in Body and Imagination* (London: Dance Books Ltd, 2004).

ONWARD

For many practitioners the word choreography is complicated; so too, it seems, is the word dance, despite the fact that it is probably one of the first words a child will understand in many cultures. My conversations with artists in the previous chapter explored some of the reasons why these words, for them, have become complex – reasons linked to fundamental concerns about what is important to us as artists and human beings. I like one of the definitions of choreography used by the artist Jonathan Burrows:[1] 'Choreography is about making a choice, including the choice to make no choice'.[2]

Where choreography and dance is made, seen and participated in, is obviously crucial to how it is perceived and experienced and I have tried to explore this question of space and context throughout the book and over a long time span. The journey reveals, I believe, that there have been missed opportunities for independent and experimental dance practice to have a more supported and visible trajectory. However, as we know, *not* always being in the limelight gives a certain freedom to explore, change and develop; it creates the opportunity to learn through mistakes and to be closer to the realities of everyday experience; it allows us to be artists.

The question of where to place experimental choreographic work is, I believe, critical and is evident in the shift that some artists have made from theatres to galleries as preferred sites.[3] The cross-disciplinary links between visual art and dance, painters and choreographers, exist through the work of several generations of radical artists – and the discussion about dance in galleries has been going on since at least the 1960s. The choreographer Rosemary Butcher[4] was one of the few UK-based practitioners who made significant dance work within the gallery context – a context that seemed able to frame and support her spare, visual works that are free of the theatrical mechanisms that most usually are part of dance. She said this about her work:

> I have worked in galleries because of the nature of the work. I think that the work is better when intimately viewed […] it seems that I have taken an attitude towards dance that collides with visual art. People have told me that what I do is quite painterly. Certainly, the process is about making images happen as on paper or in sculpture, rather than creating prescribed movement.[5]

The fact that Rosemary Butcher was able to work within the more conceptual world of galleries as a choreographer is, in the UK, unusual. As the artist Rosemary Lee discusses in the previous chapter, most galleries continue to be wary of live performance, or certainly dance which may hint at theatrical strategies, preferring the objectification of performance through film, photography, installation and writing. The chapter 'Minimal Dance' focuses on several works in gallery spaces that I and collaborators were involved in – including X6 Dance Space at the Whitechapel Gallery in 1979 – and recent projects at the Hayward Gallery[6] and Tate Modern[7] in London have echoed the Whitechapel's strategy to include dance artists as part of group shows. While these events have been curated by individual practitioners, the choreographers and dancers involved often remain anonymous; most usually the invitation to dance artists is to explore material which endeavours to activate the spaces around existing object-based work by visual artists in exhibition, rather than creating spaces of their own. However, some galleries *are* providing a space for more conceptual dance work and at this time there are several choreographers who would prefer the context and support of the gallery rather than the theatre with all of its assumptions about the need for theatrical paraphernalia.

Many dance practitioners have also chosen to expand their professional context by working within the community. Since the 1970s there has been a flourishing of community arts in a wide variety of settings and in more recent years dance has been a leading force in the field of arts education and arts and health. New and independent dance practitioners have been the primary researchers and developers of this movement, as the culturally diverse, interdisciplinary techniques and influences they work with provide the know-how and appropriate skills to meet the challenges of working within mixed-community settings. The necessity for artistic and formal discipline is imperative within this work, which engages with some of the most disadvantaged groups in society, yet too often these projects get labelled as 'community work', implying that they are somehow not engaging with artistic strategies and skills. The artist Fergus Early, whose work with Green Candle Dance Company has pioneered much innovative dance work within diverse community settings, says:

> We do offer many people who wouldn't ordinarily have the chance an opportunity to dance. So I see very young children dance, I see very frail older people dance, I see sick children and disabled adults and every kind of person dance.[8]

Only an *artist* could imagine being able to dance with these diverse groups and have the skills and the confidence to make it happen.

Over the last 40 years or so France, Germany, Belgium, Holland and some other European countries seem to have done better than the UK at supporting innovative dance practice and training, with the possible exception of dance in community and education settings. While conservative trends are eroding some of this work in Europe, there has, nevertheless, been more investment over the years in the infrastructure, including many more opportunities for touring to mid- and large-scale venues across the European Union, dedicated international festivals, continuing support for mature students and a number of schools and colleges for New Dance training and research. The German choreographer Pina Bausch,[9] who was a pioneer of this postmodern European movement, was an artist who did manage to combine art, theatre and community in a profound way. She seemed less interested in how people moved than in what moved them and used theatrical and emotional language with abstract and formal strategies. Her works expressed involvement with cultural and societal images and attitudes and a concern with the subjective experience of the individual within the collective, often conveyed as an epic chorus. The following words express her distinctive process:

> What I try is to find the pictures, or the images that can best express the feelings I want to convey. And you have to find your own way to show these things. I am not telling a story in a normal way. Each person in the audience is part of the piece in a way; you bring your own experience, your own fantasy, your own feeling in response to what you see. There is something happening inside. You only understand if you let that happen, it's not something you can do with your intellect. So everybody, according to their experience, has a different feeling, a different impression.[10]

When students and others ask me: 'What is a choreographer?' I tell them it is many things: an author, some kind of dance and movement expert, researcher, possibly a teacher, dancer, director,

devisor, manager, producer and often a film-maker. I tell students that contemporary choreographers have earned their right to be taken seriously as professional artists who aspire to originality and make works that are thought-provoking and should be seen by many people. Despite this vision, choreographers and dancers are often used and exploited to decorate and service other sectors. If this work is providing jobs and promoting dance, there is nothing inherently wrong and I am not suggesting all professional dance should only exist as 'high art' practice – dance will always take place in many different kinds of cultural and community spaces. However, I am suggesting that choreographers are often not allowed to leave the entertainment sector or the studio 'emergent' space: as the choreographer Shobana Jeyasingh[11] says '[…]cultivation should also extend beyond the new. It is equally valuable to enjoy consolidation.'[12] Choreography, for me, is not only about dance; it is about dance being part of something much bigger; it can after all be a meeting place for aesthetics, science, psychology, health, ethics, intergenerational activity, diversity, ritual and community. It has also been a place where traditionally women have excelled and it is vital that this continues.

My time is now balanced between my own choreographic practice and supporting intergenerational artists and companies through mentoring, teaching and directing the Dance Research Studio which has become part of an important network of independent spaces within the UK. What the word *Independent* now means for dance in the present era is a potent question and if we call our work independent, what, as Matthew Hawkins asks in the previous chapter, is it independent from? Over many years I have had the opportunity to work in contexts and with people who are very clear about their political position and how that informs and shapes their work. I have noticed however, that it is sometimes more difficult for young people now to find that clarity in a world that is perhaps even less supportive to the arts and in many ways, given the promise of change in previous eras, disappointing on issues such as gender equality, conservation of the environment and world peace. It is not surprising that, as an older, more experienced artist, I find myself challenging the myth that all young people have to break free from the certainties of previous work, which is assumed to be more complacent than their own. I suggest, rather, that those of us who are exploring dance as a progressive art form, at whatever age, should stick together in the face of a growing social conservatism. In her book *The Art of Making Dances*, written in 1958, Doris Humphrey,[13] while convinced that 'Anything so vital as dance will survive' nevertheless articulates concerns that she could just as well have written now:

> I think all the branches of the proliferating tree should be examined with the heart, brains and conscience of the caretakers and this includes the public, the choreographers, the business management, the dancers, students, teachers, government officials – in short, everybody who has even a passing interest in the art. And if these people – individually, collectively, or both – refuse to grow up, think in the present and make of the dance a living thing, our times are going to seem to history like a prolonged infancy, or a twiddling of nineteenth-century toes while the present turns to ashes.[14]

As I write I am working in the studio with some old familiar methods and materials, again playing with found objects, fragments of text and random images – what I call 'externals', but which could just as easily be called 'internals'. I invited the writer and academic Ramsay Burt[15] to join me and a group of

91 *About Us*

artists in the research process, which we are calling *About Us*.[16] The following quote from his contribution to our research blog gives a sense of the questions we are exploring:

> Jacky has been creating situations in which people can talk, and exchange, and raise issues around emotional experiences. This seemed to me to relate to the binaries inside/outside, private/public, and personal/political. How might some of the material generated during the R&D period – much of which seems to me to be affecting – relate to the particular ways in which people are having emotional experiences within Austerity Britain, post-crash Europe, and the car-crash-in-slow-motion of environmental degradation? I'm not saying that the material being developed is 'about' this, but just asking where showing people who are being open about emotional experiences (not all of which are necessarily painful or melancholy) might resonate with audience members because of the way it seems to pick up on a more generalised space relating to contemporary experiences?[17]

Life inevitably gets more complex as one gets older and it becomes impossible to separate artistic practice from everything else. With other artists, I work with 'what is on top' – our everyday stressful and joyful experiences; we improvise, we make things and as Ramsay observes – we talk – there is space for our feelings in the studio. This is the beginning of a research process towards a new work that in *some* form will return to working with 'guests' in both new and old spaces and which I hope through its formal embodiment will engage with issues that are relevant to society.

Even though the choreographic space I hold can sometimes seem fragile, being a choreographer gives my life energy, focus and meaning and I feel optimistic about the future. Choreography, the making of art that disappears, is not always valued in a cluttered world of products and objects – and yet it may be incredibly important to humanity.

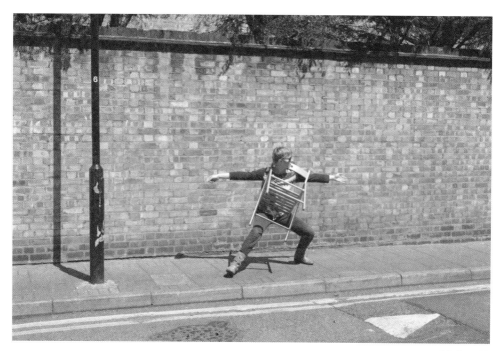

92 *About Us*

Notes

1. Jonathan Burrows: dancer and choreographer; he has worked internationally and was resident artist at Kaaitheater, Brussels. He has made commissioned works with William Forsythe, Sylvie Guillem and the Royal Ballet. He is on the faculty of Performing Arts Research and Training Studios (PARTS), Brussels and is a visiting lecturer at Royal Holloway University, London. His long-term collaborator is the Italian composer Matteo Fargion.

2. Jonathan Burrows: 'Contract/Performance Space/Language/Choreography', in *A Choreographer's Handbook* (London: Routledge, 2010), 37–40 (40).

3. See *Who Cares? Dance in the Gallery & Museum* by Sara Wookey (London: Siobhan Davies Dance, 2015). The publication opens up a useful discussion about this currently shifting context through a collection of conversations with dance artists, curators and directors. Sarah Wookey is a dancer, choreographer and director of Wookey Works Studio; Siobhan Davies Dance was founded in 1988 by the choreographer Siobhan Davies. Based at Siobhan Davies Studios in London, the company has evolved from a national and international touring dance company into an investigative contemporary arts organisation which explores how to apply choreography across a wide range of disciplines, including visual arts, film and craft.

4. Rosemary Butcher (1947-2016): UK-based choreographer who, in the 1970s, was inspired by American modernists such as Trisha Brown, Lucinda Childs and Meredith Monk. Over 40 years she made many rigorous, minimalist dance works in diverse spaces, often in collaboration with visual and film artists. A book about her work, *Rosemary Butcher: Choreography, Collisions and Collaborations* edited by Rosemary Butcher and Susan Melrose was published in 2005 (London: Middlesex University Press, 2005).

5.	Rosemary Butcher: quote from' Collisions and Collaborations – Robert Ayers in Conversation with Rosemary Butcher, 2001', in *Rosemary Butcher: Choreography, Collisions and Collaborations*, ed. Rosemary Butcher and Susan Melrose (London: Middlesex University Press, 2005), 56–66 (57).

6.	'Mirrorcity', Hayward Gallery (2015): interdisciplinary exhibition which addressed the dilemmas and consequences of living in a digital age. Live dance work was integrated (curated by Frank Bock) and several exhibiting artists worked with dance and performance through film.

7.	BMW Tate Live: *If Tate Modern Was Musée de la danse?* (2015): this project proposed the transformation of the art museum via the lens of dance. It was curated by the French artist Boris Charmatz.

8.	Fergus Early: 'Your Body Knows a Lot of Things', in *The Wise Body: Conversations with Experienced Dancers*, ed. Jacky Lansley and Fergus Early (Chicago and Bristol: Intellect, 2011), 173-184 (183).

9.	Pina Bausch (1940–2009): German dancer, choreographer and teacher. Early training at the Juilliard School in New York where she worked with Antony Tudor and other seminal modern pioneers; she was also inspired by the Living Theatre, Happenings and early postmodern dance work. In 1962 she returned to Germany where Kurt Joos offered her a position in his Folkwang Ballet. In 1972 Bausch was offered the position of director of the Wuppertal Ballet which she renamed Tanztheater Wuppertal and where she made many innovative ensemble dance works which toured internationally over 35 years.

10.	Pina Bausch: 'Come Dance with Me' (Interview with Pina Bausch by Nadine Meisner), *Dance and Dancers*, November 1992, 12–16.

11.	Shobana Jeyasingh: is an Indian-born choreographer who has been creating new work for her company, Shobana Jeyasingh Dance, for 27 years. She works with a wide range of collaborators from different media and her work has been widely toured in Europe, the USA and Asia. Commissions from other companies include works for Rambert, Random Dance, Ballet Black, Beijing Dance Academy and City Contemporary Dance Company, Hong Kong.

12.	Sanjoy Roy: 'Shobana Jeyasingh on elephants and mayflies: is there mid-life for the middle-scale contemporary dance company? An interview with Sanjoy Roy' in *Animated* (Leicester: The Foundation for Community Dance (now called People Dancing), Winter, 1998).

13.	Doris Humphrey (1895–1958): American dancer and choreographer who, with her contemporaries Martha Graham and Katherine Dunham, was one of the second generation modern dance pioneers who followed forerunners Isadora Duncan, Ruth St Denis and Ted Shawn. On leaving the Denishawn Company, where she was a leading dancer, she and Charles Weidman formed the Humphrey–Weidman Company. She taught choreography at the Juilliard School and at Connecticut College and wrote *The Art of Making Dances* (New York: Holt, Rinehart and Winston, 1959).

14.	Doris Humphrey: *The Art of Making Dances* (New York: Holt, Rinehart and Winston, 1959). 'Conclusion', 167–176 (176).

15.	Ramsay Burt: Professor of Dance History at De Montfort University, UK. His publications include *The Male Dancer: Bodies, Spectacle, Sexualities* (New York: Routledge,1995, revised 2007); *Alien Bodies: Representations of Modernity, 'Race' and Nation in Early Modern Dance* (London: Routledge, 1997); *Judson Dance Theater: Performative Traces* (Abingdon: Routledge, 2006); *Writing Dancing Together*, with Valerie Briginshaw (Basingstoke: Palgrave Macmillan, 2009); *Ungoverning Dance: Contemporary European Dance and the Commons* (New York: Oxford University Press, 2016); *British Dance: Black Routes*, edited collection with Christy Adair (London and New York: Routeledge, 2016). He has lectured internationally and is a regular teacher at PARTS in Brussels.

16. *About Us* (2017): experimental, interdisciplinary research project initiated and directed by Jacky Lansley with film artist Roswitha Chesher, composer Sylvia Hallett, dramaturg Ramsay Burt and performers Vincent Ebrahim, Ursula Early, Lucy Tuck, Esther Huss, Ingrid Mackinnon, Maxwell Mackinnon, Maria Ghoumrassi and Fergus Early. As a group they have drawn on the personal and political, the extraordinary and mundane, to explore stories and images which cross borders of age, race, gender and artistic disciplines. The work emerged from an interdisciplinary programme, *Crossing Paths* (2016), which was devised by the Dance Research Studio with support from the Arts Council of England. *About Us* will be presented at different sites during 2017.

17. Ramsay Burt: extract from a research blog (May, 2016) discussing processes involved in the R&D project *About Us,* choreographed and directed by Jacky Lansley and curated by Dance Research Studio.

WORKS AND PHOTOGRAPHY CREDITS

CHAPTER 1

The Truth About Me, **1973**
Choreographed and designed by Jacky Lansley with Strider
Performers: Nanette Hassall, Wendy Levett and Christopher Banner
Music: The Everly Brothers and Elvis Presley
Place Theatre, London and on tour with Strider in the UK (including HM Prison Wormwood Scrubs)

Halfway to Paradise, **1972**
Devised and choreographed by Jacky Lansley with Strider
Performers: Jacky Lansley, Barry Flanagan, Sally Potter, Richard Alston, Fergus Early, Gordon Mumma, Diana Davies, Wendy Levett, Christopher Banner and Colette Lafont
Music: Billy Fury
Institute of Contemporary Arts, London

Hundreds and Thousands, **1972**
Devised, choreographed and performed by Jacky Lansley, Sally Potter and Diana Davies with Strider
Design concept by sculptor Barry Flanagan. Performance accompanied by the Ross & Cromarty Orchestra (offshoot from the Portsmouth Sinfonia)
Place Theatre, London; Edinburgh Festival; the Institute of Contemporary Arts, London as part of 'The Body as Medium of Expression'; and the Sonja Henie Centre in Oslo, Norway as part of an exhibition called 'British Thing'

Auk **and** *Fallen Angels,* **1973**
Devised and performed by Jacky Lansley, Sally Potter and Diana Davies in collaboration with John Bull Puncture Repair Kit
Based on scripts by Mick Banks
Birmingham Arts Laboratory; Oval House, London
Image 02: Performers - Diana Davies, Jacky Lansley; Photographer unknown

Dry Dock, **1973**
Choreographed by Diana Davies
Performer: Jacky Lansley
Music/Sound: Erik Satie, 'Gymnopédies' and John Darling
Place Theatre, London

Episodes, **1973**
Limited Dance Company
Devised and performed by Jacky Lansley and Sally Potter
Music: Bolero by Maurice Ravel
London School of Contemporary Dance (central stair case and cafe)

Curtains Courtesy, **1974**
Limited Dance Company
Devised and directed by Jacky Lansley and Sally Potter
Performers: Participants of Edinburgh Arts 74, including Heidi Giuntoli, Elisa Decker, Janet Rosing,
Jane Whittaker, Cheri Gaulke, Barbara Bouska, Linda Olle, Carla Stetson and Deborah Hansen
Demarco Gallery, Edinburgh Festival
Image 03: Photographer Bill Beech

Tartan Introduction **(or** *Card Piece)***, 1974**
Limited Dance Company
Devised and performed by Jacky Lansley and Sally Potter
Pollock Halls of Residence, Edinburgh University
Image 04: Archival description of *Card Piece* by Jacky Lansley and Sally Potter, 1974

Lochgilphead, **1974**
Limited Dance Company
Devised and directed by Jacky Lansley and Sally Potter
Performers: Jacky Lansley and Sally Potter with students from the Edinburgh Arts 74 programme
Curated by Richard Demarco
Lochgilphead, Scotland as part of Edinburgh Arts 74
Images: 05, 06, 07, 08: Performers - Jacky Lansley, Sally Potter; Photographer Bill Beech

Hurricane, **1974**
Limited Dance Company
Devised, directed and performed by Jacky Lansley and Sally Potter
Oval House Theatre, London

Aida, **1974**
Limited Dance Company
Devised and directed by Jacky Lansley and Sally Potter
Performers: Jacky Lansley, Sally Potter, Fergus Early, Craig Givens, Janet Krengel and musician Colin
Wood
Oval House Theatre, London

Brief Encounter, **1975**
Limited Dance Company
Devised and performed by Jacky Lansley and Sally Potter with Caroline Potter
Oval House Theatre, London
Images: 09, Performer Jacky Lansley; 10, Performer Sally Potter; Photographer Caroline Potter

Park Cafeteria, 1975
Limited Dance Company
Devised and performed by Jacky Lansley, Sally Potter, Rose English, Judith Katz, Lynn MacRitchie and Sylvia Stevens
Serpentine Gallery and Hyde Park, London
Images: 01, 11,14, Performers - Sally Potter, Jacky Lansley; 12, Performers - Rose English, Judith Katz, Jacky Lansley; 13, Performer - Sally Potter; Photographer Geoff White

Death and the Maiden, 1975
Limited Dance Company
Devised and performed by Jacky Lansley, Rose English and Sally Potter with Dennis Greenwood (Part 1)
Lighting designer: Steve Whitson
Part 1 presented at Snow Hill Station as part of the Birmingham Festival of Performance Art; Parts 2, 3, 4 and 5 at the Thema Vrouw Festival, De Lantaren, Rotterdam
Image 15: Performers – Sally Potter, Rose English and Jacky Lansley; Photographer Hans Pattist

Rabies, 1976
Limited Dance Company
Devised, directed and performed by Jacky Lansley, Sally Potter and Rose English
Roundhouse, London
Image 16: Invitation card; archival photograph: Sarah Schrauwen
Image 17: Performer Jacky Lansley; Photographer unknown

Mounting, 1977
Limited Dance Company
Devised and performed by Jacky Lansley, Sally Potter and Rose English
Curator: Mark Francis
Museum of Modern Art, Oxford
Image 18: poster/invitation card designed by the artists
Image19: Photographer Brian Alterio (courtesy Modern Art Oxford)

Grass Roots, 1974
Limited Dance Company
Devised and directed by Jacky Lansley and Sally Potter
Performers: Students of Bingley College
Bingley College, Yorkshire
Image 20: Photographer Francis Green

CHAPTER 2

Triptych, 1976
Performer: Jacky Lansley
Butler's Wharf, London
Image 21: Photographer Geoff White

Dance class at X6 Dance Space, 1976
Image 22: Photographer Geoff White

Dance Object, **1977**
Choreographed, written and performed by Jacky Lansley
X6 Dance Space, London
Images 23, 24, 25: Photographer Geoff White

Dancing Ledge, **1977**
Choreographed and directed by Jacky Lansley
Performers: Jacky Lansley and Rose English with a chorus of artists associated with X6 Dance Space, including those in the photograph: Timothy Lamford, Craig Givens, Malcolm Dart and Vincent Meehan (Lansley and English lying on the floor)
X6 Dance Space, London
Image 26: Photographer Geoff White

Women Dancing, **1978**
Devised and performed by Jacky Lansley and Rose English
Acme Galley, London
Images 27, 28, 29: Drawings by Rose English
Image 30: Photographer Geoff White
Image 31: Diagram by Mike Leggett

Juliet and Juliet a Duet – Romeo and Romeo a Duel, **1979**
Devised and performed by Jacky Lansley and Rose English
Music: Extracts from the ballet by Sergei Prokofiev
X6 Dance Space, London; Drill Hall, London
Image 32: (presented to each member of the audience at the start of the performance), Photographer unknown

Edge City, The Fast Supper, Bagwash, **1978/1979**
Devised and performed by Helen Jives: Anna Furse, Suzy Gilmour, Jacky Lansley and Maureen O'Farrell
Drill Hall, London; X6 Dance Space, London
Image 33: From the poster for *Edge City* designed by Helen Jives; Photographer William Raban
Image 34: Original 'menu' (programme) for the first performance of *The Fast Supper,* designed by Helen Jives

Zena Mountain, **1979**
Created and performed by Jacky Lansley
Drill Hall, London
Image 35: Zena and guest Marilyn Halford; Photographer unknown

CHAPTER 3

I, Giselle, **1980**
Choreographed and directed by Jacky Lansley and Fergus Early
Performers: cris cheek (*sic*), Fergus Early, Suzy Gilmour, Jacky Lansley and Sue MacLennan
Music: Stephen Montague after Adolphe Adam
Song lyrics: Suzy Gilmour
Designer: Craig Givens
Text: Jacky Lansley and Fergus Early
Photography and artwork for slides: Jeanette Iljon
Premiered at the Drill Hall, London followed by London and UK tours, including Battersea Arts
Centre, Theatre Royal Stratford, Froebel Institute, Hounslow Civic Centre, Old Half Moon, The
Bluecoat, Liverpool, Crewe and Alsager College etc.
Image 37: Photographer Jill Posener
Image 38: Artwork and photography Jeanette Iljon

The Impersonators, **1982**
Written, choreographed and directed by Jacky Lansley
Performers: Betsy Gregory, Vincent Meehan and Stephanie Nunn
Composer: Sylvia Hallett
Designer: Pamela Marre
Drill Hall, London
Image 39: Performers Betsy Gregory, Vincent Meehan; Photographer Jill Posener

A Child's Play, **1987**
Devised and directed by Jacky Lansley
Performers: Sally Cranfield, Jacky Lansley, Steinvor Palsson and Chris Rowbury
Sound design (with music from Hungarian Rhapsody No.4; Composer: Franz Liszt): Philip Jeck
Costume designer: Moggie Douglas
Lighting designer: Michael Hulls
UK tour, including Leicester Polytechnic Performance Centre; Trent Polytechnic, Nottingham;
Chisenhale Dance Space, London; the Place Theatre, London; St Paul's Centre for the Arts, Oxford;
Northampton Arts Centre etc.
Image 40: Performer - Steinvor Palsson; Photographer Jacky Lansley
Image 41: Performer - Chris Rowbury; Photographer Jill Posener

The Breath of Kings, **1986**
Devised and directed by Jacky Lansley
Performers: Fergus Early, Jacky Lansley and Gale Burns
Text: William Shakespeare, Richard II, Act 1, Scene 1
Dartington College of Arts, Devon, as part of the Dartington Dance Festival – curated by Mary
Fulkerson and Katie Duck
Image 42: Photographer Jessica Loeb

Do My Shoes Reflect the Quality of My Intellect? **1998–99**
Written, choreographed and performed by Jacky Lansley
UK university tour, including University of North London; University of Brighton; University of
Winchester; Chichester University
Image 43: Photographer Steve Blunt

Les Diables (research project), **1998–99**
Devised and directed by Jacky Lansley
Performers: Luke Burrough, cris cheek (sic), Vincent Ebrahim and Fergus Early
Musicians: Philip Howard, Catherine Spencer and Andrew Keenan
Music research: Michael Finnissy
Design research: Paul Minter
Cinematographer: Tamara MacLachlan
University of North London; Chisenhale Dance Space, London
Images 44, 45: Drawings with notes by Jacky Lansley

Bird, **2001**
Directed and choreographed by Jacky Lansley
Performers: Sonia Ritter, Fergus Early, Kevin Pamplin, Tori Jones and Emma Sweeny, Chorus (students
of King Alfred's College, Winchester): Lee Bamford, Lisa Beresford, Stephanie Hughes, Joseph
Krajewski, Hannah Lamb and Karen Tween
Composers: Philip Howard and Michael Finnissy
Musicians: Thomas Allard, Philip Howard, Daniel Rees-Jones and Jeremy Woodruff
Costume designer: Nina Ayres
Lighting designer: Francis Stevenson
Purcell Room, South Bank Centre, London; Stripe Theatre, Winchester; Portsmouth Studio Theatre
Image 46: Performers – Sonia Ritter, Tori Jones, Emma Sweeny; Photographer Dee Conway
Image 47: Drawing of a costume design for the 'Chorus' by Nina Ayres
Images 48, 49: Research notes by Jacky Lansley

The Life Class, **2005**
Short film written and directed by Jacky Lansley
Performers: Vincent Ebrahim, Kathryn Pogson, Tim Taylor, Fergus Early, David Bennett, Ursula Early,
Robert Cawsey, Yoko Nishimura, Sue O'Sullivan and Eliot Shrimpton
Music: *The Firebird* by Igor Stravinsky
Executive producer: Rachel Bailey
Director of photography: Hugo Glendinning
Editor: Jo Ann Kaplan
Pianist: Philip Gammon
Costume designer: Paul Minter
Filmed on location at the Dance Research Studio, London
UK premiere: The Horse Factory, London; European premier: NapoliDanza International Festival of
Videodance

Images: Performers – 36, Vincent Ebrahim; 50, Kathryn Pogson, Philip Gammon; 51, Yoko Nishimura, Eliot Shrimpton, Sue O'Sullivan, Robert Cawsey; 52, Vincent Ebrahim, Fergus Early, David Bennett; 53, Bird's students with Wolf; 54, David Bennett, Ursula Early. All stills from the film – Cinematographer Hugo Glendinning

CHAPTER 4

Holding Space, 2004
Choreographed by Jacky Lansley
Performers: Sandra Conley, Fergus Early, Robin Eun-ha Jung, Gareth Farley, Tania Tempest-Hay and Lucy Tuck
Music: Franz Schubert (selected movements from the late piano sonatas)
Producer: Dance Research Studio in association with ROH2
Pianist: Philip Gammon
Lighting designer: Tom Mannings
Costume consultant: Paul Minter
Clore Studio, Royal Opera House, London
Images: Performers - 55, Lucy Tuck, Tania Tempest-Hay, Robin Eun-ha Jung; 56, Sandra Conley, Fergus Early, Lucy Tuck; 57, Robin Eun-ha Jung; 58, Gareth Farley, Tania Tempest-Hay; 59, Sandra Conley, Robin Eun-ha Jung, Tania Tempest-Hay, Gareth Farley; Photographer Hugo Glendinning

CHAPTER 5

View from the Shore, 2007
Choreographed by Jacky Lansley
Performers: Fiona Chivers, Fergus Early, Quang Kien Van, Tania Tempest-Hay and Sheron Wray
Music: Lindsay Cooper, Concerto for Sopranino Saxophone and Strings
Producer: Dance Research Studio with Hall for Cornwall in association with ROH2
Film: Hugo Glendinning
Musicians: David White, Barbara Degener, Oliver Lewis and Alastair Taylor
Costume designer: Nicola Fitchett
Lighting designer: Anna Watson
Hall for Cornwall, Truro; Clore Studio, Royal Opera House, London
Images: Performers - 60, Tania Tempest-Hay; 63, David White; 64, Sheron Wray, Fergus Early; 65, Sheron Wray, Quang Kien Van; Photographer Hugo Glendinning
Images 61, 62: Research drawings by Jacky Lansley

Anamule Dance, 2007
Choreographed by Jacky Lansley
Performers: Fiona Chivers, Fergus Early, Quang Kien Van, Tania Tempest-Hay, Tim Taylor, Helen Tiplady, Sally Williams and Sheron Wray
Music: Jelly Roll Morton, from the Alan Lomax Recordings, 1938

Published by Rounder Records. Additional composition and arrangements of Morton's work by composer Jonathan Eato
Producer: Dance Research Studio with Hall for Cornwall in association with ROH2
Costume designer: Nicola Fitchett
Lighting designer: Anna Watson
Hall for Cornwall; Clore Studio, Royal Opera House, London
Image 66: Performers – the whole company; Photographer Hugo Glendinning

CHAPTER 6

Standing Stones, 2008
Choreographed by Jacky Lansley
Performers: Daniella Ferreira, Ayano Honda, Katie Keeble and Paul Wilkinson
Music: Wolfgang Amadeus Mozart, Clarinet Quintet K581
Musicians: Dave White, Jonathan Delbridge and Edward Enrico Gerber
Producer: Ascendance Rep
Costume design: Emma Hopkinson and Jacky Lansley
Lighting designer: Michael Mannion
Premiered at York Minster, followed by a tour of 14 UK cathedrals
Image 67: Performers – Katie Keeble, Daniella Ferreira, Paul Wilkinson; Photographer Jim Poyner
Images 68,69: Upper Paleolithic cave paintings from the Lascaux site, France; published by Editions Semitour Périgord. Image titles: 68 – 'Cerf qui brame' (the bellowing stag); 69 – 'La scene du puits' (the scene of the well)
Image 70: Research drawing of Carlisle Cathedral by Jacky Lansley
Images 71, 72: Gargoyles in the Chapter House, York Minster; Photographer unknown
Images (with the whole company): 73, Photographer Norman Reid; 74, Photographer Ellie Keeble

CHAPTER 7

Guests Research, 2010
Directed by Jacky Lansley and Tim Brinkman
Performers: Ursula Early, Claudia Hope, Brett Jackson, Angela Kelly, Polly Motley and Tim Taylor
Curator: Dance Research Studio with Hall for Cornwall
Music researcher: Jonathan Eato
Design researcher: Fiona Chivers
Lighting designer: Mark Seaman
Documentary filmmaker: Lucy Beech
Hall for Cornwall, Truro
Images (with the whole company): 75, Photographer Lucy Beech; 76, Photographer Jacky Lansley; 78, Photographer Iris Chan; 77, Performers - Ursula Early, Angela Kelly; Photographer Iris Chan

CHAPTER 8

Guest Suites, 2012
Choreographed by Jacky Lansley
Performers: Fergus Early, Sanna Eriksson Ryg, Esther Huss, Hannah Mi, Huri Murphy, David Ogle and Tim Taylor
Music: Johann Sebastian Bach, Suites 1–3 of the Six Cello Suites; and Jonathan Eato, Suite Inserts
Producer: Dance Research Studio in association with ROH2
Cellist: Audrey Riley
Lighting designer: Jack Robson
Design consultant: Nicola Fitchett
Clore Studio, Royal Opera House, London; York Minster; Barbican Theatre Plymouth
Images: 79, Tim Taylor, Esther Huss, David Ogle, Huri Murphy; 82, Hannah Mi and David Ogle foregrounded; 83, Sanna Eriksson Ryg; 84, Sanna Eriksson Ryg, Esther Huss, Huri Murphy; 85, Audrey Riley (cellist), Sanna Eriksson Ryg, Esther Huss, Huri Murphy; 86, Tim Taylor, Esther Huss, Huri Murphy, Sanna Eriksson Ryg; Photographer Hugo Glendinning
Image 80: Research drawing of Chapter House, York Minster by Jacky Lansley
Image 81: Drawing of 'Ley Lines' by Jack Robson

CHAPTER 9

Artist: Rosemary Lee
Performers: 100 women of all ages and backgrounds
Dance Umbrella, 2011
Image 87: *Square Dances* (2011); Photographer Hugo Glendinning

Artist: Tony Thatcher
Image 88: Photographer Silvy Panet-Raymond

Artist: Matthew Hawkins
Image 89: Photographer Colin Thom

Artist: Miranda Tufnell
Performers: Tim Rubidge, Eeva Maria Mutka and Cai Tomos
Sound composition: Sylvia Hallett
Musician: Jonah Brody
Visual artist: David Ward
Image 90: *Pneuma* (2015); Photographer Christian Kipp

ONWARD

About Us (2016)
Research project directed and choreographed by Jacky Lansley
Curated by: Dance Research Studio
Performers: Vincent Ebrahim, Esther Huss, Ursula Early, Lucy Tuck, Fergus Early, Maria Ghoumrassi, Ingrid Mackinnon and Max Mackinnon

Sound/music composition: Sylvia Hallett
Cinematographer/editor: Roswitha Chesher
Lighting/Technical Director: Nao Nagai
Dramaturg: Ramsay Burt
Created and filmed at Dance Research Studio and in surrounding outdoor locations
Image 91 (performance at Siobhan Davies Studios): Performers - Vincent Ebrahim, Fergus Early, Maria Ghoumrassi, Esther Huss, Ursula Early and Ingrid Mackinnon; Photography (film still) Roswitha Chesher
Image 92: Performer - Esther Huss; Photographer Sarah Covington

BIBLIOGRAPHY

Adair, Christy: 'Beginning Again – New Dance', in *Women and Dance (Women in Society – A Feminist List)*, ed. Jo Campling (London: Palgrave Macmillan, 1992), 182–198 (190).

Adewole, Funmi: 'Raising the Level: The ADAD Heritage Project', in *Voicing Black Dance: The British Experience 1930s–1990s*, ed. Funmi Adewole, Dick Matchett and Colin Prescod (London: Association of Dance of the African Diaspora [ADAD], 2007), 12–15.

Blackburn, Julia: 'X6 Performances' (*Dancing Ledge* by Jacky Lansley), *New Dance Magazine*, No.1 (London: X6 Dance Space, 1977), 13.

Borelli, Melissa Blanco: 'Introduction', in *She Is Cuba – A Genealogy of the Mulata Body* (Oxford: Oxford University Press, 2016), 5–28 (7).

Brett, Guy (text), English, Rose (scripts), Rentell, Anne-Louise (interviews): 'Interview Sally Potter', in *Abstract Vaudeville: The Work of Rose English*. Edited by Martha Fleming and Doro Globus (London: Ridinghouse, 2015), 95–102 (95).

Burrows, Jonathan: 'Contract/Performance Space/Language/Choreography', in *A Choreographer's Handbook* (London: Routledge, 2010), 37–40 (40).

Butcher, Rosemary: 'Collisions and Collaborations – Robert Ayers in Conversation with Rosemary Butcher, 2001', in *Rosemary Butcher: Choreography, Collisions and Collaborations*, ed. Rosemary Butcher and Susan Melrose (London: Middlesex University Press, 2005), 56–66 (57).

chris cheek (sic): 'A Leap in the Dark: Breaking Out' (review of *I, Giselle*), *The Guardian* (London: 16th January, 1982).

Early, Fergus: *On Standing Still: A View from the Floor* (London: Dance UK Magazine, Issue 67, 2007), 14–15.

Early, Fergus: 'Your Body Knows a Lot of Things', in *The Wise Body: Conversations with Experienced Dancers*, ed. Jacky Lansley and Fergus Early (Chicago and Bristol: Intellect, 2011), 173–184 (183).

Gilbert, Jenny: 'There's Weird and Wondrous Life in the Old Girl Yet' (review of *Bird*), *The Independent on Sunday*, (London: 18th March, 2001), 6.

Gilmour, Suzy, Lansley, Jacky, Furse, Anna and O'Farrell, Maureen (Helen Jives): 'Helen Jives in Edge City', (collective review), *New Dance Magazine*, No.9 (London: X6 Dance Space, 1979), 14.

Humphrey, Doris: 'Conclusion', in *The Art of Making Dances*. Edited by Barbara Pollack (New York: Holt, Rinehart and Winston, 1959), 167–176 (176).

Johnson-Small, Jamila and Hemsley, Alexandrina: *A Contemporary Struggle* (London: Project O and the Live Art Development Agency, 2013), 9.

Kaye, Nick: 'Modern Dance and the Modernist Work', in *Postmodernism and Performance: New Directions in Theatre* (London: Macmillan Press, 1994), 71-89, (89).

Langer, S. K.: *Feeling and Form: A Theory of Art* (New York: Charles Scribner's Sons, 1953), 175.

Lansley, Jacky, English, Rose, Potter, Sally: *Mounting* (Oxford: Museum of Modern Art, Oxford, 1977).

Lansley, Jacky: 'Writing' (Editorial). *New Dance Magazine*, No.1 (London: X6 Dance Space, 1977), 3.

MacRitchie, Lynn: 'I, Giselle' (review), *Performance Magazine*, No.8 (London: *Performance Magazine*, November/December 1980), 10–11 (10).

———: '*Mounting*' (review of *Mounting* – the performance), *New Dance Magazine*, No. 3 (London: X6 Dance Space, 1977), 20–23.

McLaughlin, Marguerite: 'Juliet and Juliet a Duet – Romeo and Romeo a Duet, Action Space' (review), *Performance Magazine*, No.4 (London: *Performance Magazine*, December/January 1980), 7.

Meisner, Nadine: 'Jacky Lansley and Rose English at the X6 Dance Space', *New Dance Magazine*, No.11 (London: X6 Dance Space, 1979), 20.

———: 'Come Dance with Me' (interview with Pina Bausch), *Dance and Dancers* (London: November issue 1992), 12–16.

Midgelow, Vida L.: 'Reworking the Ballet – (En) Countering the Canon', in *Reworking the Ballet – Counter-Narratives and Alternative Bodies* (London: Routledge, 2007), 9–35.

Percival, John: 'Proving experimental art can be fun' (review of Strider), *The Times* (London: 4th October, 1972).

Pinkola Estes, Clarissa: 'Nosing Out the Facts: The Retrieval of Intuition as Initiation', in *Women Who Run with the Wolves* (London, Sydney, Auckland and Johannesburg: Rider, 1992), 74–114.

Potter, Sally: 'Afterword', in *Naked Cinema: Working with Actors* (London: Faber & Faber, 2014), 417–420.

Roy, Sanjoy: '*Holding Space*' (review), *Dance Now*, Autumn (London: Dance Books Ltd., 2004), 107–109.

Solway, Andy: 'Interview with Jacky Lansley', *New Dance Magazine*, No.39 (London: X6 Dance Space, 1987).

Stein, Gertrude: 'Plays', in *Lectures in America* (New York: Random House, 1935), 93–131.

Tufnell, Miranda and Crickmay, Chris: *Body Space Image* (London: Dance Books Ltd, 1990).

———: *A Widening Field: Journeys in Body and Imagination* (London: Dance Books Ltd, 2004).

INDEX